How to draw and sell digital cartoons

Leo Hartas

BARRON'S

First edition for the United States, its territories and dependencies, and Canada published in 2004 by Barron's Educational Series, Inc.

This book was conceived by

ILEX
Cambridge, England

Publisher: Alastair Campbell
Executive Publisher: Sophie Collins
Creative Director: Peter Bridgewater
Editorial Director: Steve Luck
Editor: Stuart Andrews
Design Manager: Tony Seddon
Designers: compoundEye
Artwork Assistant: Joanna Clinch
Development Art Director: Graham Davis
Technical Art Editor: Nicholas Rowland

All inquires should be adressed to:
Barron's Educational Series, Inc.
250 Wireless Blvd.
Hauppauge, NY 11788
www.barronseduc.com

International Standard Book No: 0-7641-2662-8

Library of Congress Catalog No: 2003112247

For more information on this title please visit:
www.tfcpus.web-linked.com

Printed and bound in China

9 8 7 6 5 4 3 2 1

Contents

Chapter 1

Introduction	6
What Is a Cartoon?	8
Genre	10
Press Start	12
Computers as an Aid to Production	14
Only by Computer	16
Pixels at Work: Dicebox	18

Chapter 2

Digital Inspiration	20
The Spark	22
Who?	24
The One-Liners	26
Pixels at Work: Doctor Who	28

Chapter 3

The Mighty Pen	30
Short and Long Forms	32
Story Workshop	34
Pixels at Work: Fred the Clown	36

Chapter 4

Rough Work	38
Designing the Setting	40
Character Design	42
Page Layout	44
Frame Composition	46
Composition in Practice	48
Pixels at Work: Web's Best Comics	52

Chapter 5

Stepping out with a Line	54
Setting up the Page	56
From Paper to Pixel	58
Drawing into the Machine	60
Drawing and Inking with Vectors	62
From Sand to Rubber Band	64
Pixels at Work: Arq Angel	66

Chapter 6

A Splash of Color	68
Planning Your Colors	70
Technical Color	72
Coloring In	74
Digital Painting	76
Coloring In Practice	78
Textures	80
Pixels at Work: Athena Voltaire	82

Chapter 7

Into the Third Dimension	84
Spatial Thinking	86
Sketching with 3D	88
Poser	90
3D Characters	92
Scene Machine	94
3D Trickery	96
Video Games	98
Pixels at Work: The Underdog	100

Chapter 8

Play it Again—But Just a Little Different	102
Looking Ahead for Reuse	104
Organization	106
Montage	108
Pixels at Work: Shutterbug Follies	110

Chapter 9

Say What?!	112
Balloons	114
Lettering	116
Big Noises	118
Pixels at Work: Blambot	120

Chapter 10

Roll the Presses	122
Getting Started in the Traditional Business	124
Established Publishers	126
Pixels at Work: 2000 AD	128
The Grand Opus	130
The Deal	132
Self-publishing	134
Pixels at Work : Heart of Empire	136

Chapter 11

Digital Distribution	138
Using the Web as a Showcase	140
Web Comics	142
Flash Comics	144
Getting Known	146
Making Money from the Web	148
Modern Tales	150
Pixels at Work : Pax-iLL	152

Equipment	154
Glossary	156
Index	158
Acknowledgments	160

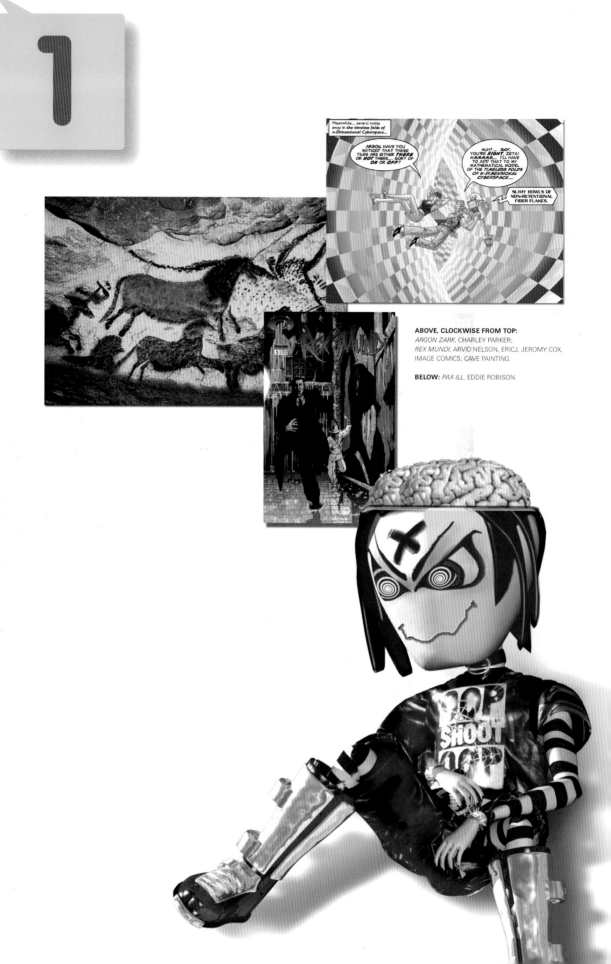

ABOVE, CLOCKWISE FROM TOP:
ARGON ZARK, CHARLEY PARKER;
REX MUNDI, ARVID NELSON, ERICJ, JEROMY COX,
IMAGE COMICS; CAVE PAINTING.

BELOW: *PAX-ILL*, EDDIE ROBISON.

Introduction

Cartoons and comic strips are among the oldest forms of artistic expression, predated only by verbal storytelling. From the first daubings on cave walls, visual storytelling has progressed through the ages to the digital medium, where it has found a new home.

The computer can play a part in every area of comic-book production, from organizing an artist's first ideas to distributing the finished product to the reader. Even traditional printed comics are sent via computer to be processed by digital presses. As an artist, using computers can, at the very least, save you time. At best, the computer is a virtual studio full of new techniques and materials. It can stimulate your creativity and help you develop new ways of sharing your work.

The real breakthrough lies in the area of distribution. With the Internet and the falling costs of digital printing, artists can afford to experiment with ideas and stories mainstream comic book corporations would never touch, thereby discovering and building new and exciting markets.

If you're looking to get your comic-book world out into the real world, this book provides the knowledge you'll need to set you on the path. Then, it will be up to you to see where that path leads.

What Is a Cartoon?

"Cartoon" is a broad term, and one that's pretty tricky to define. At its most fundamental level, a cartoon does the same job as any creative medium: It expresses the creator's idea to someone else. Beyond that, cartoons range from the single-frame "gag"—as seen in newspapers the world over—to strip cartoons, which can cover anything from a simple four-panel serial to a long-form "graphic novel."

A cartoon's type can often be distinguished by its form: a sequence of images, which may or may not contain text to explain the image or reproduce character dialogue. This wouldn't apply to single-frame cartoons, of course. The style, however, is pretty much universal: the "toon."

ABOVE: COMIC STRIPS COMMUNICATE THROUGH A SEQUENCE OF IMAGES. USUALLY THESE IMAGES TELL A STORY, WITH CRUCIAL POINTS PICKED OUT FOR DEPICTION. COMICS SHARE THE SAME AREA OF CREATIVITY AS FILM AND THEATER IN THAT TIME, THE FOURTH DIMENSION, IS CENTRAL TO THE FORM. IN COMIC STRIPS, TIME IS IMPLIED BY THE SEQUENCE AND ARRANGEMENT OF FRAMES.

(SC6 CONT)

TAKES AROUND SIX STEPS ABOUT HALFWAY, JUDDERING THIS WAY AND THAT.

CHUG: "HYDRAULIC FLUID! ELECTRIC MOTORS! THEY'RE NONE OF THEM WORK WITHOUT STEAM TO DRIVE THE ARMATURE."

PAGE 4

① GRASPING HAND.

SC 7 3 SECS

A POINT OF VIEW CAMERA MOVE. 3 OF CHUG' FOOTFALLS GETTING SLIGHTLY NEARER THE LETTER BOX EACH TIME

CHUG: "ELECTRONICS! IT'S COG WHEELS AND CRANK SHAFTS DRIVE THE WORLD."

SC 8 2 SECS

CHUG'S LOWER BODY COMES INTO SHOT, HIS HAND REACHING FOR THE LETTER.

HESITATES ON HAND, A JUT FORWARD THEN GRASPS IN AIR TOWARDS GROUND

SC 9

SIDE SHOT FULL BODY REACHING BUT FAILING TO GET ENV.

2½-3 SECS

THE LETTER FALLS JUST BEFORE CHUG GETS IT. THE GROUND IS CLEARLY BEYOND HIS REACH.

CHUG (O.S.): GROAN.

SC 9B

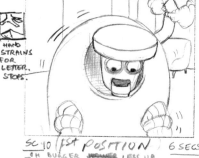

HAND STRAINS FOR LETTER. STOPS.

SC 10 1ST POSITION 6 SECS

OH BUGGER LESS UP. LESS SURPRISE. ARMS NOT UP. CLOSER AT END QUICKER. LOOK AROUND INAP

KNOWS ALMOST WHAT'S HAPPENING NEXT - A SCHEMING OLD BUGGER

STRAIGHTENS UP, LOOKS AT CAMERA

CHUG: "OH BUGGER".

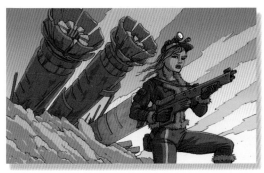

She stood against vivid stripes of pinks and orange across a sky turning deep blue as night approached. At the crest of a rocky outcrop, three great cylindrical structures, gray and discolored with rust, rested at chaotic angles. Each ended like a huge metallic flower, petals opened to reveal the yellowing thrusters inside. The girl held the gun from her hip. A gray metal tube adorned with a bright orange construction and a number of bright pinpricks of light....

PICTURES CAN BE FAR MORE CONCISE AND EXPRESSIVE THAN WORDS ALONE. THE TEXT TO THE RIGHT BARELY DESCRIBES THE ILLUSTRATED SCENE.

Toon

I use the term "toon" to refer to a style of visual simplification, common to cartoons whether they are daily newspaper gags or feature-length animations. The toon abandons photorealistic detail in favor of lines and colors that suggest form, character, and expression, rather than attempting to represent them directly. For the reader, this simplified art is expressive, easy to read, and instantly recognizable. For the artist, it also means that repeatedly drawing the characters and background is much quicker and easier.

Words and Pictures

Why use pictures at all? Stories are told very successfully using words alone. Pictures, however, communicate universally, across language barriers. Pictures also convey ideas in a more succinct and expressive way than words alone.

Comics and film

The idea of telling stories through a sequence of images has been extended through the comic strip and on into films and animation. A very close relationship exists between film and comics. Much of the visual grammar used in comics is used in film, and vice versa. Both live-action and animated films are storyboarded, and a storyboard is basically a type of comic strip. The most obvious difference between the two is that comic strips are easier and much cheaper to make. As long as you have skill and imagination, you can conjure awesome locations, extravagant special effects, and a dream cast of actors, without a multimillion-dollar budget.

The comic bind

The greatest creative restrictions on comics have always been limitations imposed by mainstream audiences, and therefore by the comics industry itself. In the U.S. and U.K. comics are often viewed as sensational power fantasies for juvenile minds. Although many examples split these assumptions wide open—think of Alan Moore's *From Hell*, Daniel Clowes's *Ghost World*, or Chris Ware's *Jimmy Corrigan*—comics still have a long way to go to before they're taken seriously in the larger culture. The situation in Europe and Japan is more encouraging, however. There, comics with adult themes are as popular as children's comics.

> → QUICK TIP: Study film. Almost every narrative, compositional and pictorial device used in filmmaking works for comics too.

BAGLEY & SPACEY. GEORGE PARKIN. **www.geoparkin.com.**

I've got a confession to make, Leroy.

I've been contemplating suicide.

I'm afraid life's immutable discharge of disappointments, rejections, lies, and frequent attacks of diarrhea, have scoured my mind into nothing but a wispy thread of fragile nerve endings.

My feelings of loneliness are only overshadowed by my insignificance. Therefore, I resign from this cold and lonely universe realizing I have not gained nor lost any indifference from my fellow insignificant human beings.

OLIVER PIKK. DEREK KIRK KIM. **www.**smallstoriesonline.com.

Genre

Like any creative form, the cartoon has been classified into a number of genres, some more distinct than others. These provide a kind of shorthand, establishing what the artist should deliver and what the reader should expect. Unfortunately, most comics and artists are pigeonholed into one genre or another, although some straddle several, and others defy any classification at all. Some distinctions are based on style, others on content. For this reason, the following list is only a rough guide.

CHILDREN'S STRIPS FROM *THE DANDY.*

The gag

One-frame gags and short-strip funnies are the cartoons that have traditionally been found syndicated in newspapers and magazines. A regular spot like this represents a dream job because of its security—as long as you can supply a constant source of funny ideas. This genre is gaining popularity on the Internet, and there is a growing market in syndicating gags to the thousands of magazine and news sites looking to expand their content.

Children's comics

Children's comics form a large portion of the industry, with numerous titles in constant need of writers and artists. The work is almost exclusively restricted to drawing existing characters under licence, with strict guidelines and working practices. Direct publishing to children on the Internet is in an early stage of development. There are obvious issues around child safety, not to mention difficulties surrounding how children pay for products on the Web. Children's comics, however, are a thriving market, with the ever-present potential of a character becoming a craze and achieving cult status.

Licensed characters and TV or movie tie-ins

There has always been a market for comic strips that take popular television and film characters and extend their adventures. Character license forms a large proportion of published comic-book production, with the large corporations that own popular characters and brands selling licenses to publish various weekly strips and albums. From the artist's perspective, the work is generally for a fixed fee with no royalties. It is poorly paid but regular, and he or she must draw in the style of the license, which can be quite exacting.

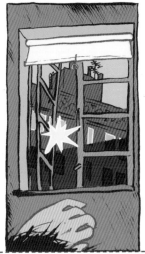

IMITATION OF LIFE, NEIL BABRA.

Superhero comics

At one stage, the superhero genre was in danger of completely swamping Western comics, to the point that no other genre, apart from gag strips and children's comics, could exist. It continues to dominate mainstream comics, although sales are restricted to a relatively small market of (mostly) young males. In the mid-1980s, the genre faced a long, slow death from a dearth of original ideas. Forced to reinvent itself, it thankfully found fresh avenues. It is many a young artist's dream to draw the bulging muscles of their favourite heroes, but be warned: entry into the industry is highly competitive and demands advanced drawing skills.

Underground comics

The underground genre defies easy categorization; "alternative" might be another description. Its roots lie in the 1960's American hippie movement, when titles such as *Zap Comix* and *The Fabulous Furry Freak Brothers* were released. These were fiercely antiestablishment and carried humorous stories centered on drugs, music, and sex. Although a few Web comics could be described as "underground," the genre is less popular than it was and is unlikely to provide an artist with much in the way of revenue.

European comics

European comics are far more diverse than the single-genre umbrella might imply, with titles covering everything from children's comics to history to science fiction to erotica. What ties them together is an attitude: comics are taken far more seriously by the mainstream in Europe than in America or Britain, and consequently there exists a huge, diverse, and well-respected industry where comic artists are revered as celebrities. There is also a recognizably European graphic style that features clean lines and color washes, with its roots in the famous work of Hergé's *Tintin* and René Goscinny and Albert Underzo's *Asterix*.

The New Wave

The New Wave covers a new breed of comics that emerged in the 1990s, created by artists such as Daniel Clowes (*Ghost World*) and Chris Ware (*Jimmy Corrigan*). These artists are stylistically diverse, but the genre can be roughly defined by its content, which tackles personal themes and might be autobiographical. With the emphasis on real-world issues and emotional response, New Wave comics hold a strong appeal for readers of various ages and of both sexes. A handful of publishers have grown up to promote this work, but it is on the Web that many of these comics find their natural home.

The New Way

The New Way represents the most diverse group of all—the Web comics. I am placing them in one group, but in style and content they cross a very wide area indeed. Web comics are not often directly intended to generate an income, but they can help promote an artist and his or her ideas. Some Web comics do, in fact, generate a modest income by charging a subscription fee to the site. Perhaps the most interesting feature of this genre is how the idea of reading pictures and text in sequence is being redefined. By using the possibilities of HTML navigation or Flash animation, these titles show a way for comics to break through the barriers of static frame arrangements and explore the flow of time between the panels.

Press Start

Most of us complain from time to time about technology developing faster than we can keep up with, and the area of art creation is no exception. Digital systems are now involved at almost every stage of the process, and it is possible to create a work of art and distribute it worldwide without it ever becoming a physical object. Some cartoonists have already embraced the digital process, but want to take greater control of their work. If you're not one of them, then there are other good reasons why it's time to get a handle on computers.

Time and money

As with all commercial endeavors, speed is an essential part of comics creation—the faster something is completed, the more work you can take on, and the better paid you will be. There is no doubt that computers help speed up your work, but they can also be a hindrance, leading you down blind alleys of frustration. Some of the best time-savers are the simplest, such as being able to email artwork instantly to a publisher rather than standing in line at the post office. Some of the worst time-wasters are caused when the computer offers too many choices: it's all too easy to lose an afternoon fiddling with a fancy Photoshop plug-in.

In this section, and throughout the book, I'll give my opinion on how time-effective a particular digital process is. Of course, you'll ultimately have to decide for yourself: It may be worth investing a lot of time to

achieve a certain style or learn a complex program if it will save you time in the future.

→ QUICK TIP: The monitor is the one part of a computer system worth spending extra on for quality. You will spend a sizable chunk of time staring at the screen, so the larger and clearer the display, the better. Aim for a 19-inch or 21-inch conventional CRT monitor, or a 17-inch TFT screen if you opt for a flat-panel display.

Hardware costs

If you are new to computing, your first expense will be the machine itself. Fortunately, computers fall in price year after year, and a system suitable for even an ambitious graphic artist can be found at reasonable prices. For years, computer hardware struggled to keep up with the software running on it, and this was particularly the case for artists, who use more power-hungry software than the average consumer. These days, the situation has changed to the point where a midrange, midcost computer can easily be used for most digital comics production. You no longer have to stretch your budget by buying the highest specifications—despite what any computer sales adviser might tell you. If the machine you have chosen runs out of memory or is a little underpowered, you can usually upgrade it later. A list of recommended requirements can be found later (*see page 154*).

→ QUICK TIP: If you buy another graphics package instead of Photoshop, make sure that it offers layers—one feature that you cannot do without.

Software cost

Software is another thing for which you'll need to budget. Industry-standard software packages, such as Adobe Photoshop, can cost nearly as much as the computer itself. It is always worth investigating alternatives that cost a lot less—look for lower-cost

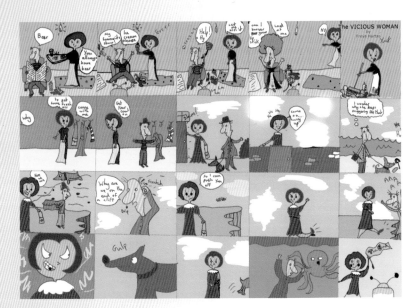

versions, such as Photoshop Elements; budget rivals, such as Paint Shop Pro; or older versions that might be given away on magazine cover–discs. These often come with an upgrade deal if you like the package. The main concern when choosing software is compatibility. You don't want to complete a 120-page book, only to find that your publisher can't read the file. This is less of a problem in graphics, because most programs output to the same file formats—PSD, TIFF, JPEG, and so on.

Learning to walk

Let's admit it: if you have never used a computer before, it is going to take you time to get up to speed. If this is the case, however, then the time you spend learning digital graphics will also improve your general computer knowledge—what you discover as you use your new software will also be applicable to other programs. This process can seem daunting, but you don't have to know everything before you reach for the "on" switch. Newcomers will have an especially hard time getting to grips with 3D applications, but even though that particular learning curve is very steep, the time and effort spent is easily balanced out by the creative benefits.

> → QUICK TIP: Computer programs come with a wealth of support material, both in electronic and printed form. It's tempting to fiddle around with software until you find out how it works—and that is a valid part of the learning process—but you can save a lot of time and frustration by just reading the manual.

Background learning

You don't need to know how a car works in order to drive it. The same is true of computers. If you just want to create cartoons, you can get along fine without detailed knowledge of the hard this and the RAM that. However, sometimes things go wrong, and it's usually at the worst moment. It is therefore worth making an effort to learn a bit about the inner workings of your machine. Cultivate a nerdy friend, subscribe to a computer magazine, and have a go at solving problems for yourself. Once a computer becomes "income critical," you can lose serious money when you can't work because of a computer breakdown—and that will cost you on top of the repair bill.

> → QUICK TIP: "Save and back up" are words you should be chanting constantly—even in your sleep. Saving work and backing up to a separate drive will avoid the digital equivalent of the dog eating your Bristol board.

Computers as an Aid to Production

Every stage of traditional comic production can be replaced by a digital method, often making it faster or more efficient, and allowing you to clean up mistakes at a click. The entire process does not have to be digital however: some areas, such as penciling, remain easier with old-fashioned graphite on paper.

Reference research
No longer do you have to spend hours trawling through books at the local library. Sophisticated search engines, such as Google Image Search (www.google.com), allow you to find pictorial references in an instant.

Collaboration
Computers facilitate collaboration. Many artists and writers already work like this, collaborating on projects with strangers thousands of miles away, having only met them via the Internet. You can find prospective collaborators by reading and posting notices in Web forums and on bulletin boards.

Writing
Wordprocessing programs make scriptwriting and story-planning easy. Cut and paste features enable you to restructure your work just by dragging paragraphs around. It is also very easy to correct and revise work.

Layout
Pencil and paper is still the fastest way of trying out layouts, but a few artists do their thumbnail layouts digitally (*see page 44*) so that they can shift the frames around with greater ease.

Storyboarding
Storyboarding software is used primarily by the animation industry to create animatics (trial animations), but it also works in cartoons, because individual sketch frames can be easily reordered. The leading applications are StoryBoard Quick Power Production Software (www.storyboardartist.com) and Boardmaster Board Master Software (www.boardmastersoftware.com).

Digital Drawing
You can draw directly into the computer using a graphics tablet, which most artists find a more natural way of working than mouse and keyboard. However, a stylus on a hard plastic pad will never give you the real tactile response of pencil on paper.

ABOVE LEFT TO RIGHT: COMPUTERS CAN TAKE THE LOAD OFF THE CARTOON ARTIST'S SHOULDERS, BUT HE OR SHE STILL NEEDS TO FIND SOME INSPIRATION SOMEWHERE.

Alternatively, you can use vector-based drawing packages, which allow you to build pictures up point by point and line by line, then fill them with texture and color. The results look sharp and clean, and it is easy to correct your work, making such programs ideal for the less confident draftsperson

Thanks to cheap flatbed scanners, it's also easy to get your pen and pencil art into digital form. By scanning a tight pencil layout and darkening the line, you can even avoid the entire inking stage.

Coloring
The computer is perfect for artists who want to obtain flat, consistent color or use smooth color blends. Meanwhile, programs such as Corel Painter can mimic traditional art materials, capturing their subtlety and spontaneity without risk of getting paint on your clothes.

Lettering
There are many computer comic-script fonts from which to choose, and the flexibility of layout makes lettering on computer faster and easier than traditional methods. Vector drawing tools, such as Macromedia Freehand and Adobe Illustrator, can be used to create fantastic titles and sound effects.

Reuse
Once you have artwork stored in digital form, you are free to adjust and reuse it as often as you like. The reuse of backgrounds, objects, or even character drawings can save you huge amounts of time, as long as you take care to avoid obvious repetition.

Finalizing
Prepping files for printers can now be handled by the artist, thus saving costs. However, if you are working for a publisher, let them handle this stage, because the only costs saved will be theirs. Meanwhile, high-speed Internet access and CD-ROM writers allow you to send work in digital form instantaneously. This can give you another day or two on the deadline.

LUNACADAVER. JASEN LEX. **www.awefulbooks.com**.

Only by Computer

Although computers can speed up traditional methods, they also offer a huge range of new possibilities to explore. You can carry out simple tasks, such as varying a pattern on a character's shirt, or do something more ambitious, like construct a virtual 3D world for your backgrounds.

FLAT LIFE. LEO HARTAS

Flat color

Producing areas of consistent flat color is a challenge with paint and ink, but it's easy for the computer. The color can be precisely controlled from the desktop all the way to the printer.

Texture

Many repeating textures—brickwork, rock, sand, water— are available from sources on the Internet, and many textures can be created procedurally, including veins, bricks, and camouflage.

Digital photography

Digital cameras have revolutionized computer art, thanks to the speed with which images can be taken from the real world and transferred onto computer. Photographs can be used for reference and texture-gathering, visual notetaking, backgrounds and pose reference, or even creation of photographic comics.

Internet treasure chest

There are huge online repositories of useful images that can be used for reference or in cartoons themselves. If you do use material from the Web, be aware that it may be copyrighted. Unless the source says that it's royalty-free, don't use an image without seeking permission first.

Computer-generated 3D

Characters, environments, and even whole worlds can be created in virtual 3D inside the computer. The usefulness of 3D is already being adopted by comic artists as the cost of the technology drops. The upside of 3D is that complex

ABOVE: *ARGON ZARK*, CHARLEY PARKER. **ABOVE RIGHT:** *FANGLEWORTHS*. LEO HARTAS. **BELOW:** *TOURIST TRAP* AND *DILEMMAS*. LEO HARTAS AND DAVE MORRIS.

objects can be created once and then reused many times. A building or vehicle can appear in different frames from almost any distance and angle, without any need to redraw each time. It's also much easier to create lighting and shading. On the downside, 3D work is time-consuming, and there's yet to be a 3D package that could really be called intuitive.

Flash and the Web

Macromedia Flash has had a big influence on artistic style. Like vector-drawing packages, Flash creates objects from shapes, lines, and fills, all fully editable and resolution independent. Its clean lines, flat colors, and easy animation have made it a popular choice for creators of Internet comics, but it is just as useful if you're working on comics for print.

Super zappers

There is a huge range of special filters, plug-ins, and standalone programs that can create amazing graphic effects in a matter of moments. Instant lightning, explosions, smoke, meltdowns, disintegrations, trees, and people—the list goes on and on.

Interactive

For cartoons that will eventually be read onscreen, the flexibility of the computer can allow it to become a new literary form. Using Web-based technologies, including Flash, the cartoon can allow the reader to take on the role of the hero. He or she can make the plot go where they want or get background detail on the characters involved, all by selecting options from the screen.

Animation

Animation is basically an extension of the still cartoon, and one that's also made the leap into the digital world. Many of the tools used by comic artists—including Illustrator, Photoshop, Freehand, Flash, and the various 3D packages— are also used by animators, leaving room for plenty of crossover. It also helps that art created for static cartoons now can be used as a basis for animation later.

Pixels at Work: Dicebox

Jenn Manly Lee
www.dicebox.com

Jenn draws a successful, long-form strip, which she publishes on Girlamatic.com

How has the computer benefited your work technically?

It has allowed a great deal of flexibility and control while saving me an immense amount of time. This is true even with the part I do the least on computer, my line work. I can take my rough pencils and scan and place them in my Photoshop file, and then evaluate composition and size and how the art relates to the lettering before going on to my finishes.

The bulk of the work that I do with the computer is the colors, which I do in Photoshop with a Wacom tablet. I can maintain a level of consistency in color throughout while still having the freedom to experiment and explore different directions, using the History function in Photoshop or saving different versions to compare. If I make a significant discovery or decide I have been wrong about a color choice, I can go back and alter previous pages as I see fit. Also, given my hectic life, I can easily use a spare 15 minutes to go in and do some coloring, which is invaluable.

I also use the computer to do my lettering, using a font made from my own handwriting. This saves me an immense amount of time as well as allowing me to finesse the placement from a composition and storytelling aspect. Then there's the advantage of having a spell check.

How do you feel about publishing on the net and traditional print publishing?

What I would say about my own work I think applies to many of the cartoonists out there. The main advantage to publishing one's work on the Internet versus going the traditional print route is a greater ability to reach your intended audience while pursuing the story and art that you are truly interested in. You're not second-guessing what a publisher, distributor, or store might be willing to invest in. And self-publishing online, the initial time and money investment is miniscule compared to what it is for print.

In my case, most of what I see as my intended audience might never go in to a comic book store, but they probably get online. In fact, I've had few people tell me that Dicebox was the first comic that they really read. This is partly because there is a greater cross-pollination between interest groups online versus offline. And your story is right there for them, not hidden in a corner of a speciality shop under some X-Men, or out of print. And because it's right there, it's easier for someone to decide to give it a try.

But most of all there is being able to tell the story you want, and how you want to tell it, beyond the interactive possibilities and not being constricted to a printer's spread or printing restrictions. I feel free to build the story as slowly as I please, as long as I keep my audience entertained. And I can treat each chapter as a chapter, as part of an entire story instead of as a standalone issue.

Have you got any helpful tips for someone who is just starting out?

Set yourself up with the basics: access to a computer and scanner; access to the Internet with your own Web space; Photoshop and a program that properly prepares graphics for the Internet, such as Fireworks. Get a basic understanding of what HTML is and how to build a Web page.

Experiment and figure out what you want. Explore what's out there in comics online as well as the various communities. And just do it—get it out there; that's the best way to learn and improve. You might fail more often than not, but you learn ten times as much that way than by years of hands-off research.

2

Digital Inspiration

Having ideas and writing them down—the idea is at the very center of any cartoon and everything else is subservient to it. A strong story will be acceptable to readers even if it is badly drawn. One of the questions most frequently asked of a writer or artist is "where do your ideas come from?" The answers can vary considerably: personal experience, dreams, other books, films, TV, or the ubiquitous, "It just dropped into my head." Although a single idea may be good in itself, it needs a lot of work to develop into a project. There are many things to consider when polishing an idea, not least of which is how commercial you want the venture to be. This will depend greatly on who you expect your audience will be.

ABOVE: *SPIKE*. AL AND GIDEON. WWW.IRONCIRCUS.COM. OTHER IMAGES: *IDEAS MACHINE*. LEO HARTAS.

The Spark

New ideas can be fickle—it often seems that the harder you try, the harder they come. Real originality requires a huge jump of the imagination, which means it doesn't come along all that often. Instead, many new ideas just rework old ones or take a look at them from a new angle. Contrary to what some people believe, you can train your mind to spark ideas even if you feel that this doesn't come naturally. There are strategies to help ideas flow, the first being to find inspiration in what you already know or can find out about.

You! What, me? Yes, you!

Some of the best ideas are taken from our past experiences. You don't need to have come from a family of Mafia hitmen or have been a NASA test pilot to have had interesting experiences. The motivations and stories of characters always come back to basic human emotions. Most of us have felt them at some time: joy, disappointment, anger, love, jealousy. These are themes you will find at the core of even the most exotic fantasy or outlandish sci-fi adventure.

This life

The best inspiration comes from the world around you, but you need to open your eyes and take note of what you see. There are grand themes in international news and small details of everyday life that can be woven into a plot. Sometimes things that appear mundane have hidden depths. Daniel Clowes's *Ghost World* is, on the surface, just a story about a couple of bored teenagers with too much time on their hands, but it operates at multiple levels: it's also a story about friendship, children turning the corner into adulthood, fear of the future and of the unknown, among other themes.

The flickering screen

TV and film have a huge influence over the creative work we all do. This is not surprising—we cannot help being impressed by the creative successes of others. You can argue that what has been successful before must contain the right formula. By learning and repeating the formula, you can repeat the success. This idea is at the heart of a lot of corporate thinking, and wherever you stand on the issue, it needs to be taken seriously. Publishers are suspicious of new and original ideas, and they don't always recognize potential when they see it. As a result, they often play safe with the tried and tested.

In the frame

It's tempting to take inspiration from comics themselves. The problem is that the comic industry has being doing this for years already, to the point where many comics have become sidelined in specific niche genres, such as superhero comics and children's strips. Your love of comics is the reason why you want to make them, but look beyond comics for your inspiration first.

HITCHHIKING JOEL ORFF. **www.jorff.com**. JOEL'S *HITCHHIKING* IS CLEARLY INSPIRED FROM LIFE EXPERIENCE.

→ DIGITAL PUBLISHING: Taking the digital route can also open up new ways of sharing—and selling your work.

Presentation and promotion: A computer can be helpful for an artist wanting to make a good impression and promote his or her work. At the simplest level, you can look professional with well-designed letterheads and business cards, produced on the desktop with a good inkjet printer. You can also send out a digital portfolio on disc or via email, and even present it on a website.

Micropublishing: Micropublishing involves printing short runs of your comic and selling it through local bookshops. Prices are constantly falling in digital printing as color laser printers become affordable and print on demand (POD) book publishing bureaus become common. Although a good way to start, micropublishing suffers from very limited distribution—essentially, it comes down to how many copies you can sell by hand.

The Internet: The Internet provides a completely different publishing model for the cartoonist, allowing you to send your comic directly to the audience without going through a publisher or incurring the costs of printing and distribution. The main stumbling block has been reluctance on the part of the consumer to pay for comics in a medium where free material is the norm. However, new systems of micropayment are gaining ground, and there is growing evidence that consumers are prepared to pay for quality cartoons.

RED HOT. LORNA MILLER. **www.lornamiller.com**
"ALTERNATIVE COMICS HAVE ALWAYS BEEN LIMITED BY FINANCIAL RESTRAINTS, MEANING THAT ARTWORK IS USUALLY PRINTED ONLY IN BLACK AND WHITE. THIS IS NOT A PROBLEM WHEN PRODUCING WORK TO BE PUBLISHED ON THE NET. COMICS ARE AN IDEAL MEDIUM FOR CONVEYING IDEAS ON THE INTERNET BECAUSE SHORT, SNAPPY TEXT AND BRIGHT, ZINGY COLORS WORK PERFECTLY ON-SCREEN. AS NEWSPAPERS AND MAGAZINES CUT THE SPACE AVAILABLE FOR COMIC STRIPS, THE NET HAS PROVED AND CONTINUES TO BE A WELL-PAYING ALTERNATIVE FOR MANY ARTISTS."

Sparking inspiration

Here are a few ways to get the sparks flying:

- Study the human interactions you see around you.
- Trawl the news, especially local, for unusual and quirky stories.
- Look at your own past, and quiz friends and family about theirs.
- Take time to stop thinking and "absorb" the atmosphere around you.
- Make notes and sketches, and collect magazine and newspaper cuttings.

Once you think you are onto something, make an exhaustive list of everything you think could be even remotely connected to it. Often a good idea can have a brilliant idea hidden just beside it.

→ QUICK TIP: For each idea, make a folder on your computer for scanned drawings, photos, and text.

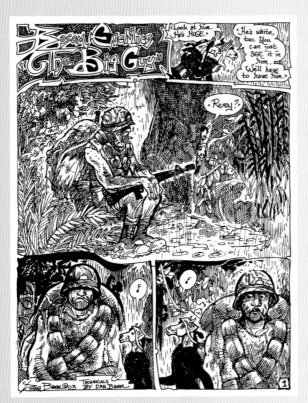

BOSOM ENEMIES: THE BIG GUY. DONNA BARR. **www.stinz.com**. DONNA SOUGHT INSPIRATION FOR *BOSOM ENEMIES* IN HER HUSBAND'S WAR EXPERIENCES.

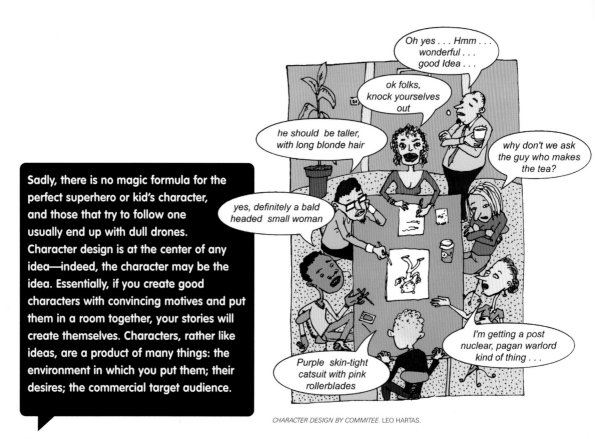

Sadly, there is no magic formula for the perfect superhero or kid's character, and those that try to follow one usually end up with dull drones. Character design is at the center of any idea—indeed, the character may be the idea. Essentially, if you create good characters with convincing motives and put them in a room together, your stories will create themselves. Characters, rather like ideas, are a product of many things: the environment in which you put them; their desires; the commercial target audience.

CHARACTER DESIGN BY COMMITEE. LEO HARTAS.

Who?

The main person

I almost wrote "The Main Man." This highlights something worth thinking about. Too many comics over the years have featured male protagonists and have been aimed at a narrow audience of white males. To survive and flourish, comics need a more inclusive outlook to encompass the interests of women, ethnic groups, and gay and disabled people.

In any long-running strip, the protagonist needs to be interesting, but must also have room for his or her personality to grow. It is rewarding to see the hero's hardened heart soften, or watch the hero take on a mature attitude where once he or she behaved selfishly.

Old friends

Of course you will want to have more than just the one character. Usually, a story will have a protagonist and a group of friends or colleagues with whom to interact. There are no rules, but certain patterns do emerge. In many comics, the protagonist is something of a blank onto which readers can project themselves and become more involved in the tale (e.g., the title character in *Tintin*). The really interesting characters are the friends, the main one

being the buffoon sidekick (e.g., Captain Haddock in the *Tintin* stories), whose role is usually to get the central character into trouble. Others may include the overly sensible one, the brainy one, the pompous idiot, and so on.

Inner demons

At the most obvious level, a character will have a straightforward motive—for example, having to kill evil Dr. Spleen to save the world. More interesting characters will be multifaceted, sometimes pursuing conflicting motives. For instance, think of that film-noir staple: the hard-bitten detective who is both repelled and attracted to a murderer. Sometimes the entire plot of a story can revolve around a character wrestling with their inner demons.

Events and growth

Some of the most interesting stories come from watching a character's personality grow or change in response to events in the plot. A character may come to love someone they originally didn't care for because of the way they see them behave under stress, or learn to despise a former friend for the same reason.

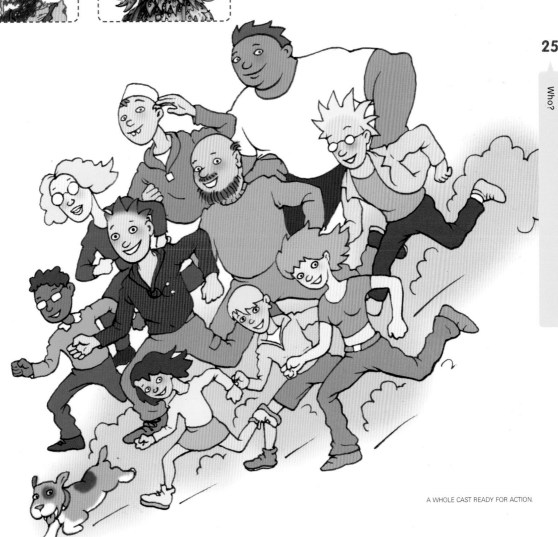

ONE CHARACTER, TEN DIFFERENT TREATMENTS.

25

A WHOLE CAST READY FOR ACTION.

26

The One-Liners

One-frame gags and short comedy strips have long been regulars in even the most serious newspapers and magazines. In order to work, jokes need to be comprehended quickly, which is why the format of picture and text is perfect. The best one-framers show a fascinating economy and clarity of ideas, and have elevated their major characters to icon status.

NEW ADVENTURES OF DEATH. DOROTHY GAMBRELL. **www.catandgirl.com**. "I DRAW ON COMPUTER PAPER WITH WHATEVER PEN IS AROUND. CAT AND GIRL IS SCANNED INTO PHOTOSHOP (AND CLEANED UP, AND COLORED, AND LETTERED...). DEATH IS DRAWN IN THE SAME WAY, ALTHOUGH I HAVE RECENTLY STARTED PLAYING WITH MAKING THE BACKGROUNDS IN ILLUSTRATOR."

Stand-up comics

Characters in humorous one-frame gags and strips usually differ in two aspects from those in other cartoons. The first is obvious in that they are usually drawn in a quick, simple style with few lines and are caricatured, sometimes to the point of almost being more iconic than strictly representative. The second is that, from gag to gag and strip to strip, they rarely show any personal growth. The static personality allows for plenty of laughs as the audience can instantly recognize the stereotype.

Writing for laughs

There are no formulas for writing comedy: either you're funny or you're not. The idea in cartooning that the image is as important as the word is even more the

BAREFOOTZ. HOWARD CRUSE.
www.howardcruse.com. THE *BAREFOOTZ*
EPISODES WERE ORIGINALLY DRAWN FOR
PRINT IN THE 1970S AND HAVE BEEN
RECENTLY TOTALLY REDESIGNED AND
REDRAWN FOR ONLINE PRESENTATION.

case in gags, where simplicity and directness are key.
Many one-framers use the tension between image and
words to generate the laugh. Some of the most
sophisticated cartoons, such as those from Gary
Larson's *The Far Side*, draw on their audience's ability
to spot subtle ironies.

Strips that use regular characters can generate comedy
from the audience's familiarity with the characters'
established personalities. Such strips can operate in
entirely self-sufficient settings that never need to make
references to the external world.

Drawing for laughs

Since the beginning of "funnies," a particular graphic
style of exaggerated features and actions has
emerged—a style that continues in children's comics
today. Over the past 20 years, these graphic limitations
have generally been dropped, allowing
artists to develop a more unique signature style.
Compare *Peanuts* and *Garfield* to *The Far Side* or
Doonesbury to get an idea.

Pixels at Work: Dr. Who

Lee Sullivan
www.leesullivan.co.uk

Lee has worked for many years in comics, mainly drawing licensed titles such as *Thunderbirds*, *Transformers*, *William Shatner's TekWorld*, *Thundercats*, *Wildcards*, *X-Men* and *Judge Dredd*. His recent work, a successful series of *Doctor Who* webcasts for the BBC, crosses the boundaries between still comics and full animation. The webcasts are presented in Flash by James Goss at the BBC and combine clever reuse with simple animation to create an innovative new form best described as an "anicomic." Lee maintains an excellent page of advice for aspiring comic artists on his site.

"As with the previous webcasts, I supplied general backgrounds and characters, both full-length and close-up. I drew roughs for the finished illustrations, which, when approved, were hand-drawn in pen-and-ink black line, then colored using Photoshop. All the characters were supplied as separate elements, but in some instances (where characters would have to move around objects within a set or elements of the set would move, like the Time Rotor of the TARDIS console) the backgrounds were supplied as layered Photoshop files. This also enabled James to float objects across the screen while tracking or zooming, which added to the perspective of a shot. Almost everything within the Professor's study was a separate element, for example. Indeed, the whole room was a reworking of a university

FRAMES FROM *SHADA*, THE BBC WEBCAST. **www.bbc.co.uk/cult/doctorwho**.

interior first seen in *Death Comes to Time*, which through the magic of Photoshop I was able to flip, create new walls and extend the set considerably, and once I discovered that I could use the *Distort* facility of Photoshop to re-angle flat or perspective walls, I was able to supply new angles on the rooms with very little redrawing.

Flash has the effect of curving many of the lines that I drew, noticeably on the Police Box windows, and the first examples of the new look were a bit shocking—all the subtle graduated color was replaced by solid color. However, the animation properties were obviously much greater. I quite liked the effect Flash had of making my drawings look like old woodcuts—rather like the early printing process— and it's always interesting to see one's work filtered in some way. When I saw what was being done to my

work by Flash, it was easier to know what I needed to supply for some of the later episodes. Also, because the animation was able to make peoples' arms move, I supplied various limb alternatives for James to use.

A lot of "cheating" you might think, but even so, my *Shada* project folder contains 375 files, many of which are multilayered, amounting to 5.5 gigabytes! A typical background file would be 100 to 200 megabytes."

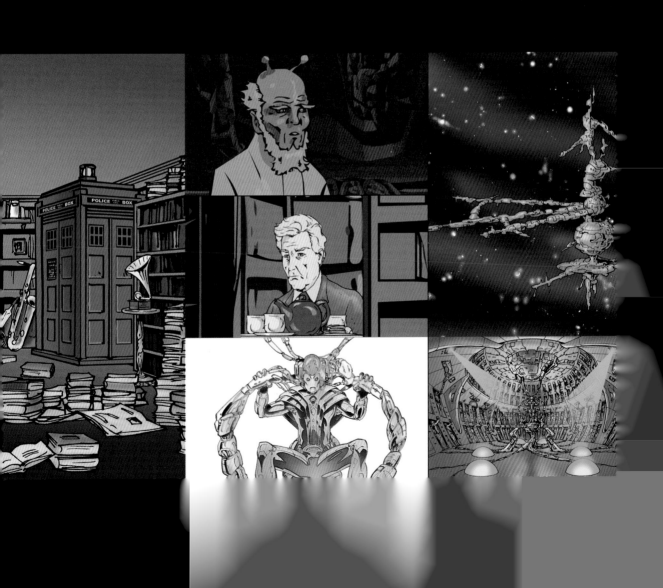

The Mighty Pen

There are several ways of approaching scriptwriting for comic strips, some of which don't involve a script at all. Where scripts in the traditional sense are always necessary is when an artist and a writer are working separately on a strip. Scripts become important as a means of communicating ideas between the two (and typically an editor if the work is being done with a publishing house).
The standard method is for the writer to complete a script with instructions to the artist for what is to be drawn in each frame. After approval by an editor, the artist starts work, sometimes without ever meeting the writer. Some of the most interesting and fruitful results materialize when the writer and artist discuss the story first and plan the strip as a set of quick thumbnails. Solo writers can have far more flexibility, especially if they are publishing themselves. Some freeform comics are even produced on the fly without any script at all. Scripts, however, are usually an important part of the planning behind a comic, allowing you to arrange, check, and polish your project so that you can be sure none of the time-consuming artwork production will be wasted.

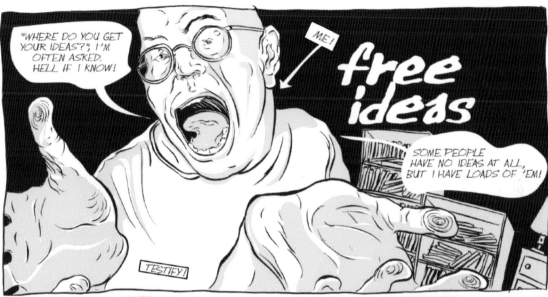

FREE IDEAS. JED ALEXANDER. **www.jedsite.itgo.com**.

Short and Long Forms

Comic stories come in a number of formats. There are three main short formats, each requiring a different approach. Kids' comics often have one-off tales of between one and six pages starring established characters. With such limited space, the story is typically little more than a single incident, and thus needs to be more or less self-sufficient. British comics traditionally have a number of different story episodes in a single issue. Each episode, of around 4 to 8 pages, typically has an incident conclusion even though it is part of a longer story. The same goes for American comic books, which are traditionally 24 pages long.

The relatively new concept of the album, so called because it was originally all of the episodes sold as one book, is also described as long form. Essentially books of more then 64 pages, the long-form format allows much greater time and space for character and plot development.

Super sketching writers

Many writer-artists plan out their comic in thumbnail-sketch form first. Thumbnails are small, quick sketches showing a brief representation of a frame. They may go through several stages, with many thumbnails being rejected in the process. Working in thumbnails has the advantage of getting you thinking about visuals at an early stage, and they enable you to work directly with words and pictures combined. One key benefit is that you can quickly see where you can pare down the dialogue, because the necessary information can be better conveyed using the picture. In contrast, writing a text-only script often results in too much dialogue, adding a further level of editing after the initial roughs have been made.

The whole

At this stage, it is important to establish what you are attempting to achieve. Of all the stages of cartoon production, sketching is the most flexible, because things can be changed easily and you can experiment without losing too much work. Use this time to tune the pace of the story, test the emotional highs and lows, and build up to the final denouement.

DICEBOX. JENN MANLEY LEE. **www.jennworks.com**.

THE ABSTRACTOR IN DEAD CAT BOUNCE

Damon Hatchet, world-renowned conceptual artist, attends the crowded opening of his new exhibition, Mashed, when a billionaire art dealer known only as "Premier," buys the entire exhibition at three times the asking price. Premier invites Damon to his luxury private island and commissions him to construct the ultimate deconstruction of our time, a "mashed" London. Using Damon's girlfriend, River Green (aka "No-girl") as a hostage, the unhappy artist is strapped onto "Warhead," the hulking great human missile. Premier aims Warhead and the hapless artist at the capital, his finger hovering over the launch button. The international art world rushes to buy a piece of Damon's greatest-ever performance art piece, sending Premier's stocks stratospheric. Unknown to Premier, Damon has super artistic powers after mistaking a cocktail of experimental acrylic paints for an alco-pop.

List of what is happening on pages 2 to 3

Title frame
Scene setting
Society girl praises Damon's work, alluding to his possible prowess as a lover. News arrives of Premier buying the entire exhibition.Extra celebration, more drinks. Society girl and River have an argument over Damon. Damon and River leave for Damon's studio.

Page 2

Title

Frame #1: Large overview of Damon's private view party. Two society girls flirt with Damon.

Society girl #1: Oh Damon, your work is so wonderfully big and strong.
Society girl #2: Yeah, it just seems to like, grow, to fill the space.
Damon: Well, why not drop by my studio sometime?

Background art critic #1: Yes, yes, but don't you see the incongruity of the potato, harshly macerated among uncaring…
Background art critic #2: …surely it symbolizes the inner torment of the outer serenity inside the…

Frame #2: Close-up of Damon's manager, Catrina Gold-Hardly, pushing through the crowd, looking desperate.
Catrina: Damon!

Frame #3

Catrina: Oh, I'm so glad I found you. Wonderful news, we've sold the lot… and…

Frame #4

Catrina: For three times the asking price!
Damon: Ace!, C'mon, let's get out of here!

Page 3

Frame #5: Time Passing. Champagne being poured into glasses.

Frame #6: Close-up of Damon and the two girls.

Society girl #1: Where did you get to?
Society Girl #2: Kaz and I are simply dying to see that studio of yours!

Frame #7: River appears between them.

River: NO!

Frame #8

Society girl #2: Darling, we're first. Hurry! you might just catch that vagrant by the trash can outside.
River: I said NO! NO!

Frame #9: River headbutts the girl, thumps her stomach and kicks her. Kaz looks on horrified.
River: NO means NO means NO!

Frame #10: River drags a drunk Damon from the party.

If you are working on your own, it's a good idea to have someone else read through your script. This is the time to be tough on yourself—don't be frightened to throw out ideas if they don't seem to be working. Work in increasing levels of detail over the whole strip, starting with the basic story and only adding detail when satisfied that it works. Leave it for a few days and then read it again. You will probably find things you want to change. If you are writing with text only, note down the mood and atmosphere that you imagine, along with notes on what the frame should depict.

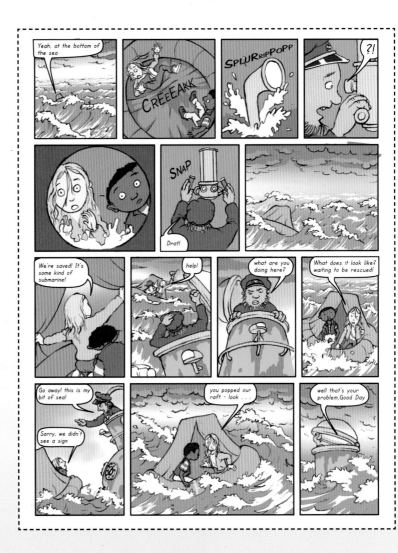

Story Workshop

Writing stories is a huge subject that has been covered in detail by many other titles. If you are writing longer comics, it is worth studying film scriptwriting because it's closer to comics creation than novel writing. As with most creative activities, intuition and instinct are just as important as formula and hard graft. The dos and don'ts on these pages are not rules, only pointers, and the list is by no means exhaustive.

What to look for

Emotion. Themes such as love, hate, and jealousy should ultimately drive your characters and create the plot.

Humor. It is not always appropriate, but even in the darkest tales, humor can enrich the writing.

Layers of story. Don't overdo it, but you can run concurrent stories, either in the picture, dialogue, or background.

Layers of meaning. Embedding extra themes and motives shows the complexity of life.

Stay focused. It is easy to wander off the main plot and go down blind alleys. Put every idea through a simple test: Does it help the story or not?

Structure. Build a strong plot structure. Once it is in place, you can hang all kinds of embellishments and details on it and the story will still work.

Rhythm. A good story will take you through fast and slow parts. Even an action comic needs quiet moments to allow readers to catch their breath.

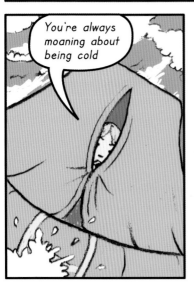
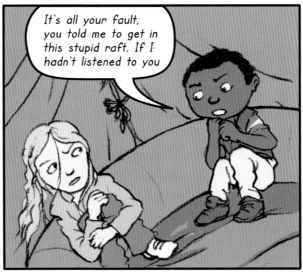
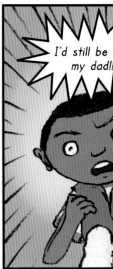

Incidentals. Sometimes it is worth focusing on a detail, an object, something that someone said, or a view from a window. Details can add richness and texture to a story.

Establishing scene. It is traditional in film and television that if you change scenes you should have a general shot showing where the action is taking place and the positions of the characters. This also makes sense in comics.

Villains (the interesting ones). Villains should have some depth—a reason for their hatred. Some of the best ones are not evil at all; they just have a different point of view.

Subtlety. Many actions and emotions are best described with subtle visual gestures, such as a look or a posture.

What to watch out for

Too much text. Characters giving long speeches, especially if they are just giving an exposition of the plot, soon lose the reader's attention.

Villains (the boring ones). Try to avoid cardboard cutouts, or evil guys with one thing on their mind, particularly "world domination."

Inconsistent motives. Characters should change their motives only with events that affect them, not just to suit the plot.

Too much atmosphere. Endless frames filled with gloomy landscapes are tedious and wasteful of a comic buyer's hard-earned money. Atmosphere is a visual thing that can be carried behind the action, apart from the odd establishing shot.

Overbearing plot. Overly complex plots are never a substitute for good storytelling. Find the appropriate level for your story and audience, then stick to it.

Talking heads. Readers tend to get bored by too much dialogue because it is visually static. If you have a dialogue-rich section, keep it interesting by including secondary visual action in the frame.

The Christmas IDIOT

SPOONY and the FRED BARON

On the FIFTH DAY of CHRISTMAS MY TRUE LOVE GAVE TO ME

Five Old Things

Four Corny Words

LOVE
HONESTY
TRUST
COMMITMENT

Three Henchmen

Two Purple Gloves

And a Large Fridge In a Pear Tree

FRED the CLOWN KEEPS...

GETTING LOST | **GOLDFISH** | **BAD COMPANY** | **OFF THE GRASS** | **A SECRET**

Pixels at Work:
Fred the Clown

Roger Langridge
www.hotelfred.com

"My working method is still pretty traditional: I draw everything on paper with a brush and pen, then scan it and color it on the computer. (I work at 600 dpi—this makes it easier to format the strips for print at a later date.) To color it, I usually start by doing everything in shades of gray, in 10 percent increments (so I have areas of 10 percent black, 20 percent black, 30 percent black etc.). Once that's done, I convert the document to CMYK (again, thinking of an eventual print version), muck about with the color balance to make the grays into shades of red or yellow or whatever it might be, and recolor anything I feel like recoloring until it all looks right. (This method gives some cohesion to the balance of colors in the strip—it's sort of cheating, but it works and it's reasonably quick, which is important.) Then, once the strip is colored, I save a copy at 72 dpi in GIF format and upload it to the website.

On Web stripping generally, it was a great step for me to take because it meant I was keeping productive and doing something I liked. I started doing Fred the Clown as a weekly thing at a time when I was doing a lot of soul-destroying, desperately dull illustration work, which was taking up an enormous amount of time, and very little comic-book work, which at one time I had been doing almost exclusively. It saved my sanity, frankly. When I decided to self-publish my own comic book a couple of years later, I had a huge backlog of material to choose from just because I'd been cranking this thing out once a week for so long. It also gave my comics career a much-needed kick-start—I'm doing a lot more comic work now, mainly on the strength of Fred the Clown.

I'm not really convinced that Web strips are the future of the medium or the way forward or whatever. To me, they're a cheap and easy means of getting my stuff in front of people, nothing more. It's one more means of distribution, and one that it would be foolish in this day and age not to take advantage of, particularly as the two media have largely different audiences (with some overlap, admittedly). I haven't gone the way of some Web cartoonists and tried things that only work on the Web and not in print; for me, that makes as much sense as doing work for print but not using the Web. Although as a reader I'm interested in what people are doing in that direction, it's not really what I'm about as a cartoonist."

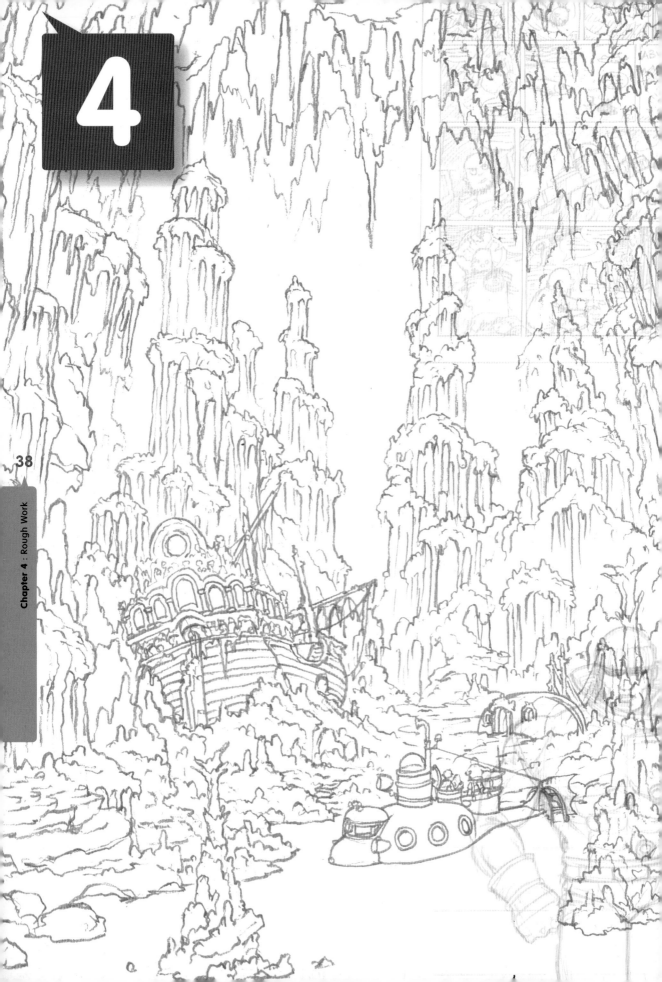

Rough Work

Pencil on paper remains the fastest and most effective way to work on your initial drawings. It is possible to draw directly into the computer using a drawing tablet, but the lack of immediate tactile response makes this difficult for many artists. Devices are available that allow the artist to draw directly onto a screen, as though drawing onto an electronic pad, but at nearly $2,000 for the least expensive tablet, these are beyond most artists' budgets.

Yet even the drawing and then scanning method has advantages over the nondigital route. One of the main benefits of digital comics is increased flexibility. Using traditional methods, chances for major revision disappear after the drawing stage—but not with digital techniques. However, to keep the chances for revision open while using a computer, it is important to begin planning at the earliest stages, even while you are still working with paper and pencil.

OPPOSITE PAGE: *DEEP SEA STAR.* LEO HARTAS.

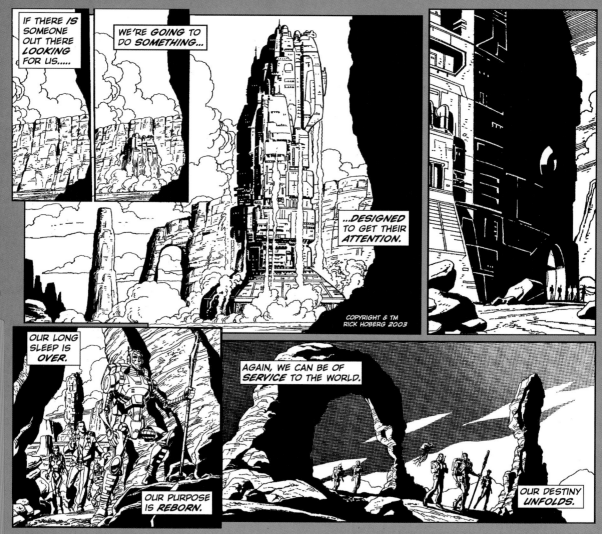

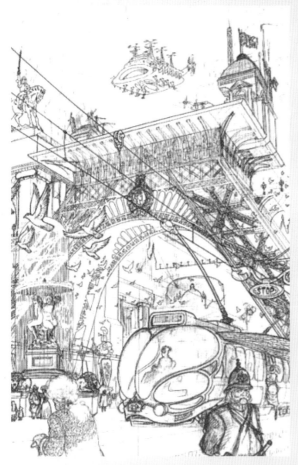

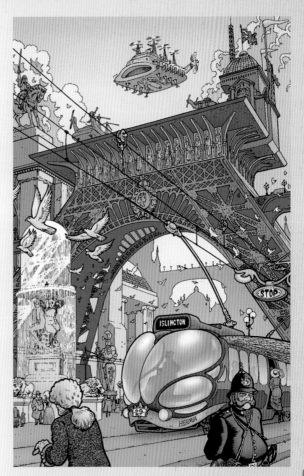

HEART OF EMPIRE. BRYAN TALBOT. **www.bryan-talbot.com**. BRYAN CREATED A COMPLETE ALTERNATIVE HISTORICAL VERSION OF LONDON CLOSELY BASED ON VICTORIAN DESIGN.

Designing the Setting

A place on the page

The background setting varies in importance with different cartoons. Sometimes a couple of lines describing a horizon and the sun in the sky are enough to indicate that the characters in the foreground are standing somewhere and that it's daytime. This is often the case with comedy strips, where the interaction of the characters is all-important and anything else is only a prop. In other strips, the setting is as important as the characters or, because of your graphic style, demands to be rendered in every detail. In later chapters I cover a number of techniques where the computer can be of great help in cutting down the workload involved in drawing backgrounds.

A place in the sun

Where you decide to set your story has major implications for the quantity of work you make for yourself. A real-world setting may necessitate a considerable amount of reference-gathering. This may

not be a problem if the setting is in your hometown, in which case a couple of days with a digital camera will be enough to gather the required information. But producing an accurate historical cartoon can be a lot of work, especially if it's set far away from where you live. Hergé was known to have traveled to many of the locations where the *Tintin* adventures are set in order to gather reference material, but that isn't always possible.

A place in your head

If you are planning a fantasy or science fiction comic, then the problems of factual accuracy do not arise, of course—it's up to you what a Zenoglorian Splinter fighter or the Keeper of the Seventh Gate look like. However, fantasy and sci-fi require a lot more work for the imagination, especially if you want to create an imagined world that goes beyond the stereotypes of *Star Wars* and *Lord of the Rings*. In an already crowded market, originality and invention stand out. The graphic style needs to be consistent with itself, not only to give your world credibility but also to help create the overall brand of your comic.

Character Design

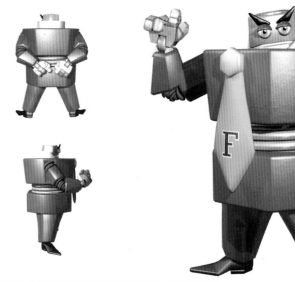

IF A NUMBER OF DIFFERENT ARTISTS WILL BE WORKING ON A LONG-RUNNING CARTOON, IT'S IMPORTANT TO ESTABLISH GOOD TURNAROUNDS.

Good-looking characters

To get a complete feel for a character and keep the look and style consistent through the story, try drawing a character sheet or turnaround (a drawing of a character from several key angles). Turnarounds, which are always used in animation, are even more critical if you are working on a project where you need to communicate with other artists and creatives. Remember that you may be redrawing the character many times over in different poses, so try to avoid too much detail. It's also important to give each character an identifiable profile so that they are easy to distinguish from one another, and so that your readership can instantly recognize them among the host of other comic characters out there. More than anything, the main character represents the "brand" of your cartoon, so it needs to be as distinct as possible.

Humorous characters

Over the years, a number of conventions in character design have emerged. They are by no means rules, however, and some of them are beginning to look distinctly old-fashioned. Take the traditional style that appeared in cartoon strips in the 1930s and continued into the animated cartoons of the 30s, 40s, and 50s. This style—with smaller bodies and exaggerated head and features—has become a kind of shorthand to indicate that what you are reading is going to be funny. The original look has dated, but you don't have to avoid it completely. Updated versions do the same job today.

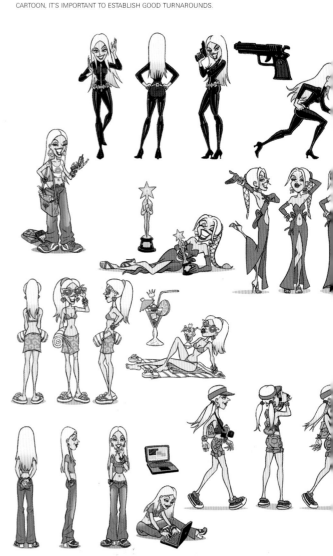

LIP GLOSS GIRL. GEORGE PARKIN. GEORGE TRIES OUT THE SAME CHARACTER IN A VARIETY OF POSES AND COSTUMES TO GET A GOOD ALL-ROUND FEEL.

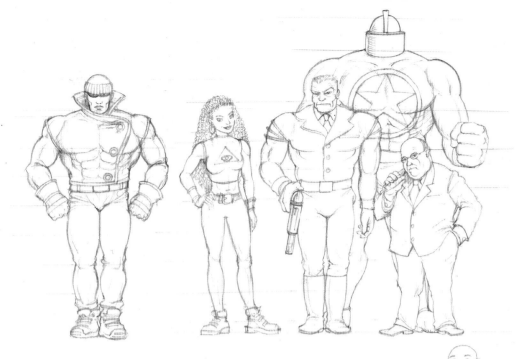

Power characters

The superhero tradition has very entrenched conventions: Heroes typically stand a head or two taller than the guy on the street and have masses of exaggerated muscles. As with all character drawing, but especially with superheroes, you need to study human form and anatomy to make your character look convincing. It's also getting harder to make a hero look different. With thousands of superheroes now patrolling comic-book pages, truly original costumes are few and far between. Seeking inspiration in the broader world, rather than from existing superheroes, will help your hero stand out from the caped-crusader crowd.

Expressive characters

As you work on your character design, think about how your character would look when experiencing different emotions. You might expect that emotions are expressed on the face alone, but you can use the whole body to fully convey a feeling, even if it's fleeting. When you are thinking of an expression, it's a good idea to get up and act it out. Make a note of your entire posture—even how your hands and feet express the gesture—and then exaggerate it. Humorous strips and animation will often exaggerate far beyond what is normal, or even possible, in the real world.

THIS PAGE: WORK ON POSES AND EXPRESSIONS TO BRING THE CHARACTER TO LIFE. EXAGGERATION ADDS A SENSE OF ANIMATION TO THE FACE AND BODY.

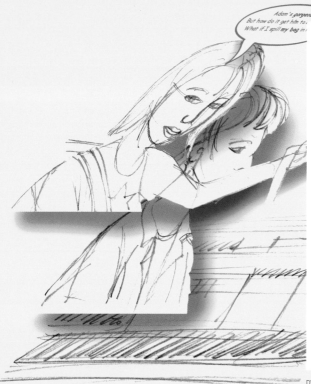

DYNAMIC COMPOSITION, FRAME-BUSTING MOTION, AND STRONG, GRAPHIC DRAWING: THIS STRIP IS ACTION ALL THE WAY.

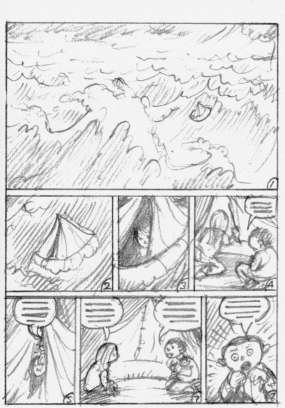

A MAP: A PAGE-BY-PAGE DIAGRAM DESCRIBING THE CONTENT AND LAYOUT OF YOUR FRAMES.

Page Layout

Across the page

Once you have the basic story worked out, either as a script or a set of thumbnail sketches, you can begin designing pages. Format is all-important here; you should first approach the work on the largest scale—the entire story. It is only from this "zoomed-out" view that you can place the story across several pages.

From this point on there are a number of layout issues to address. These will depend on what format you are working to, whether it's a book, newspaper strip, or a comic for the Web.

Turning tricks: layout for print

A strip that crosses several pages in a traditional printed comic book is automatically divided into spread-sized sections. This gives a natural rhythm to the story on which the cartoonist can capitalize. The most obvious is the page turn. The final frames on the spread are a good place to put a cliffhanger, and the first few frames are good for a surprise or shock.

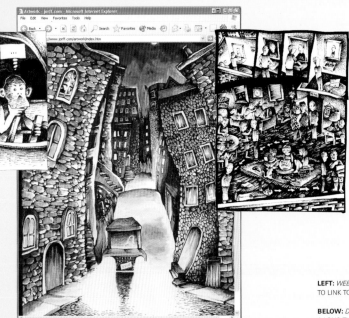

Clicking tricks: layout on the net

The various new methods of presenting and reading comics that the Internet offers are covered in more depth later (*see pages 142–145*). On the Internet, comic artists can be far more freeform, perhaps showing just one frame at a time, having a whole story on one long Web page or running hyperlinks to parts of a single frame. Although these are fun and exciting techniques to experiment with, you have to decide whether you ever want to see your strip in print. If you have designed it specifically to sprawl across the Web, you may have trouble transforming it into a book if the opportunity arises later.

In the frame

The obvious way to present a comic strip is as a series of frames reading from left to right in rows across the page. Comedy strips usually keep to this simple layout with the odd frame enlarged to accommodate more characters. In general, it is a good idea to make some frames as large as a half-page or whole page to give visual variety to the design. Larger frames can also work well as establishing shots at the start of a chapter.

Frame the action

Action comics typically break the frame with superheroes being punched across the page and explosions raining fire on adjacent frames. They also use exaggerated compositions and perspectives to heighten drama. There is often a fine line between making good use of these devices and making the page illegible.

Thinking with a digital head

There are several things to consider while drawing roughs. The main one is reuse, which is covered in more depth later (*see pages 102–105*). To maintain a level of flexibility so that you can move elements around and reuse them, it's worth splitting a frame into different layers. For example, you can draw the background and your characters on separate layers so that when you scan them, you have the flexibility to move the two layers around. Text balloons can be added later, but you can quickly type out the text on the computer to test how much space it will occupy. It also helps to make your pencil lines strong and to keep the paper as clean as possible to facilitate scanning later.

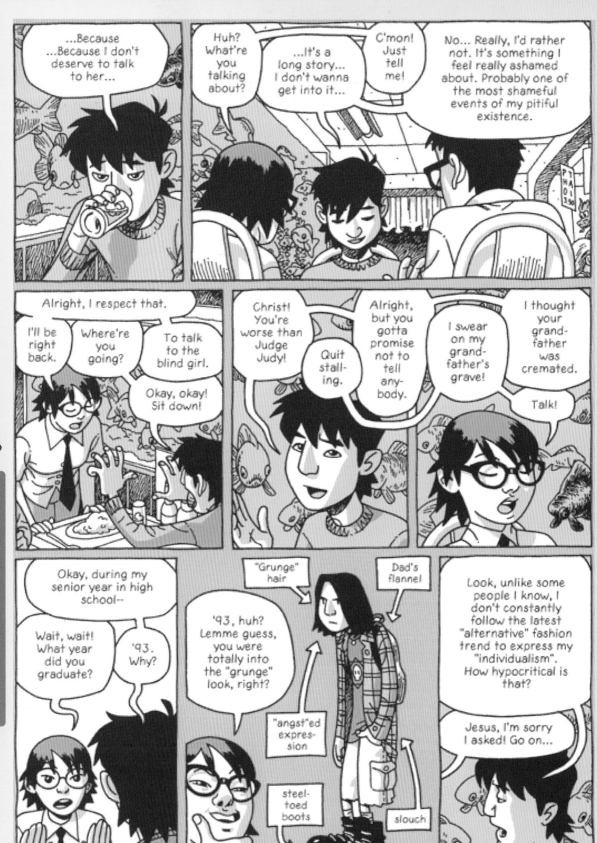

46

SAME DIFFERENCE. DEREK KIRK KIM. A WONDERFUL EXAMPLE OF VISUAL VARIETY IN AN OTHERWISE STATIC CONVERSATION BETWEEN CHARACTERS.

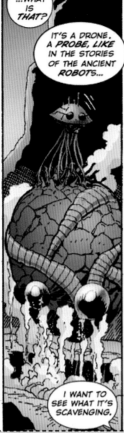
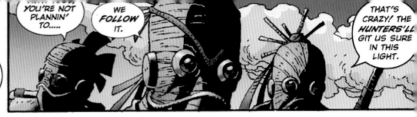

GIZMO AND GEARS. RICK HOBERG AND MATT WEBB. ACTION AND SCALE ARE GIVEN EXTRA INTENSITY BY USING A VARIETY OF PERSPECTIVES AND ZOOMS.

47

Frame Composition

Frame rates

The multitude of techniques available to the cartoonist for telling stories in pictures would require a whole book to cover comprehensively. To understand all of the possibilities, study comics, but also study its close relative, filmmaking. Here are a few ideas:

- Just as in films, vary the "camera" view and angle from frame to frame, sometimes zooming in so that a face fills the frame or zooming out for a long shot.
- You don't always have to show who is talking; speech can come from outside the frame as long as you have established who is speaking.
- Showing incidental details can help to create atmosphere.
- Build suspense, perhaps by showing a mystery character only from the back.
- Have characters move in the direction of the story to drive readers on.
- You don't always have to show the whole figure.
- Use diagonal shapes to create a feeling of unease and vertical and horizontal lines for calm.
- Don't forget the weather—it's a great atmospheric tool. Also, don't forget the power of light and dark. You can say that time passes or you can convey the feeling of it passing.
- Add secondary action, especially where there is a lot of dialogue from talking heads.
- Don't forget to include space for text panels, speech balloons, and sound effects.

Composition in Practice

Let's see how composition works, frame by frame, on a real strip. Like some sort of art critic, I'll attempt to pick apart my thoughts from when I composed the opening pages of *Deep Sea Star*. Of course, these pages can't show all of the discarded ideas and blind avenues that ran around in my mind before I settled on the final spreads. In fact, looking back at the work, I can still see many areas that fall short of perfection, but every artist has to face this eternal problem: when to stop planning and when to commit your ideas to final artwork.

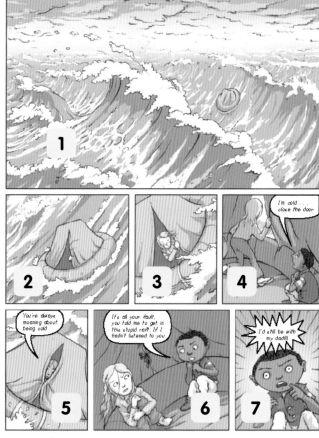

DEEP SEA STAR. LEO HARTAS

Wider concerns

Before even starting to plan the composition of the pages, there were a couple of factors that would already guide my hand. First, I had to keep the layout reasonably straightforward because it's aimed at children ages 7 to 10. For an audience who have just learned to read, moving away from the left to right, down the page convention common to all Latin-based writing might be too confusing. Comic art can break these conventions, and a lot of work continues to push the boundaries, but a certain level of sophistication is sometimes required to decode it. My other concern is purely subjective, I have always liked the simple layouts of Herge's *Tintin*, where the reader can become engrossed in the story without consciously being aware of the layout at all.

1 This is an opening establishing shot. It was important to show the tiny raft, small and vulnerable, being tossed about in the vast, stormy ocean.

2-3 A simple cinematic zoom on frame 1. You see just a hand, then the girl.

4 The action switches to inside the raft, and for the following frames I show it at opposing angles to give a sense of its constant chaotic movement.

5 This action could just as well be an interior, but I switched the view back outside to add variation.

6 The frame needed to be larger to accommodate both characters. I also wanted clear space between them to hint at their antagonism with each other. Looking back, I think I could have shown more action in the figures as they struggle to keep from sliding around in the slippery plastic inflatable raft.

7 I wanted to finish the page on a dramatic note. The flash lines and halo behind Abu are devices to heighten the tension.

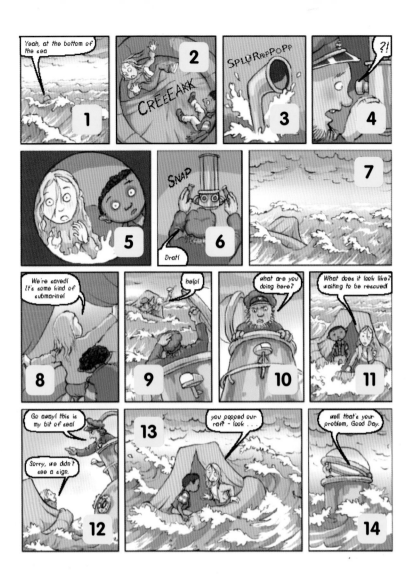

1 Page 1 allowed more space to set the scene and start to focus the reader's attention. On page 2, I wanted to really get the story moving, so there are more frames, smaller and tightly packed. In frame 1, I again wanted to show their helplessness in the huge seascape as Tixy utters her grim reply.

2 This overhead shot neatly describes the beginning of a surprise event. The reaction of Tixy and Abu, along with the sound effect, helps guide the reader to the bulge in the floor.

3 A close-up. We assume that this periscope has come up through the floor because of the action in the previous frame.

4 A sudden cut to a new character showing a reaction. This frame is a surprise, considering nothing has been mentioned about him before. It relies heavily on the preceeding and following frames and the assumption that the reader already knows of periscopes. I could have gone for a straight establishing shot of the submarine, but I wanted to tease out its debut.

5 A classic point-of-view (P.O.V.) showing the childrens' reaction. Finding different ways to view the action always adds variety

6 A snapping shut on this sequence.

7 This is a breather, time for the characters and the reader to absorb what has happened.

8 Having had time to think in the previous spread, Tixy believes she knows what happened and, pushing the flaps of the raft wide open, expresses her excitement at the anticipated rescue.

9-12 This is a standard cinematic conversation with P.O.V. and "over-the-shoulder" shots. Constantly switching the view keeps the viewer's interest. Also, the captain of the submarine, Bilgebelly, is usually depicted above and overlooking the children, which symbolizes his power over the situation.

13 Pulling away from the children in this frame hints at their diminishing optimism.

14 Page 2 leaves the reader to mull over the shocking attitude of the captain as he washes his hands of a problem he made worse. What fate awaits the children? Leaving on a cliff-hanger drives the reader to turn the page.

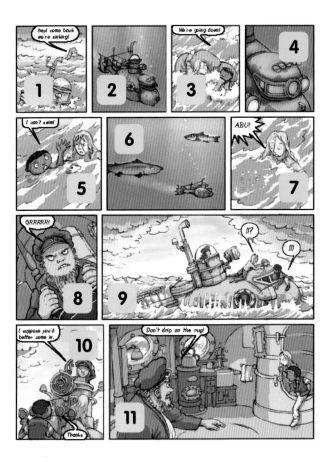

I went for four strips across the page, a self-imposed rule on which I planned to base the whole story. On page 1 you will notice that I broke the rule, occupying the top two strips with a single frame. Overall, however, I stuck to the rule, which I believe gives the layout a stability throughout the book. Note that the strips are a fraction deeper the lower down the page they are. This is an aesthetic illusion that is pleasing to the eye and gives the design a subtle visual strength on the page.

The palette

The restricted palette came about almost entirely by accident. You will notice that I work with local color, that is to say everything is the color it is with no variations for light conditions except for a simple second darker tone to simply describe shadow and form. Relying on local color can be restrictive—for example, I would have no control over color coordination if a character's chosen clothing didn't suit the walls of a living room later in the story. Looking at the strip, I think it was a mistake to make the interior of the submarine so similar a blue to the external events. A better solution would be to have the interior a rusty brown, helping to separate it from the exterior and give it a comforting warmth in contrast to the harsh sea outside.

1-6 The terrible consequences of the captain's action are played out. I had initially thought of extending this sequence to the end of the page to make the drowning of Abu another page-turning cliff-hanger. However, spinning it out would have made it too long, damaging the dramatic rhythm of the scene. I interspersed Abu and Tixi's perils with the calm descent of the submarine. This highlights their doomed situation and reminds the reader of the captain's awful behavior.

7 Abu succumbs to the waves. This is handled entirely visually with the accepted device of bubbles on the surface, together with frame 5.

8 The frame says a lot without any words apart from the captain's "Grrrr." The lower viewpoint, the captain looking up, and his holding the controls all show that he has taken the submarine in an assent. His face suggests that he is irritated by his own change of heart.

9 The submarine surfaces, to the surprise of the children. The break in the clouds hints at their changing fortune. I took a long view encompassing the length of the submarine so that readers could clearly read the entire complex event.

10 The captain grumpily invites the children in. Notice the low angle of the shot, reminding the reader the captain is still the one in charge.

11 This is a wide establishing shot where the actions of the protagonists are secondary to the background. When entering unfamiliar environments, it helps to give a wide view so the reader can get a feel for the new surroundings.

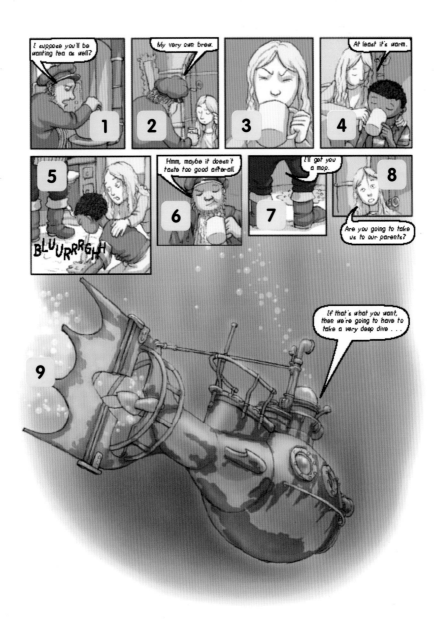

1 The viewpoint now goes to eye level, because I wanted the captain to begin to appear less threatening. He is still irritated by their presence but has resigned himself to helping them.

2-4 This simple interaction between the characters requires no special techniques, just a close-up of Tixi's reaction to the tea.

5 I thought carefully about how to depict Abu throwing up. It is a matter of judgment as to what is acceptable for a younger age group. Children always get a kick out of disgusting things, but the publisher may well consider it a bit too tasteless. As a halfway house I have slightly obscured the mess behind Abu's arm and the sound effect.

6 The captain from the children's P.O.V. Although he stands over them, we can see his attitude softening.

7 This is the first shot so far to show a cut-off view of a character that isn't a head and shoulders. This is a fairly sophisticated notion that relies heavily on reader's familiarity with the language of TV and film. The speech bubble points up to the captain's rear, though as an audience we know that his words are actually coming from his mouth! Again I partially obscured the mess on the floor.

8 The smallest frame for Tixi's plea. There isn't even enough room for the speech bubble, so I placed it over the final image.

9 You will notice that the frames became smaller as the page moves on. I did this to oppose the diagonal of the submarine and give a greater sense of it plunging into the depths. This final frame is a vignette fading off into the surrounding page and behind the frames above. This also helped to reinforce the feeling of the vast ocean depths. The interesting trick is with the speech bubble, which continues the conversation inside. The reader can assume it is the captain speaking even though we can't see him, because of Tixi's question to him in the frame before.

Pixels at Work:
Web's Best Comics

Scott Reed
www.websbestcomics.com

Scott Reed began Web publishing *The Last Odyssey* in 1999 and offers his Web comics in two formats: as digital Web books and as weekly online strips. He uses Digital Web Book Author to create the standalone downloadable Web books, which appear on screen as 3D turning pages.

Roughly how large is your readership?

The Last Odyssey and *High Strangeness* began as free, self-syndicated strips, meaning anyone could add the strips directly to their own websites. As a result, there are thousands of people who have either added the strip to their sites, or who have read them somewhere on the Web. Since moving to a paid subscription format, readership has slowly but steadily grown.

Does it provide a viable income?

Yes and no. Although there is some monetary reward that comes directly from producing *The Last Odyssey*, via the subscription service and merchandise (T-shirts, posters, coffee mugs, etc.), the strips have been a tremendous marketing tool for my freelance career. As a Web designer and cartoonist, I would say that 80 percent of my freelance income has resulted from clients seeing my online comics. For that reason alone, the time and energy involved in creating regularly updated Web comics has been justified.

Do you see your comics and the Web comic market as a whole expanding?

Absolutely. There are new Web comics being posted online every day—I've long since given up trying to keep track.

THE LAST ODYSSEY–EVEN WEB COMICS CAN USE A COVER.

How do you go about marketing?

Networking is just as much a rule of survival for businesses online as it is in the real world. I have developed solid, long-term relationships with important sponsors, such as ForteanTimes.com, which helps promote *High Strangeness*, and RPGnow.com, a role-playing game resource site that has been essential in getting *The Last Odyssey* the audience it deserves. I post news updates whenever and wherever I can, and try to keep my strips linked with key Web comic sites.

As well as presenting the comics in Web pages, Scott uses Digital Web Book Author to distribute them. With its animated turning pages, the software is the closest experience you can get to reading a real comic on the computer screen.
www.digital-page-author-software.com

5

Stepping Out with a Line

YAWN. CALEB SEVCIK. **www.moderntales.com**.

A comic strip that does not use line is a very rare sight. The line holds a drawing together, enclosing areas of white and color to create the illusion of form and space. It can convey a mass of information, from the gentle curves of organic shapes to the hard, sharp edge of a steel blade. Not least, the line is the graphic signature of the artist—the way of making his or her identity stand out in a crowded marketplace. Without the aid of color, the artist has to use more ingenuity and a wide range of clever techniques. Black-and-white linework is still a lot cheaper than full color and can be a cartoonist's entry into print, yet it is still as powerful a graphic medium as it ever was. Even in the color cartoon, it's the line that creates order and picks out form: this section also deals with preparing drawn lines for digital color (*see pages 58–59*).

Setting up the Page

If you work on paper, you take time to choose the right size and type of paper, then set out your pens and brushes. You need to do something similar if you're going to work digitally. Before you start, you have to pick the right tools and make sure you understand them. Computers have a different understanding of line and color than we do, and this has profound implications for the way you work.

For one thing, computers handle graphics in two very different ways—bitmaps or vectors. Indeed, graphics programs are generally divided into these two types. Programs that use bitmaps are commonly called "paint" programs and include the industry standard Adobe Photoshop and JASC Paint Shop Pro. Programs using vectors are known as drawing programs and include Adobe Illustrator and Macromedia Freehand.

The main difference between the two methods is in the way the computer deals with the data. However, this affects both the way you work and the sort of artwork you can produce.

56

ABOVE: VECTOR-BASED IMAGE IN MACROMEDIA FLASH.

SAME IMAGE WITH AN EXTREME ZOOM. LINES REMAIN SMOOTH AND FREE OF PIXELATION, OR THE "JAGGIES."

Bitmaps

Bitmaps store images in a grid, with each cell in that grid assigned a color. The cells are known as "pixels." Viewed up close, all you see is an ugly mass of blocks, but once the pixels are small enough, they merge to give an illusion of continuous tone, as in a photograph. It is the density of the pixels per square inch of screen or paper that determines the resolution of the image. On screen this is measured in "pixels per inch," or ppi. Printed on paper, where the pixels are output as clusters of tiny dots, this becomes "dots per inch," or dpi. The higher the resolution (ppi or dpi), the farther you can zoom in before the image breaks up into individual pixels.

A bit of a set-up

The final output should determine the initial size of the bitmap image on your computer. Artwork going to print usually needs to be at a resolution of 300 ppi. That is, for every inch on paper there should be 300 pixels onscreen. This can result in very large files.

The main problem with bitmaps is that they cannot be enlarged too much without a reduction in image quality. It is advisable to work at 300 ppi, even if you only plan to publish to the Web (which typically requires only around 72 ppi). You can then keep an archive of the 300 ppi file in case you ever want it for print later.

Bitmap-drawing programs

Widely used bitmap-based applications include:

Adobe Photoshop, **www.adobe.com**
JASC Paintshop Pro, **www.jasc.com**
Corel Painter, **www.corel.com**
The Gimp (Free), **www.gimp.org**

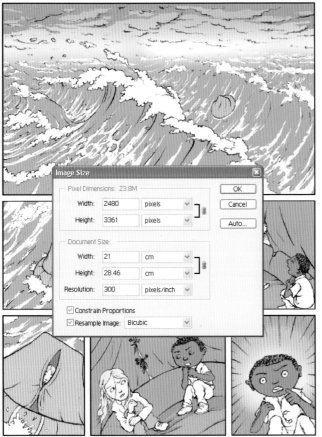

SCAN AT 50 PPI ZOOMED TO THE SAME SIZE. THE RESULT IS A LOSS OF DETAIL, OR THE APPPEARANCE OF JAGGED EDGES ON DIAGONAL LINES.

SAME 50 PPI IMAGE ENLARGED IN PHOTOSHOP TO 300 PPI.

IN THIS EXAMPLE THE ARTWORK IS FOR A SINGLE LETTER-SIZED PAGE.

57

Vectors

Drawing with vectors is a very different experience. If painting with bitmaps is like painting with traditional materials, using vectors can best be described as drawing with elastic lines. You pull the line out to the length required, then bend and twist it into shape. Lines can be joined into shapes and filled with colors, shades, and blends. Rather than store the picture pixel by pixel form, a vector graphic stores its image data as a set of mathematical instructions.

This keeps files small, and makes vector graphics perfect for delivering comics over the Internet. Other advantages include the ability to enlarge and reduce drawings without any loss of quality, and the freedom to revise as much as you want. Vectors and bitmaps can be used simultaneously in single images, and, with thought, you can combine the best of both systems. That's ideal, because although vectors are perfect for comics with clean lines and smooth shading, bitmaps make it easier to develop texture and add detail to the frame.

How vectors work

Vector information is held as a series of points in infinite space. A line drawn from A to B needs only three items of data: point A, point B and the nature of the line (thickness, color, etc). Shapes can be created from these lines and filled with color (either flat or graduated, according to the instructions). This makes vectors far more efficient for the computer and typically results in files a fraction of the size of a bitmap file.

Vector-drawing programs

Commonly used vector-based applications include:

Adobe Illustrator, **www.adobe.com**
Macromedia Flash, **www.macromedia.com**
Corel Draw, **www.corel.com**
Serif Draw Plus, **www.serif.com**

From Paper to Pixel

Scanning

There are several ways of working with line and the computer, and which you choose will depend on what your usual style is and how well it translates digitally. You may also want to consider modifying your style, if it saves time. Whereas some artists are happy to work directly on the computer, most of the cartoonists you'll find in this book work on paper, then transfer the drawings onto the computer by scanning them in. Scanning pencil artwork or inked-line artwork does not require anything more sophisticated than a low-cost flatbed scanner.

Ink on paper

In larger production houses, work on a strip is usually divided among as many as five disciplines: writer, pencil artist, inker, colorist, and letterer. The inker's skill involves taking the pencil drawings and painting the black line over them before they go on to the colorist. Inking can be achieved in the computer, although some artists find that, as with pencil drawing, your work suffers from a lack of fine control even if you use a drawing tablet.

Pencil into ink

You can bypass the hand-inking stage altogether by taking original pencil drawings and using the computer to convert them into black-line artwork. It can be argued that this process doesn't result in the same feel as hand-brushed or hand-penned artwork, and this is true

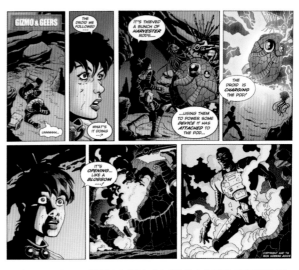

GIZMO AND GEERS. RICK HOBERG AND MATT WEBB. RICK PENCILS AND INKS THE ARTWORK FOLLOWED BY MATT COLORING IT.

to an extent. However, it comes pretty close while having the added benefit of preserving the vigor and spontaneity of the pencil line.

The pencil

Preparing pencil drawings for the computer may require some changes to your usual process. Try to make your pencil lines a consistent darkness and keep white areas clear of smudging and unwanted marks. If you do a fair bit of trial sketching before settling on a final line, try to keep this as light as possible. If your style allows for it, try to keep all spaces enclosed, because this will make any later coloring easier.

1

SCAN THE ARTWORK AT 300 PPI INTO AN APPLICATION SUCH AS PHOTOSHOP (USED HERE). TO MAKE SURE THAT THE PAPER MAKES EVEN CONTACT WITH THE GLASS, PLACE A MEDIUM-SIZED BOOK ON THE SCANNER LID TO WEIGH IT DOWN. THE RAW SCAN WILL PICK UP THE TEXTURE OF THE PAPER AND ANY SMUDGES.

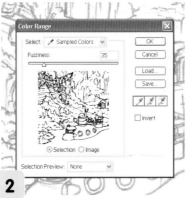

2

TO REMOVE THESE MARKS AND SMUDGES, USE THE COLOR RANGE TOOL. SET THE FUZZINESS TO AROUND 30. WITH THE SHIFT KEY HELD DOWN, USE THE EYEDROPPER TO SELECT THE AREAS OF UNWANTED PAPER TEXTURE AND AND GRAY SMUDGES THAT YOU WANT TO REMOVE.

3

YOU MAY WANT TO USE THE SELECT > MODIFY > EXPAND COMMAND BY ONE PIXEL TO MAKE SURE THAT YOU HAVE SELECTED ALL THE ROGUE PIXELS THAT YOU WANT TO REMOVE. HIT DELETE AND YOU SHOULD BE LEFT WITH ONLY YOUR CLEAR PENCIL LINE ON ONE LAYER. IF YOU DON'T HAVE AN ALL-WHITE BACKGROUND LAYER, IT'S WORTH CREATING ONE SO THAT YOU CAN SEE CLEARLY. CREATE A NEW LAYER IF YOU HAVE TO, AND USE THE PAINTBUCKET TO FILL IT WITH WHITE.

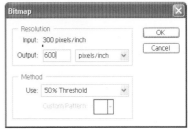

4

INCREASE THE CONTRAST ON YOUR PENCIL LINE UNTIL IT BECOMES BLACK, USING THE *IMAGE > ADJUST > BRIGHTNESS/ CONTRAST* OR THE *LEVELS* COMMAND. APPLY A VERY LIGHT *BLUR* FILTER IF THE LINES NOW LOOK TOO HARSH.

→ QUICK TIP: Before you lose your line selection, save it. It can be useful later when it comes to coloring your frame.

→ QUICK TIP: If the artwork is going to remain black and white, you can scan it in at 600 ppi and save it as a two-color file. This has the advantage of shrinking the files sizes, while boosting the quality of the result.

5

OVERSIZE SCANS: IF YOUR PENCIL DRAWING IS TOO BIG FOR YOUR SCANNER, YOU CAN STILL SCAN IT IN PORTIONS, THEN STITCH THE PARTS BACK TOGETHER IN THE COMPUTER. SCAN THE FIRST PART AT 300 PPI, MAKING SURE YOU HAVE THE STRAIGHT EDGE OF THE PAPER BUTTED UP TO THE SCANNER CORNER. THEN MOVE THE PAPER ALONG TO SCAN THE NEXT PART OF THE DRAWING, MAKING SURE YOU HAVE A GOOD INCH OR SO OVERLAP WITH THE PREVIOUSLY SCANNED PART. BETTER RESULTS ARE ACHIEVED IF THE DRAWING IS ON PAPER RATHER THAN BOARD, BECAUSE THE RAISED LIP AROUND THE SCANNING GLASS BED CAN KEEP THE BOARD FROM MAKING PROPER CONTACT WITH IT.

6

IN PHOTOSHOP, TAKE THE FIRST SCAN AND USE *IMAGE > ADJUST > CANVAS SIZE* TO ENLARGE THE CANVAS BY AT LEAST DOUBLE IN THE DIRECTION REQUIRING THE NEXT SCAN. CUT AND PASTE THE SECOND SCAN INTO A NEW LAYER ON THE FIRST SCAN. SET THE *OPACITY* OF THE SECOND SCAN LAYER TO 50%. THIS MAKES MATCHING THE EDGES MUCH EASIER.

7

USING THE *MOVE* AND *ZOOM* TOOLS, MOVE THE SECOND LAYER UNTIL THE OVERLAP ALIGNS. SET THE *OPACITY* BACK TO 100%, AND USE A BIG SOFT *ERASER* TO REMOVE ANY VISIBLE SEAMS. MERGE THE LAYERS TO CREATE A SINGLE LAYER—AND A SINGLE IMAGE.

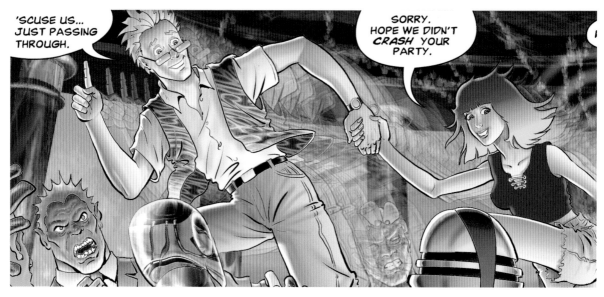

ARGON ZARK. CHARLEY PARKER. CHARLEY PARKER DRAWS *ARGON ZARK* EXCLUSIVELY ON THE COMPUTER USING A TABLET.

Drawing into the Machine

The drawing tablet

There can be advantages to drawing directly into the computer, even if a graphics tablet and stylus can't simulate the feel of pencil on paper. Removing the scanning stage is not a great time-saver, but drawing directly onto layers in a painting package can create considerable savings later, particularly if you want to reuse objects or characters from one frame in another.

The digital pencil

If you want to sketch directly into a bitmap-based program, such as Photoshop, using a tablet, there are a few tricks that might help.

First of all, make yourself a good "pencil" in your drawing application. There will be preset options available, but try to find a line width and texture that suits you. Although personal taste has a bearing, it's a good idea to decrease the pressure-sensitivity of your drawing tablet so that you have to use a fair bit of pressure to make a stronger line. The tool doesn't necessarily have to behave like a pencil, so long as it acts as an effective rough-drawing tool.

The image shown below left was created in Corel Painter. One of the great innovations in Painter is its *Quick Rotate* tool. Many pencil-and-paper artists like to turn their drawing board around as they work to give them more control. This tool allows you to mimic this with a graphics tablet.

Sometimes it helps if you start work at a much lower resolution—say, 100 ppi—and then increase the resolution later as you add more detail. Apart from being easier to block in the main shapes, this gives you the advantage of working on a smaller, faster file.

Digital pen and ink

Here are some tips for bitmap inking:

- Always ink on a new layer with your pencil scan or drawing on a locked layer below.
- As with a digital pencil, it's worth taking time to set up your own predefined pens and brushes in Photoshop. Again, look at adjusting the pressure-sensitiveness of your tablet.
- You should always work at a minimum resolution of 300 ppi to be certain of smooth line edges. If your computer is straining, try splitting up a page into single-frame documents.
- If your style uses a lot of crosshatching to fill in large areas, try creating a few predefined brushes that use a sample of your cross-hatching as the texture.
- You don't have to fill in large areas of black manually. Enclose the area with a line and pour the black in using the *Paintbucket* tool.
- If you want to draw directly into the computer, try tracing sketches or photographs taped onto your graphics tablet.
- For clean curves in Photoshop (or any other bitmap image-editor) use the *Pen* tool and *Path* tools. These give you the same control over lines and curves that you would get from a vector-graphics package. Turn the page to find out how to handle Bezier curves.

FROM TOP: EASY INKING WITH THE PAINTBUCKET TOOL.
SKETCHING THE DIGITAL WAY
CROSS-HATCHING WITH A PREDEFINED BRUSH.
INKING ON TOP OF A SCANNED LAYER.

A VECTOR DRAWING SHOWING THE SHAPES AND CONTROL POINTS FOR THE CHARACTER'S HEADS.

Drawing and Inking with Vectors

As I mentioned earlier, vectors have a number of advantages, including flexible editing, smaller file sizes, and the freedom to scale work without losing detail. Perhaps one of their best qualities is that they offer a more controllable drawing method for the less confident draftsperson. Vectors are commonly used where a flat, simple style is desired, although they also work well using their inbuilt "wobbly" hand-drawn lines. Cross-hatching and feathering can be achieved, although they tend to be tricky to control.

TURNING STRAIGHT LINES INTO BEZIER CURVES USING CONTROL HANDLES

Point drawing

Vectors are easy to draw with a mouse: It's only a matter of putting down points, and this is even easier if you scan a rough drawing to use as a guide. Each line or shape you draw is then referred to as an "object." The object can be moved, scaled, and edited as much as you like. Most programs support Bezier curves, which, once mastered, make drawing easy. Bezier curves—named after the French mathematician who worked out the calculations behind them—are lines drawn between anchor points. These can then be bent in controlled curves using handles attached to the line.

Efficient Bezier curves

The trick is to draw shapes with as few points as possible, and to use the Bezier control handles to make the curves. It is tempting to reach for the freehand drawing tool, but in some programs, including Flash, this usually generates many control points. These make the curve difficult to revise as well as memory-hungry, slowing down the program if you use too many. Illustrator's *Pencil* tool keeps them down to a minimum.

Turning bitmaps into vectors

Many vector-based drawing programs can convert bitmap images into vectors, and there are even some stand-alone packages, such as Adobe Streamline, that specialize in it. This method would be useful if you had scanned an inked cartoon that you wanted to convert for fast download or for animation in Flash.

A DRAWING SCANNED IN AS A BITMAP (LEFT) AND CONVERTED TO VECTORS (RIGHT).

Depending on the settings, original lines can be smoothed out and cleaned up. To make the conversion effective, it is important that the original artwork has simple lines, or you will end up with a vector image so complex, it will be impossible to work with.

Groupies

It is useful to group your sets of individual line objects into single objects as you work, usually once you complete and are happy with the various elements. Grouping also allows these elements to be saved for reuse in other frames. Most vector-based drawing programs support layers in a similar way to bitmap programs, and it's a good idea to use these to organize your elements in a logical way.

Drawing and Inking with Vectors

ABOVE: THIS IMAGE WAS DRAWN IN PEN ON PAPER, SCANNED INTO PHOTOSHOP, VECTORIZED IN STREAMLINE, AND COLORED IN USING FREEHAND.

LEFT: *THROB.* FRED PIPES. **www.fred-pipes.com**.

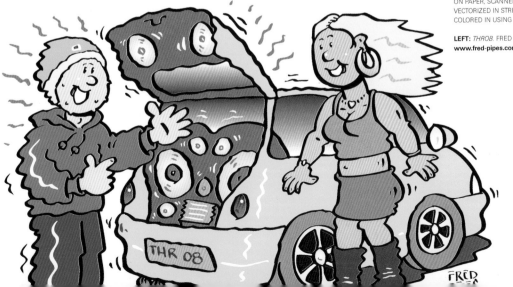

From Sand to Rubber Band

If your work leans toward the clean lines of vector drawing you should consider working in Flash. It has a number of advantages, from its unusual Paintbrush tool to the fact that any work completed is optimized for fast download over the Internet. One tool that is included almost as an afterthought is its bitmap-to-vector converter. Using it allows you to have the speed and freedom of sketching on paper, but with the sharp, clean outlines and subtle control of vectorized final artwork. Does it save time? Not especially, as it is a little long-winded, but there are benefits later in reuse and the flexibility of optimized Web display, interaction, and even animation. Remember, too, that Flash's many export options make it well suited to producing artwork for print.

3

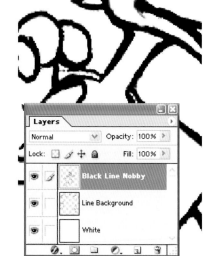

4

1

2

Another day, another sketch

The early part of this tutorial covers ground already described on page 58 in "From Paper to Pixel". You could scan directly into Flash, but you really need a bitmap program for cleanup.

1 The sketch. Note that the background drawing is just visible behind Nobby (the lupine hero of the piece) in the foreground. Keeping the background in mind as a separate entity is important if you are looking for reuse. In this tutorial I will separate the two.

2 The next phase is to clean up your pencil sketch for conversion, essentially creating a final line drawing. I continue to use pencil because I like to be able to fine tune and correct, however, it is even more effective if you ink the line.

3 Cleaning up. Follow the same process described earlier (*see page 58*).

4 If you want to cut the image into different elements, such as character and background, it's best to do it now. Cut out each element and paste it onto a new layer, then paste each layer into a separate new document.

5 The individual documents need to be converted to 2-bit color for the best results. This prevents the Flash converter from unnecessarily picking up any midtones. In Photoshop chose *Image > Mode > Grayscale*, then choose *Image > Mode > Bitmap* and press *OK* to the default settings. Because it is only two colors, black and white, the edges will appear, "jaggy" but this doesn't matter. Name and save out these separate documents.

5

6 Once in Flash import one of the images by choosing *File > Import*. Now you are ready to convert. Choose *Modify > Trace Bitmap*. You will have to experiment here to get the best results. What you are looking to create is a vector image with the minimum number of control points necessary to define the object properly. With too many points the image becomes unwieldy—too few and it interferes too much with the shape of the lines. Up the *Minimum Area* to about 30 and try the different options in the, *Curve Fit* and *Corner Threshold* drop-down menus.

7 Because the conversion process is automatic it can throw up inconsistencies as well as a certain, slightly angular look to the line. If this bothers you, you can clean up any bad glitches in the line manually by deleting and manipulating individual control points. These work in the same way as Illustrator's Bezier curve control handles. If you want white areas to be transparent, you will need to select them and delete them.

8 The final artwork with the foreground and background still on different layers. Color can be poured into spaces using the *Paintbucket* tool. Final artwork can be exported in various formats to be taken into Illustrator for lettering, or you can letter in Flash itself. Be aware that exporting can do odd things with the colors. It's a good idea to check the image in a color-calibrated program, such as Photoshop or Illustrator.

Flash is one of the best programs for reuse for two reasons. The first is that it's vector based, so you can enlarge elements to any size you require without damaging image quality. The second is its easy library system, where you can store different elements for reuse. To make good use of it you need to convert images into Flash Symbols using *Insert > Convert to Symbol*. This effectively groups all disparate lines and areas of color into one object.

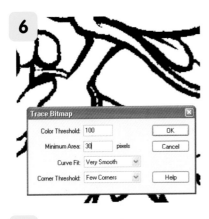

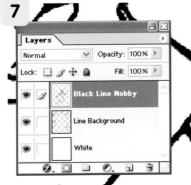

Pixels at Work: Arq Angel

Mick Szirmay
Mike Merryweather
www.arqangel.com

A young woman, the heir to the throne of a distant planet, and her protector, an android, find themselves light years from home in the epic adventure of *Arq Angel*. The Web strip is built in Poser, LightWave, Bryce, and Photoshop by Mick and Mike, who finally combine all of the components and present the story in an innovative Flash-based system.

How do you work together?

Together we write the script and storyboard out the complete episode, then I go and work on the characters. Mike's job is to build the scenery and objects. Once the cell images are completed, we import the bitmap graphics into Flash and abuse that program in ways it was never meant to be used. We build an interactive vector interface around static bitmap images. Add a dash of cool ambient music, and voila!

What other ways and programs do you use to enhance the Poser images?

Poser is excellent for character work; it's easy to see results quickly and when you use it with Photoshop to create the various texture maps you can do almost anything. In the future we hope to use LightWave for all modeling (character and scenery), as well as texturing, lighting and animation.

The strip uses an innovative format in Flash. What was the idea behind it?

The genre of the comic is one of displaying static images in a sequence. Our interface takes this to the next logical level. Instead of just looking at a small cell, we allow the user to zoom to full-screen versions of the images with the option to view storyline and text

balloons when they want them. Technologies like Flash allow you to do so much more than static-cell comic strips and yet few are doing anything but displaying their comics in HTML format. If the days were longer and time and money weren't an issue, *Arq Angel* would be brought to life in fully animated episodes.

We wanted to add life to our still cells and to give the reader the interactivity that online users have come to expect. Flash is a powerful (yet quirky) program. It allowed us to create a fully interactive interface, while adding music, story, and dialogue in a way that didn't interfere with the imagery.

What are your experiences of distributing comics on the Internet?

We've been very lucky. We joined some of the sci-fi comic webrings and that was about it. Once people saw *Arq Angel*, the word was out, and we got a lot of good press in newsgroups and chatboards. Then people were asking us if they could link to our site. As interest grew, so did the number of sites linking to us.

Do you have any future plans for Internet comics?

We have huge plans, if we can find the time to carry them out. We plan to develop the Flash comic engine further to add more interactivity on all levels, soundtrack options, interface skins, and even a choice of language for the characters to speak in.

FRAMES FROM *ARQ ANGEL*. MICK SZIRMAY AND MIKE MERRYWEATHER.

6

A Splash of Color

When it comes to coloring, computers really come into their own. Gone are the drying pots of ink, the masking tape, the messy airbrushes, and the spills. Virtually anything created with traditional coloring can be mimicked on computer. But to copy the old ways, with all their limitations, is to miss what makes the new ways so much more exciting. With a computer, you can splash digital paint around and wipe it away in an instant, interweave textures, pour rainbows, and even change the paper as you paint on it. Most commercial comics and strips are now colored on computer, offering modest savings in artwork scanning cost but big time savings in the coloring process itself.

MAIN IMAGE: BILLY REUBENS FROM *CHET AND THE DEVIL*. JUSTIN ATHERTON AND JOHN ROVNAK. **www.weirdass.net/gall_chet.html.**

FABEROONY. GEORGE PARKIN. EVEN THE BRIGHT COLORS OF CARTOON SHOULD HAVE A RESTRICTED PALETTE IF YOU DON'T WANT TO CREATE AN EYESORE.

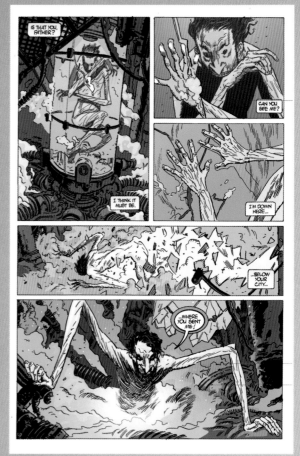

NEVERMEN: STREETS OF BLOOD. GUY DAVIS. DARK HORSE COMICS. **www.darkhorse.com**. AS THE ACTION IS SUBMERGED, GUY RESTRICTS HIS PALETTE TO ATMOSPHERIC BLUES AND GREENS.

70

Planning Your Colors

The big temptation, whether you have just started up Photoshop or have returned from a trip to the art shop with a big set of paints, is to use every color in the box. Before you go crazy, it's important to study some good old-fashioned color theory. Careful use of color is another tool that allows you to play with your reader's emotions and fully immerse them in the story you want to tell.

Demands of style and the story

The palette you choose to work with will depend on a number of factors. It may be that your chosen style of work is bright and brash or sober and subdued. Either way, the palette you use is another way to "brand" your work. Within this, you should always look to the story to find the best palette. Even if you have a brash style, coloring a story of the First World War trenches should have you using the more subdued end of the spectrum. Some types of comic, notably humorous and children's, customarily use a bright palette. The same goes for the flashy costumes of many superheroes.

ANOTHER NIGHT ON THE TOWN FROM *CHET AND THE DEVIL.*
JUSTIN ATHERTON AND JOHN ROVNAK.

"In all of our images (*see also page 69*), John and I both worked on the conceptualization of the artwork and/or story, and I used what we had discussed to produce the penciled artwork. John provided the inks, and I scanned them in so I could generate the colors with Photoshop. In Another Night on the Town, I worked up a "shadow track" with ink and grease pencil, and added that as a multiple layer in Photoshop. I wanted to make the look of the colors match more appropriately to the look of John's wonderfully expressive brushed ink lines. I'm a firm believer in the idea that the colors should enhance the illustration and improve its readability. I try to make sure that the filters and effects I use don't smother the drawing, but work with it. I love doing the colors and final touches digitally because of the flexibility. You can always go back. It allows you to try new things—and if they don't work, you can go back and try something else without having to having to completely rework the image."

Color tips

- Plan the palettes for your whole book. It's the first psychological impression someone gets when they are flicking through the comic in a bookshop.
- Consider changing palettes from page to page. This helps to maintain mood and consistency without losing variety.
- Limit your palette to a few colors that work together.
- You can use colors outside your palette, but limit them to small areas.
- Different color sets carry strong emotional cues. Red often evokes anger; blues suggest calm and space; and greens can convey sickness or meanness.
- Different colors give distance information. If you imagine the frame as a window onto the comic's world, reds, oranges and yellows appear closer to it than blues and greens.
- You can use color to guide the reader's eye across a frame, using bright tones for points of importance.

- In a subtle palette, you can establish colors that work as cues or hints in the story. For example, associating a particular shade of green with a villain can be used to show where he has already struck or foreshadow where he might attack next.
- Analyze how other artists have used color to striking effect, not only in comics but also in film, traditional art, photography, and animation.
- Changing a palette is a good way to show a change of location in the story.
- Color doesn't have to emanate from the objects: Consider the effects of light.
- Giving characters strong colors and the background duller tones can help to separate the two visually.

Technical Color

There are some technical issues to working with color on computer that are important to understand, especially if your final output is destined for professional printing.

Earlier on, I spoke about resolution and touched on the idea that a pixel contains color information. This information is variously referred to as color depth, bit depth, or color space. Each pixel takes up a certain amount of data, and we call this amount the color depth. The more colors you want in an image, the larger the color depth—and the larger the file—will be: 8 bits per pixel will give you 256 colors, but 24 bits are needed for a "true color" image. In fact, it's the dimensions of an image in pixels multiplied by the bit depth that determines its uncompressed file size. An image measuring 1,600 x 1,200 pixels in 24-bit color will be 46 million bits in size, or 5.5 megabytes.

CLOSE-UP OF THE TOP IMAGE WITH GAMUT WARNING (PHOTOSHOP: *MENU > VIEW > GAMUT WARNING*) SWITCHED ON. COLORS OUT OF GAMUT SHOW UP GRAY.

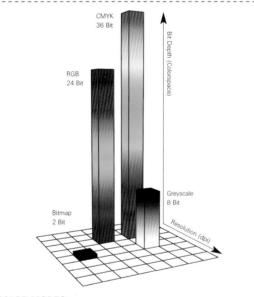

COLOR MODES
LINE ART: 1 BIT. 0=BLACK AND 1=WHITE. JUST ONE BIT TO DISPLAY BLACK AND WHITE. **GRAYSCALE:** 8 BIT. ALLOWS 256 SHADES OF GRAY. **INDEXED COLOR:** 8 BIT. 256 COLORS. SOMETIMES USED BY WEBSITES TO REACH PEOPLE VIEWING WITH OLDER COMPUTERS OR SLOW INTERNET CONNECTIONS. **RGB:** 24 BIT. USED BY TVS AND MONITORS, WHICH MIX THREE CHANNELS (RED, GREEN, AND BLUE) TO MAKE THE COLORS YOU SEE ONSCREEN. EACH CHANNEL CONTAINS 8 BITS, GIVING A TOTAL OF 24 BITS. **CMYK:** 32 BIT. USED FOR FILES DESTINED FOR PRINT. USES FOUR CHANNELS, ONE FOR EACH OF THE PRINTER'S INKS. EACH CHANNEL HAS 8 BITS.

Screen vs Print color

Whereas the color on your screen is made by combining red, green, and blue (the RGB model), conventional color printing uses four colors: cyan, magenta, yellow, and black (abbreviated to CMYK) to mix all of the colors used. As with RGB, each color is represented by its own 8-bit channel, but the difference in the way that colors are mixed has a huge effect on the way they are printed. The advantage of using the CMYK mode within your image-editing application is that each channel can be precisely adjusted to give complete control over the printed colors. The important thing to keep in mind is that some of the luminous RGB colors you see on-screen are not possible to print. Photoshop calls these colors "out of gamut."

CMYK in practice

The problem for the artist is that CMYK files demand more disk space than equivalent RGB files and are heavier on system resources. In practice, it is far better to work in RGB unless you are looking to match colors precisely with print. The only caution to working in RGB is that if you use luminous (out of gamut) colors they will be disappointingly dull when converted to CMYK. As for the conversion itself, it is best to talk to your publisher or printer first, because they may know which conversion techniques will best suit their printing process. If that's the case, you can work in RGB with

THE *COLOR PICKER* CAN WARN YOU WHEN A COLOR RUNS OUT OF THE PRINTABLE GAMUT, ENABLING YOU TO MAKE AN ALTERNATIVE SELECTION.

CMYK preview on (in Photoshop, *View > Proof Setup > Working CMYK > **View Proof Colors***), meaning that whatever colors you choose, your paint program will display them as CMYK.

Color Calibration

If you are serious about your colors, it is important that you get all of your equipment speaking the same color language. Scanners, monitors, and personal printers can all vary quite considerably, even before you throw your own view of colors into the mix. There are plug-ins and programs available that help automate the task of color calibration, but the subject can become very technical. Artwork going to print can also pass through a number of other machines and processes that can affect the color. Unless you work closely with a printing house, it can be difficult to maintain your specified colors, especially once other variables, such as paper type, enter the equation.

File types

Whichever application you work in, it will usually offer a choice of file formats in which you can save. Some retain more information than others, and some are designed to compress images so that they take up less disk space or can be downloaded faster from the Web. As a result, choosing the right file format is important.

The best file format to save in while you are working is the native format of the software you are using (PSD or .psd in the case of Photoshop). This retains more information (such as layers and channels) and it's worth keeping and backing up your finished PSD even after you stop working on a page. Any other file format you save your work to later should come from this "master" file otherwise you risk both a loss of quality and the loss of the most flexible version of your work.

When sending work to your publisher or printer, it is best to send in TIFF (.tif) format. TIFF is a widely used format that is recognized by QuarkXPress, publishing's industry-standard layout program. TIFF reduces file size by flattening the layers, and you can further compress the file by checking LZW Compression, a lossless compression format. This shrinks the data without actually losing anything, meaning image quality will not be affected. For more on file types see page 154.

73

Technical Color

> → **QUICK TIP: If sending work off on CD, format it as ISO 9660 standard with only 8 letters (plus a 3-letter extension) to each file name. Even though this means you have to do without descriptive names, it ensures that the CD can be read by any Mac or PC computer without file names undergoing a harsh and potentially confusing shortening.**

Coloring In

Most comics and cartoons use the basic coloring style of black line with a flat ink wash because it is effective and, most of all, fast. In the past, it required special skills to paint consistent flat color with bottled ink or gouache. When you're coloring on computer, however, it's a simple task.

Layers setup

Coloring is where layers really come into their own. Shown below is an optimal layer setup using Photoshop, but you can work just as well using different arrangements. The main idea is to always keep the line separate from the color and use the layer blend mode—the setting that defines how each layer interacts with those below it—to mimic the transparency of traditional coloring inks.

Palette building

Most programs allow you to create your own color swatches and palette sets that you can save to use later. As you collect colors into the palette, it's a good idea to sort out a few darker and lighter versions of the same colors and arrange them logically. To work quickly with colors you already have, load a finished image or a scanned one and sample a color from it using the *Eyedropper* tool, or by holding down the Alt key while you are in *Brush* mode.

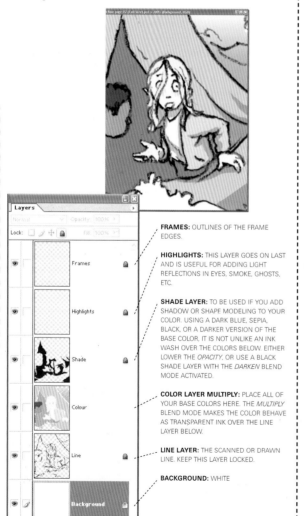

FRAMES: OUTLINES OF THE FRAME EDGES.

HIGHLIGHTS: THIS LAYER GOES ON LAST AND IS USEFUL FOR ADDING LIGHT REFLECTIONS IN EYES, SMOKE, GHOSTS, ETC.

SHADE LAYER: TO BE USED IF YOU ADD SHADOW OR SHAPE MODELING TO YOUR COLOR. USING A DARK BLUE, SEPIA, BLACK, OR A DARKER VERSION OF THE BASE COLOR, IT IS NOT UNLIKE AN INK WASH OVER THE COLORS BELOW. EITHER LOWER THE *OPACITY*, OR USE A BLACK SHADE LAYER WITH THE *DARKEN* BLEND MODE ACTIVATED.

COLOR LAYER MULTIPLY: PLACE ALL OF YOUR BASE COLORS HERE. THE *MULTIPLY* BLEND MODE MAKES THE COLOR BEHAVE AS TRANSPARENT INK OVER THE LINE LAYER BELOW.

LINE LAYER: THE SCANNED OR DRAWN LINE. KEEP THIS LAYER LOCKED.

BACKGROUND: WHITE

IMITATION OF LIFE. NEIL B. **triggercut.diary-x.com**. INTENSE PURE COLOR STRENGTHENS THE EMOTIONAL UNDERCURRENTS IN NEIL'S JOURNAL WEB COMIC.

Coloring

↑ Name your layers to avoid confusion.

↑ It's always a good idea to create new layers if you want to try something experimental, or to isolate some of your work.

↑ If your software allows it, lock up your line layer. You may find that you need to edit it, especially to close areas off if you make use of the *Paintbucket* tool, but remember to lock it up again. There is nothing more irritating than to find you have spent the last hour or so coloring the line layer.

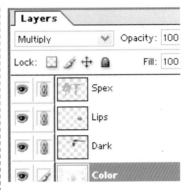

↑ If you find you have a lot of layers building up as you work, take a moment to review them. It's a good idea to merge layers from time to time, both to save having a huge, unwieldy list and to reduce file size. It also helps to commit yourself to changes in your work. Never merge the line layer with the color layer, however.

← Sometimes you will want to isolate a single element, such as a character. There's no way around: you must manually select the element with a selection tool. Using the *Polygonal Lasso* may be easier than using the freehand *Lasso*.

Don't forget to save the selection in case you need it again later (*Photoshop > Select > Save Selection*). ↙

← When pouring color using the *Paintbucket* into the color layer, don't forget to check the *Use All Layers* box. Also, set the *Tolerance* setting quite high. This will make the color overflow a little into the edges of the line, avoiding stray white pixels.

Digital Painting

If your style demands levels of shade, depth, and texture, the computer can provide the necessary tools to create them. You can even use it to produce work that looks as though it has never been near a machine but was rendered with paint-encrusted brushes on a rough canvas. Using such effects, however, typically requires a great deal of handcrafting, because many of the automatic filters, including those in Photoshop's "Artistic" set, are too obvious and crude at their default settings. Unless you take time to work with the settings, you won't fool anyone.

33	42	55	70

SHADOW LAYERS FOR *DEEP SEA STAR*.

ABOVE: HIGHLIGHT LAYERS FOR *DEEP SEA STAR*. **TOP:** USING A STAR-SHAPED BRUSH

In the shade

Shading can give extra depth to your artwork and allow forms to appear more three-dimensional. Make a new layer for shading, and keep it separate from the color and line layers. The layer can be set to either the *Multiply* or *Darken* blend modes with black, a dark blue, or sepia as the shade color. Adjust the intensity of the shading with the *Fill* parameter. You may find you need more layers of shade for different colors in the base color layer.

→ **QUICK TIP: Negative shading.** If you have a style where you use modulated shading, it can be easier to fill the whole area with solid shade and then use a soft airbrush *Eraser* to remove it, leaving areas of lighter shades. Here, areas were erased from the overall sea green to leave the lighter areas on the sub and the bubbles.

HAWAIIAN DICK. STEVEN GRIFFIN, IMAGE COMICS. **www.monkeyfun.com/hawaiiandick**. THIS WAS ACTUALLY COLORED ON COMPUTER BUT IT LOOKS ENTIRELY HAND-PAINTED.

Machine imperfect

Although computers have provided the means for quick coloring, many would argue that perfect fills and graduations give the work a cold, mechanical style. The subtle variation of a hand-rendered watercolor wash and the "happy accidents" that occur when ink from an old pot blobs and bleeds are missing from most computer work. However, if you seek to maintain the human touch, you can still make good use of the computer by scanning painted or partially painted artwork and using the machine to edit, clean up, and apply final touches to each frame.

Impossible brushes

Variety can be achieved by experimenting with different tools and applications. Corel Painter allows an almost infinite variation of brush strokes and a way of working that's as close to real painting as digitally possible, and Photoshop's digital brushes are highly effective, and among its most overlooked tools. You can load a number of predefined brushes that ship with Photoshop via the *Load Brushes* command on the *Brush* palette.

Expanding the *Brush* palette allows you to fine-tune their behavior. Clicking on a brush dynamic reveals a number of sliders, enabling you to adjust qualities such as *Scatter*, *Jitter* and *Purity*. Don't forget to select the control: Many effects only work with *Pen Pressure* switched on.

Real brushes

It is possible to mimic the real-life behavior of paint media on computer, but only in Painter. With this program, you can even paint impasto, where the physical thickness of the paint on the canvas is apparent. It is also possible to paint with watercolors that bleed into each other and leave speckled pigment in the paper texture, just as a real watercolor does. What's more, you can do all of this in the comfort of layers, without the fear of getting paint on your clothes!

Highlights

Adding highlights is usually the final touch to an image. This has to be done on a separate layer and at the top of a layer stack, using *Normal* as the blend mode.

Marks on this layer will cover both color and line. If you want the line preserved, you will have to put the line layer at the top of the stack with *Multiply* on. Most of the time you will be using white to highlight, but sometimes a soft color is more effective, such as a faint yellow. You can also use this layer to paint smoke and special light effects, such as fog or ghosts.

> **→ QUICK TIP: Look for a set of star-pattern brushes in Photoshop. (You may have to load them.) Although they are a bit corny, they work perfectly for the odd twinkle in the eye or sparkle on a sword.**

Coloring in Practice

With the drawing complete, I often approach coloring with some trepidation, because I am not a natural colorist. Like all artists, I have a vague idea in my mind of what I imagine the final painting will look like, but this is often unreliable—shifting and changing—and only taking shape as I commit color to the screen. In this example from *Deep Sea Star*, the captain and children have arrived at his secret base deep inside a submerged extinct volcano. It was important to impress the reader with the vast space, so I took a wide view of the scene, with the submarine and characters tiny among the giant rock formations.

1

2

3

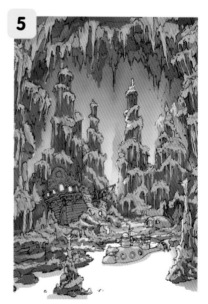

4

5

1 Blocking in
I choose two basic colors, a gold and dirty turquoise, to echo the colors in the rest of the story. In the early stages of coloring, it is important to take an imagewide view of the frame, working across broad areas with the view zoomed out. My first objective is to fill in as much white space as possible with a limited palette. This blocking in allows me to start the process of balancing colors early, giving me the psychological boost that I'm getting somewhere. I use the system of layers, one for line, color, and shading, as described on page 74.

2 Selections
Once I've blocked in two or three colors I usually make and save each as a selection. These are useful later when I want to isolate basic color areas to work in. In Photoshop, choose *Select > Color Range* and click on the color. To save the selection pick *Select > Save Selection* and type in a name for it. You can call it back with *Select > Load Selection* later on. Creating the selections while still working with flat color is easier than attempting it later, as the colors become more detailed.

3 Distance
Once the main color blocks are in, I work on the distant background. I isolate the area using the yellow blocking selection and invert it with *Select > Invert*. To get the sense of the cave receding into a ghostly mist, I use a big (300 pixel) soft brush and a mixture of turquoises.

4 Local color
Now I add the local color—that is, the actual color of objects without the effect of light and shade on them. Typically, I work fast and somewhat sloppily, caring little about straying over lines so that I can keep an eye on the overall color balance.

6

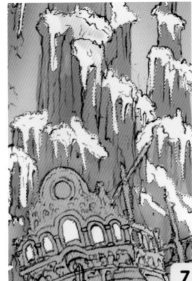

7

8

9

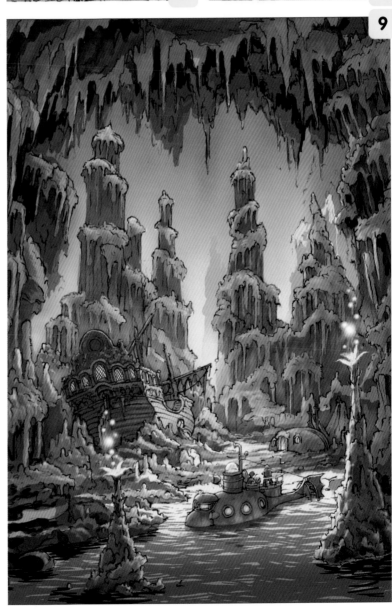

5 Blocking in the shadows
On a new layer, I begin painting in shadows in black with the fill reduced to about 30%. Now the image is really starting to take shape as the shading brings out the sense of a 3D space you could walk into.

6 The zoom
Only when I am beginning to be happy with the overall image do I start to zoom in and work on details. Here I have started a second layer of deeper shadow to add more depth. While I start new shadow layers to experiment, I usually merge them with the first shadow layer as soon as I am confident it is working, preferring to have no more than four working layers at a time. I also start cleaning up my earlier sloppy painting.

7 Balancing act
Throughout this process I always zoom out and check the overall balance of the image, sometimes making quite large changes. Here I find the basic yellow I first applied to the distant stalagmites is too raw, so I knock it back with a paler hue. Note that I hide the shadows layer to get a better view of the color layer.

8 The icing on the cake
The final stage is to add highlights, such as special effects and the glints of light from details. These have to be used with care, otherwise they can look artificial and conflict with the sense of depth in the rest of the painting. I add these effects on a new layer that sits above all the other layers—even the line layer.

9 Finished!
The coloring took about 3 hours. There are a few areas that could do with a little extra work, but the main objective, to create a believable 3D space that draws the eye in, has essentially been achieved.

Textures

Texture can be used in many ways. Some are obvious: putting bricks on a wall, working a subtle grain into an otherwise flat color. Adding texture can be part of an artist's style—putting splatter and scratchiness in the color—or it can help to describe shape and form when it distorts around a three-dimensional object. Texture can also be applied as a background image.

Paper textures

Consider giving your work a global texture. One of the easiest ways is to scan a blank sheet of paper and, with a little adjustment of contrast, bring out its graininess. Place this, like real paper, under all of your paint and line layers. Don't forget that, on a computer, you can try out different scales and levels of contrast and darkness. Try scanning textures, such as sandpaper, wood, card, and cloth.

Scanned textures

You can create different effects by scanning different kinds of materials. Place a layer of acetate down first to protect the scanner, especially if you plan to use powders and viscous liquids. Cooking oils, grains, sand, gravel, sticks, grass, nuts and bolts, and steel wool can all create interesting textures.

Photographed textures

One of the most useful devices of the digital age has to be the digital camera. Use it to collect textures, from tree bark to bricks to rust to plain old grime. To avoid unwanted shadow in the texture, take photographs on an overcast day with the camera positioned at a right angle to the surface. It's surprising how textures can be worked into a drawing so thoroughly that a reader won't be able to identify their origin.

Repeating textures

You can load textures into Photoshop's texture bank to be used in various tools, such as brushes and fills. Bear in mind that the texture needs to repeat, otherwise unsightly seams will appear.

- Find an area of the texture that seems the most consistent, and crop it into a square.
- If the image is quite large, you may want to reduce its size before you try to work with it.
- Use the *Offset Filter* with *Wraparound* checked. The horizontal and vertical offset amounts should be 50 and 50. This should make sure that any seam will appear in the middle of the image.
- Use the *Rubber Stamp* tool with a soft *Brush* to clean up the seam.
- Check your pattern by selecting all of it and choosing *Edit > Define Pattern*.
- Open a new file larger than your pattern and apply a fill (*Edit > Fill*). Choose *Pattern* in the *Use* list.

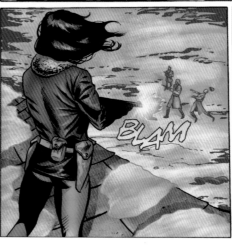

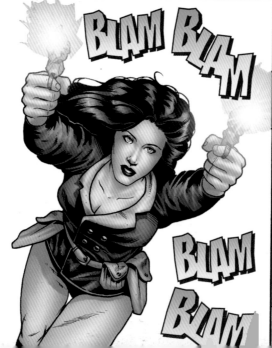
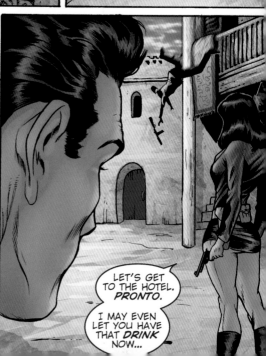

Pixels at Work: Athena Voltaire

Steve Bryant + Paul Daly
www.moderntales.com

This strip follows the adventures of *Athena Voltaire*, a beautiful Hollywood stunt-plane artist, as she battles crazed Nazis in Tibet. It's a great story in the tradition of 1930s derring-do and is notable for its beautiful artwork.

Please could you give us an idea of your process?

Paul Daly writes each episode in full script format. Because Paul is an artist as well, he supplies me with a ton of reference material when he turns over the story. He also very loosely "directs" stuff in his script, allowing a lot of freedom for me to use whatever staging he suggests, or ignore it. I've also tweaked some dialog here and there when I've gone to letter it, usually only for the sake of space.

When Paul turns a script over to me, I look through his references and staging, and thumbnail it out, noting what I need to find references for (locales and such) and what I need to specifically shoot reference photos of. My thumbnails are really loose, so I can play around with composition in the drawing stage.

Once I get something I like in the rough stage, I lightbox my pencils onto two-ply Bristol board. My originals are 10 ½ x 16 ½ inches. I pencil incredibly tight—probably way too tight—but this allows me more freedom when I ink. If I've solved all the problems correctly in the pencils, then the process of inking is merely technical.

I ink using a combination of brushes (Winsor-Newton Series 7) and Pigma markers. I prefer the Pigmas to technical pens (a pain to clean!), and they're permanent and lightfast, so my originals won't degrade over time.

I then scan in my inked page and email it to Chad Fidler, colorist supreme. Once Chad works his wizardry with it, I composite it with the lettering layer I've already created.

What's particularly noticeable is your wonderful use of scene setting and wide shots. It looks as though you use photographs, but edit them so skillfully into the rest of the strip that no one can tell.

We've had a few scenes where I'll posterize a photo [dramatically simplify its detail and colors] and drop it into the line art, much like Stan Drake used to do on the Juliet Jones newspaper strip. I think that Neal Adams has done it, as well. As far as why the posterized photos are integrated so seamlessly, that is a result of Chad's efforts. The guy is amazing.

Did you intend *Athena Voltaire* to be Web only?

Athena Voltaire started off as a pitch for a four-issue print mini-series that we began shopping around conventions in the summer of 2002. Through a mutual friend, we were put in touch with Chris Mills and Joey Manley (the editor and publisher of AdventureStrips.com, respectively). The site seemed like a great place to launch our heroine as we continued to shop the print version of her adventures. With the demise of Adventure Strips, we were fortunate enough to be picked up by its sister site, Modern Tales, which is where we are as of now. We are in the process of putting together a new proposal for *Athena Voltaire* and hope to use the Web and print synergistically.

What do you think of publishing on the Web?

I love it. I'm amazed at the immediacy with which I can introduce people to my work and to comics. I can send out an email to my family and friends with a hyperlink to *Athena Voltaire*. My wife can forward it around her office. Just by clicking on a hyperlink, people can be introduced (or reintroduced) to comics. No more excuses about not being able to find the comic shop, or no parking at the comic shop, or any of the myriad of lame excuses that we've all heard.

ATHENA VOLTAIRE. ACTION, ADVENTURE, AND BEAUTIFULLY REALIZED BACKGROUNDS.

Into the Third Dimension

Everyone will know of the hugely successful 3D animated films that have been released in recent years: *Toy Story*, *Monsters Inc.* and *Shrek*, to name a few. They are synonymous with lavish Hollywood budgets and frighteningly fancy computer systems. But as computer prices have fallen, so has the cost of the most sophisticated 3D software, so even the humble comic artist can afford some very capable equipment. 3D has some real advantages for cartoon work: It enables the artist to create more realistic, solid-looking objects, which can be reused and repositioned in an infinite number of ways. This has clear advantages for reuse. It is also a fact that one growing area of employment for comic artists is on comic-style 3D computer games.

Unfortunately, 3D has one major and one minor disadvantage. The big one is complexity: To use 3D applications effectively and create good looking backgrounds or characters, you will have to learn a great deal. The smaller problem is style. It takes time and a good understanding of the technology to produce work that bears your stylistic identity rather than one imposed by the software.

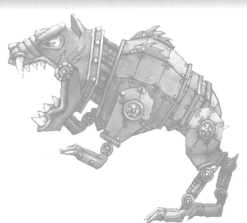
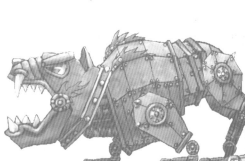

Spatial Thinking

Understanding 3D on computer starts with one simple premise: what you are doing is creating a virtual 3D space inside the computer and filling it with virtual objects, then taking a virtual photograph of it with a virtual camera. As in the real world, light comes from various sources and bounces off the objects, into the camera lens. It is important to understand that the space is mathematical. Although you can do amazing things like stretch a car with a couple of mouse clicks, how you see the scene is still limited by the laws of perspective and the behavior of light.

3D basics

↑ To make working in a 3D space through a 2D interface (the computer screen) possible, software uses the mathematical plotting convention of X, Y, and Z: X=side to side, Y=up and down and Z=in and out of the screen.

↑ Using these coordinates, it is possible to plot points within a virtual 3D space.

↑ These points can be joined and filled, creating a polygon.

↑ Polygons can be joined together to create objects, which are also known as meshes.

↑ An object can then be given different surfaces to create various appearances.

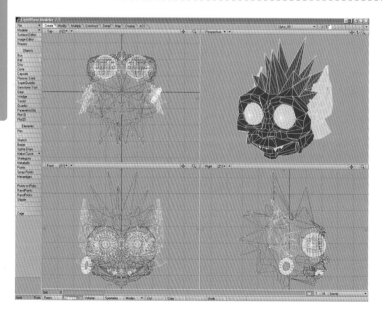

← Using this process and various software tools, increasingly complex polygon meshes can be created. This screenshot from Lightwave 3D shows a typical modeling environment with top, front, side views displayed in wireframe and a window showing the model in perspective as solid polygons.

↓ The captain's submarine from *Deep Sea Star*, rendered in a 3D application.

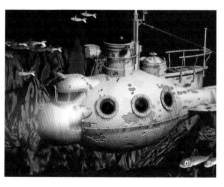

BLASTERBOT: A LOW POLYGON MODEL CREATED FOR USE IN A COMPUTER GAME, SEEN HERE IN LIGHTWAVE 3D.

PHANTOM IN THE MIRROR. GIL AGUDIN USES 3D STUDIO MAX TO STUNNING EFFECT.

The virtual photographer

From the computer's point of view, there are two ways in which the virtual photograph is handled. The one currently used in film, TV, and print is rendered. Once a scene is set up, objects and lights are placed, and the camera is in position, the computer has to take time out to calculate the scene and create the final image. The other way is used in computer games and is known as real-time 3D. Here, the computer generates the image on the fly, animating and displaying it as fast as it is calculated, usually with the help of powerful graphics hardware. Rendering has the advantage of total control over quality and is perfect for print and Web-based comics. Real-time is catching up fast in terms of quality, but an understanding of its limitations is important if you are looking to work in video games.

The programs

3D is one of the few software markets where no single product dominates, so there are viable alternatives for every level of user and budget. Strangely, price is not a determining factor of quality of output; you can buy low-cost products, such as Hash's Animation Master, and achieve movie-quality results. The only real difference is the quality and sophistication of the interface and the fact that in fields such as computer games, certain packages have become the norm. The list below is far from exhaustive. My advice is to try out a few—free demonstration versions and limited learning editions can be found for most major packages—then settle on one to learn its every nuance and feature. All are well capable of creating artwork for cartoons and comic strip.

3D Studio Max, **www.discreet.com**
Maya, **www.aliaswavefront.com**
Softimage, **www.softimage.com**
Cinema 3D, **www.maxon.net**
Lightwave 3D, **www.newtek.com**
Truespace 3D, **www.caligari.com**
Hash: Animation Master, **www.hash.com**
Blender (Free), **www.blender3d.com**
Pov-Ray (Free), **www.povray.org**

87

Spatial Thinking

Sketching with 3D

Before you move on to more complex areas of 3D, such as character design, consider the ways that 3D can aid traditional 2D drawing. The most obvious is as a help with perspective in comic strip, where different views of the same building or object are required through the story. Once the basics of a 3D package are learned, it is relatively quick to put together a simplified version of an object, make a render of it, print it out, and trace it into your comic frame. Also, many common objects can be bought or found for free, ready-made, on the Internet, which is useful if you need to draw difficult objects in perspective, such as specific makes of car or motorbike.

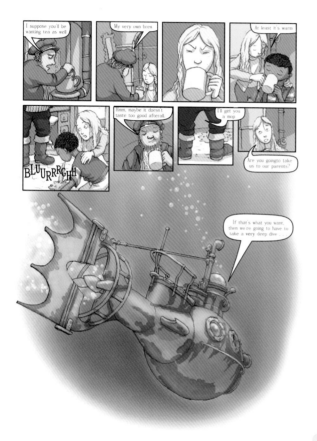

Sizing up to print a 3D image to scale

1 Measure the size of your frame on the page.

2 Multiply the dimensions of the frame size by, say, 100 (it doesn't need to be any more as the printout will be used as a rough) and input these figures into the pixel size parameters for the 3D camera. Arrange the objects in the scene, along with the camera, to get the right point of view.

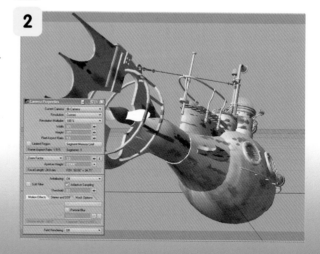

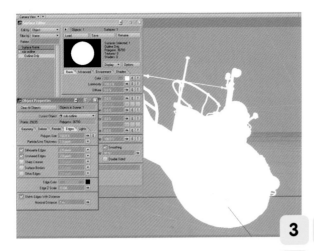

3 **4**

5

3 Make the surface of the object white and 100% luminous. Make the background white and switch on *Rendered Edges* (sometimes called *Cell-style Edges*).

4 After rendering, you should have a black-line drawing of the render. If you work on-screen you can just start work in Photoshop or your chosen application. If you want to use the render as a background for a sketch, however, you have two more stages to get through.

5 In Photoshop, set the resolution to the same figure you multiplied your original frame dimensions by and print it out. The printout should be the correct size to match your frame on paper. The clear black lines make it easy to trace on a lightbox or with transfer paper.

6 Here is a sketch render of the interior of the submarine. The object has *Luminosity* at normal and *Shadows* switched on to help with shadow placement in the final 2D image.

You can extend the use of 3D for rough drawing by using it to try out compositions or interesting lighting variations. Using more of the 3D application's capabilities, you can find out how a scene will look distorted in a reflective object, or how an object will appear if it's stretched or squashed.

89

Sketching with 3D

6

DAZ 3D'S VICTORIA MODEL.

POSER FROM CURIOUS LABS.

Poser

For the cartoon artist, there is one program that stands apart from the rest of the 3D packages. Curious Labs Poser is a specialized 3D program that allows the creation of digital mannequins—human figures that can be manipulated and posed at the artist's will. In earlier versions, the 3D models produced looked the same wherever they were used, meaning that artwork created with the aid of Poser often had a generic "Poser" look and feel. However, the latest version of the software is far more flexible, with a greater variety of mannequins to manipulate.

There are many third-party characters available for free or for sale on the Internet to use in Poser, and the models from DAZ 3D are in use by many digital artists. If you are technically proficient, you can also create your

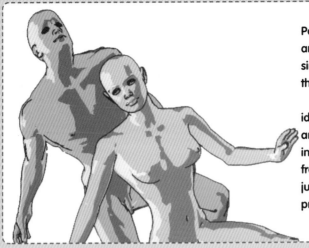

Poser can be used to great effect by traditional 2D artists wanting a basis for figure drawing: you can simply trace from line renders of Poser figures using the procedure outlined on pages 88–89.

To infuse your Poser work with your individual identity, it is important to customize the characters and environments with models of your own created in a general 3D program. Models can be imported from other applications for final rendering in Poser, just as Poser models can be exported into other 3D programs for rendering.

own models. Poser can produce incredible levels of realism, even allowing, through photographs, the creation of digital versions of real people. The program has been used extensively in digital comic strips (reuse is a real strength), but it also presents opportunities to artists who are uncomfortable drawing human figures.

Beautiful views

Other specialized 3D programs that have earned favor with digital cartoonists are the fractal landscape design packages, such as Bryce and Vue d'Esprit. These programs generate 3D landscapes mathematically from a "seed" number. You can adjust all kinds of parameters, such as water height, snow on mountains, and time of day, as well as specify types of foliage and tree cover. As with Poser, the results can be stunningly realistic, and can be used as backgrounds in comic strips.

Virtual-character software and models

For further information on virtual character software, visit the websites below.
Poser, **www.curiouslabs.com**
Daz3D, **www.daz3d.com**
Dorsch Design, **www.doschdesign.com**

World-creation software

For further information on building 3D landscapes, visit the websites listed below.
World Builder, **www.digi-element.com**
Vue d'Esprit, **www.e-onsoftware.com**
Bryce, **www.corel.com**

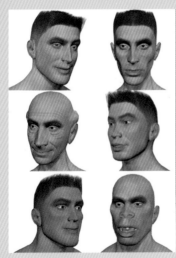

GOOD POSER MODELS CAN PRODUCE A HUGE VARIETY OF FIGURES

3D Characters

Perhaps the main task of deciding to work in 3D is the creation of 3D characters. The details of modeling and "rigging" (the animation setup) characters would take a book on their own, and would also be specific to whatever software was being used. However, this general overview should, at least, provide an idea of the type and amount of work involved. Preparing a character for use can take a week, even for an experienced 3D artist. Once completed the character never needs to be built again, it's simply posed and rendered for the action in each frame.

POLYGON WITHOUT NURBS OR SUBDIVISION PATCHES ON, LEFT, AND POLYGON WITH NURBS OR SUBDIVISION PATCHES ON.

Designing for 3D

For 3D character design, there are a couple of things best avoided from the outset. Long, flowing clothes are difficult to manipulate, and hair and fur, although possible, usually require extra software and computer power to recreate in a realistically manner.

Before launching into the design, it is a good idea to finalize the characters in front and side views. These can be loaded into the modeling software to provide some reference from which to work.

Modeling

Different programs work in different ways, but most 3D packages work through the manipulation of polygon meshes to produce objects made up from many flat faces. This is fine for the square lines of architecture, robots, or man-made constructions, but it's less ideal for the creation of soft, organic shapes.

To give those flat faces the appearance of organic surfaces, 3D software has features that smooth out the polygons into curved surfaces. These tools, which include NURBS (non-uniform rational b-splines) and subdivision patches, break up larger and less regularly shaped surfaces into smaller, more concentrated meshes automatically. This is important, because the trick with modeling is to use as few polygons as possible so that you can easily keep control of them.

Also, models with fewer polygons take the computer less time to transform, manipulate, or render.

> → QUICK TIP: You only need to build half of the character. When finished, simply mirror-duplicate the other half and join them together.
>
> Don't think you have to model every small detail. It's easier to incorporate the fine detail into the surface texture. The result will look as good, and the model will consume fewer system resources, making it easier to work with.

Surfacing and texturing

Surfacing is the process of defining the characteristics of any surface, including its color, reflectivity, luminosity and transparency. Surfacing can convey a lot of detail, but for cartoon work you really need to get into texturing. Texturing describes wrapping an external bitmap image onto a polygon surface. The big problem with texturing is that it is difficult to project a 2D image onto an uneven 3D surface without stretching and distorting it. The best method to use is UV mapping, which uses the points on the object itself to define its position. To make this work, however, the model must be unpacked and laid flat. For best results this should be done

RIGHT: EXPRESSIONS ARE BEST CREATED USING A SYSTEM OF MORPHS, WHERE DIFFERENT VERSIONS OF THE MODEL ARE CREATED AND SWAPPED IN AS REQUIRED. ONE VERSION MIGHT BE SMILING, ANOTHER MAY BE FROWNING, ANOTHER MAY BE SHOWING ANGER. MOST 3D PROGRAMS ALLOW YOU TO MIX MORPHS, CREATING SMOOTH TRANSITIONS FROM ONE TO ANOTHER. THIS ENABLES YOU TO GET A LARGE VARIETY OF EXPRESSIONS FROM JUST A HANDFUL OF BASIC FACIAL POSITIONS.

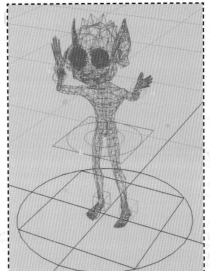

ABOVE: A "PEELED" AND FLATTENED UV MAP. THE UV MAP IS EXPORTED INTO A PAINT PROGRAM TO ACT AS A TEMPLATE FOR PAINTING THE TEXTURE MAP. THERE ARE PAINT PROGRAMS AVAILABLE THAT ALLOW ONE TO PAINT DIRECTLY ONTO THE 3D MODEL AND HAVE A SIMILAR SET OF FEATURES AS PHOTOSHOP. 3D PAINT PROGRAMS: BODYPAINT **www.maxon.net** AND DEEP PAINT **www.righthemisphere.com**. **RIGHT:** A SKELETON RIG IN LIGHTWAVE USING AUTO CHARACTER BY LUKASZ PAZERA. **acs.polas.net**.

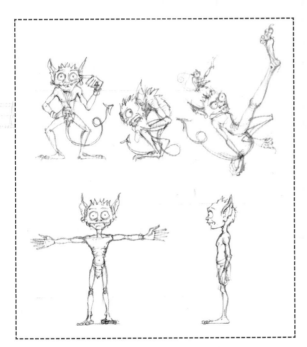

PREPARATION SKETCHES ARE VERY IMPORTANT SINCE SO MUCH EFFORT IS INVOLVED IN CREATING A 3D CHARACTER. THE FRONT AND SIDE VIEWS CAN BE SCANNED AND USED AS TEMPLATES IN THE 3D MODELING PACKAGE.

manually, though it's labor-intensive work. Once painted, the texture can then be wrapped onto the model. Creating your own textures is one of the best ways to give a model your own style, wrestling it away from the plastic, obviously artificial look the computer will default to.

> → **QUICK TIP:** If you have a painted texture and want to give it some richness quickly, use the same texture as a bump map—a special form of texture that the 3D application's rendering engine interprets in terms of bumps, pits, and raised and sunken areas.

Dem bones

Considering that comic strips are static, you could create all the poses for your character as individual models, but this is an exhausting process. It's quicker to use Bones: a feature where you build a virtual skeleton inside the character with working joints. This allows free manipulation of the character, right down to where the eyes are looking. For comic strips, skeletons can be quite basic, because there is less posing required than for animation. There are plugins available for most programs that automate the rigging process to produce amazingly agile mannequins.

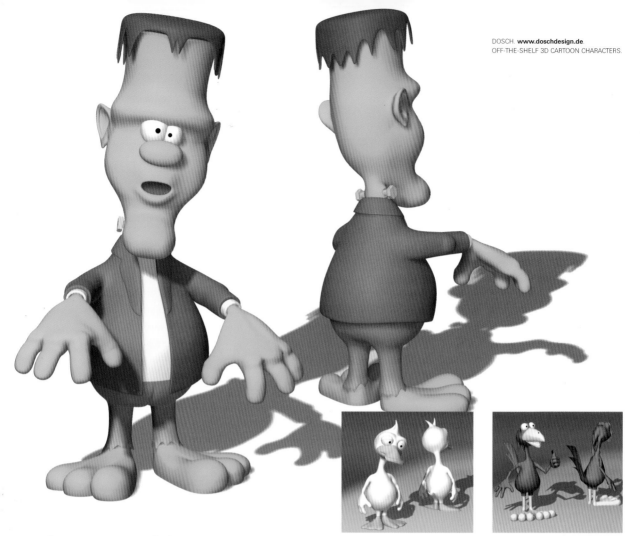

Scene Machine

Once you have your characters completed, you can begin posing them to tell the story. 3D software can be very beguiling, tempting you into working on the fly. However, it is still best to storyboard the strip on paper in advance. This can save you a lot of time in unnecessary building of props and scenes. There is no point building an entire locomotive or spaceship if you need to show only one side of it.

Lighting

Good lighting is critical to 3D, because it is the main element that defines what is seen. Lights can be difficult to control: They adhere to the same properties of light in the real world, only with a few strange anomalies added in. Some digital lights don't throw shadows, bounce off surfaces, or bend slightly to create soft shadows. Although advanced features exist to simulate these effects, they can take their toll on the time required to render the scene. Again, studying film or photography will help you to understand lighting setups in the digital world.

The camera

The 3D camera also behaves like its real-world counterpart, except for the fact that you can position it in impossible places. It also has attributes of its real-world equivalent. For instance, you can use a "zoom lens" to accentuate or flatten perspective.

A SCENE VIEWED THROUGH THE CAMERA.

THE SAME SCENE VIEWED FROM ABOVE. NOTICE HOW THE EXTERIOR IS JUST AN IMAGE WRAPPED AROUND THE WINDOW, AND HOW THE OFFICE ITSELF FLOATS IN SPACE. BUILDING THE REST OF THE BLOCK WAS NOT NECESSARY.

Sometimes the realistic, mathematical nature of 3D can be frustrating when setting up compositions. If anyone analyzed a freehand sketch and tried to turn it into a 3D render, he or she would find that nothing fitted properly. People would float just above the floor, or appear too large for the room they are standing in. Yet in the drawing, it all looks correct. It's tempting in 3D to stick rigorously to the reality of the 3D world you have created, but in practice, it is often better to ignore it. Push the character's feet into the floor, if it looks correct. The only important thing is that what you see through the lens looks right.

3D tip city

- Setting up scenes with many elements can slow the computer down, and complex wireframes everywhere make it difficult to see what you are working on. It's more effective to build simplified versions of props and background objects, then use them as placeholders for the final objects while you concentrate on getting the character poses right.
- Sometimes it's easier and quicker to do away with real 3D backgrounds altogether. Instead, paint them in 2D and drop them in behind the action. This is particularly useful when using deep landscapes, which have to be virtually huge and unwieldy so as not to show the edges.
- If you do want to include many distant objects, they can be much simpler the farther away from the camera they are, thereby saving building time and

computer power. Some programs can be set up to simplify objects in this way automatically. Also, some effects are possible in 3D, but difficult to get right. If creating static images, it might be easier to add them in a 2D paint program later.

- Reuse really comes into its own with 3D. The best trick is to take one object and turn and resize it a bit so that it looks different. This works well when you need to create a group of similar objects, such as flowers in a garden or cars on a distant road.
- Reuse your old models. If you have sweated over building a successful character, use the same mesh for all your other characters. It's amazing how pushing and pulling a few polygons around can make a completely different persona without having to build from the ground up. This is especially true of hands, feet, and ears. As a digital Dr. Frankenstein, you can take body parts and stitch them together to create a new monster!
- Keep an eye on the size of your bitmap textures. A large amount of textured objects can slow a machine down because the only memory available to display them is on the graphics card.
- Finally, it's a good idea to build everything to real-world scale even though the 3D environment is usually infinitely large. This might seem unncecessary, but it avoids problems when, for example, you bring a spoon-sized object that you made earlier into a room only to find you can't see it because it's 20 times bigger than the Earth!

3D Trickery

Earlier, I alluded to one of the problems of 3D—its tendency to create images that look obviously computer-generated and far removed from an artist's natural style. This is partly caused by the way these programs work and the fact that getting anything into digital 3D involves such a lot of processing that it is probably the least immediate artistic medium ever devised. Although these layers of work cannot be avoided, there are different ways of using 3D that are often overlooked, but can produce a more natural or distinctive cartoon style.

THE UNDERDOG. GIL AGUDIN. GIL USES CEL SHADING TO CREATE A HAND-DRAWN EFFECT. SWIFT 3D. ELECTRIC RAIN. **www.swift3d.com**.

Cel shading

Cel shading is a rendering process that draws lines around the modeled 3D objects, then fills them with flat color to create a traditional toon look. The process is used with mixed results in animation—mixed because the computer makes mistakes, as it can't know exactly where you want it to draw or omit lines. Also, the lines can look a little too mechanical and perfect. This is less of a problem for comic strips because you can easily take the rendered image and edit the line and color in your paint program afterwards. Of special note are plug-ins for some 3D programs that allow them to render cel-shaded graphics direct into Flash format. This can be an excellent way to quickly get work into a vector format for Flash-based Web comics.

↑ Make transparency masks (sometimes known as alphas) of body parts. These will be used to cut out the body parts.

2D flats

Perhaps it is a huge backward step, but few artists take advantage of 3D programs to work in a 2D way. It's the digital equivalent of the old TV animations that used 2D drawings of characters broken up into body parts, which were then animated against a background. A similar system can be set up quite easily in 3D, the advantage again being maximum reuse: you have to draw a character only once. Because it's in the computer, you can avoid having to mess around with little bits of paper. Of course, like the old TV shows, it will give the work a particular naive style, but this can be endearing. The animated show *South Park* uses 3D in this way to mimic its original hand-animated style.

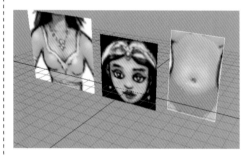

↑ Make up the body parts as simple flat rectangles in your 3D program, and map textures onto them. Make sure the rotation points of the rectangles make sense depending on each body part (e.g. the knee rotates at the bottom of the thigh).

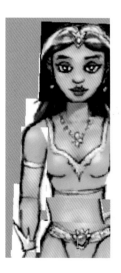

← Use a black-and-white image of the negative space around the drawing as a transparency mask, or alpha, to cut out the drawing. Link all of the parts together on a single plane: foot attached to shin, shin to thigh, and so on. Some parts will have to go behind others, depending on how you drew them originally. Make sure that all surfaces are at 100% luminosity to prevent shadows being cast.

↑ Place the camera at right angles to the model a good distance away, zoomed in to minimize perspective. (Some programs will allow you to turn perspective off altogether.) Pose your character and make a render.

← The final renders may require a little touching up in Photoshop where body parts join.

↓ Although the artwork has a viewpoint limited to your drawings, you have a great deal of flexibility with poses.

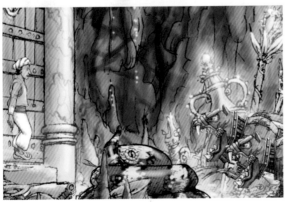

↑ Add a suitable background.

Hand done

A great way to imprint your own style into the 3D world is to get the 3D out of the computer and paint it on good, old-fashioned paper. It adds another level of work, but it can really be worth the effort. It is important to keep the scale of any textures consistent to preserve the continuity of paper texture and paint thickness.

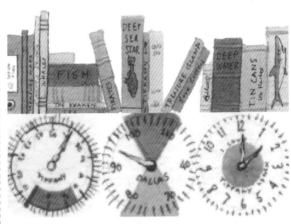

↑ A collection of textures painted by hand with watercolor. To get the correct sizes and shapes of the textures, you will need to print out the relevant parts of the UV or projection and trace it onto your art paper as a template guide. Scan the painting back into the computer at a consistent dpi; that way, you keep the scale of the paper texture correct.

↑ The hand-painted textures give the submarine a personal style.

3D backgrounds

If your cartoon is 2D and you have a lot of action in the same place or area, it can become tedious having to draw the same background again and again. Building rooms, houses, and so on in 3D is relatively simple and quick. If you map the same textures and colors onto the walls that you use in your backgrounds you can render the scene from the correct angle for each frame, match the 3D with your foreground characters, then merge it all together in Photoshop. Remember to match the 3D camera's screen size to the resolution of your artwork.

Video Games

Most video games now use real-time 3D to display in-game graphics. The console and computer games industry absorbs an ever-increasing quantity of artistic talent and this is one area of illustration that is growing fast whereas others are stagnating. Cartoons, as a style in games, have always been popular, partly because the simplification and stylization suited what have, until now, been visually crude games displays. Games engines can now produce virtual realism, but the cartoon style is as popular as ever. Video-gaming's own favorite cartoon characters, such as Mario and Sonic, rival the popularity of any characters in traditional print. Long-form comic heroes and stories continue to have a big influence on the games industry, so if you are looking to work in that sector, comics can be a natural bridge.

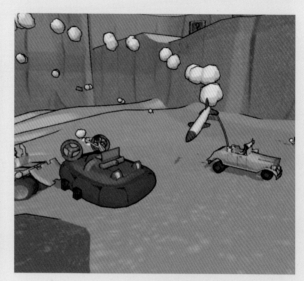

FREEDOM FORCE. IRRATIONAL GAMES.
SUPERHEROES BROUGHT TO LIFE.

Cartooning for games

The great thing about designing for games is seeing your characters come to life, and in very direct ways that only player interaction can offer. Such design work falls slightly outside the scope of this book, because it is more like animation. If you work as a 3D artist in games, you would be required to build low-polygon models because of the restrictions of the game engine. In the past, such restrictions made characters angular and, many of them, quite ugly, but as the technology progresses this is becoming less of an issue.

CEL DAMAGE. ELECTRONIC ARTS INC.
CLASSIC CARTOON MAYHEM RENDERED IN REAL-TIME CEL SHADING.

CLOCKWISE FROM TOP:

GRABBED BY THE GHOULIES. RARE. CREEPY CARTOON IN GAME MODELS. NOTE THE SLIGHTLY ANGULAR EDGES, A PRODUCT OF THE LOW POLYGON MODELS REQUIRED FOR THE REAL-TIME 3D GAME ENGINE.

KUNG FU CHAOS. JUST ADD MONSTERS. A FIGHTING GAME WITH A DISTINCT AND IDIOSYNCRATIC CARTOON STYLE.

KAMEO. RARE. A DELICATE STYLE BASED ON JAPANESE MANGA CARTOONS.

TOEJAM & EARL III. SEGA, A GAME DESIGN FULL OF INVENTIVE CARTOON IDEAS.

MUNCH'S ODDYSEE. ODDWORLD.
THESE CHARACTERS ARE BEAUTIFULLY ILLUSTRATED IN A CARTOON-REALISM STYLE.

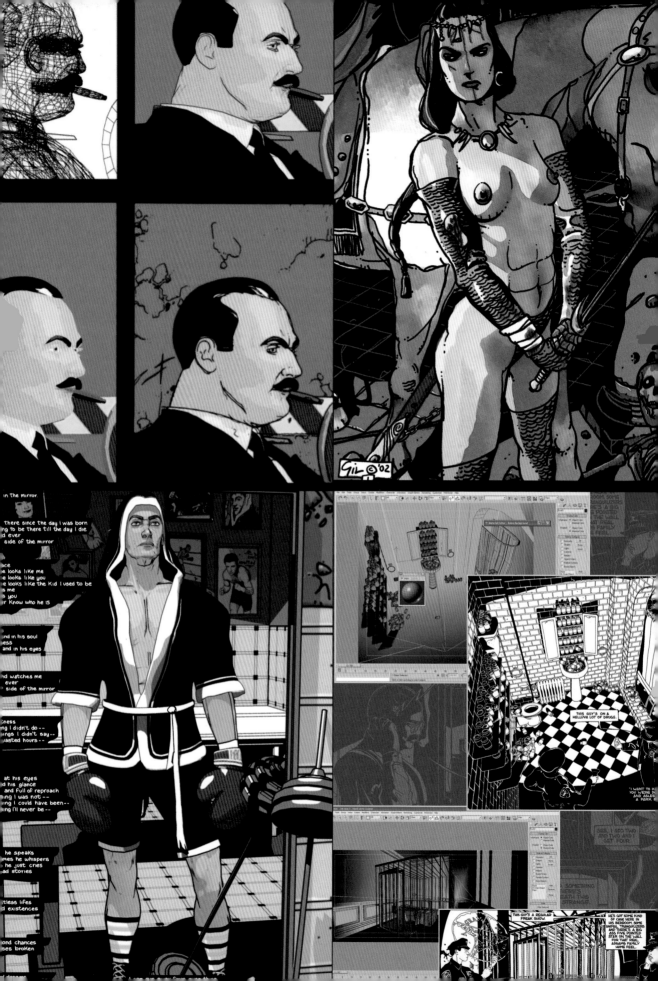

Pixels at Work: The Underdog

Gil Agudin
underdog.dreamcomics.com

The Underdog is exclusively published on the Web.

Where did the idea for the strip come from?

From many places. Graphically, from the great European comic masters: Moebius, Pratt, Manara, Bilal, Tardi, Giménez, Font, and many, many others.

For the story and the concept, I have obvious influences from movies. From old black-and-white boxing and gangsters movies like *The Set-up*, *Body and Soul*, *Requiem for a Heavyweight*, *The Harder They Fall*, or *Champion*, to Sylvester Stallone's *Rocky* (the ultimate underdog).

But I guess that the main idea came from Elia Kazan's *On the Waterfront* and especially from that great scene where Brando tells his brother: "I could have been a contender." I was just a little kid when I first saw that movie, and I couldn't stop thinking how a night like that must have been. The boxer preparing himself for the fight, and suddenly someone he trusts enters the dressing room and tells him "This ain't your night."

A lot of books and writers have also been a big influence in me, from Ayn Rand to Jack London. But basically, I love boxing, and I believe that it is a great metaphor for life. The boxing ring is like life itself. You just have one chance to give your best shot, and you have to choose between your dreams and so many interests that are built around you. *The Underdog* is everybody who fights against all odds and becomes great by never giving up.

How do you use 3D for the strip?

I use a lot of 3D for my comics. I strongly believe that the computer and 3D graphics are just another tool that the artist can use, like he uses his pencil or his brush.

I have been testing with a hybrid style that combines non-photorealistic 3D renders with hand drawings. Lately, I just make some quick 3D scenes with almost no textures and with a single lightsource. Instead of drawing horizon lines and suffering with vanishing points, I use this rough 3D render as a reference for drawing complex perspectives.

I think that the relationship between comics and filmmaking will be more and more strong as artists start using more 3D. With 3D, the comic-book artist is like a movie's director: he has his own sets, his virtual actors and actresses, he sets his cameras and lights, and starts telling a story.

Do you find 3D speeds up your work?

I can't say that 3D speeds up my work. 3D makes some of the tasks easier, but you have to invest time in some other processes, like modeling or texturing. On the other hand, I can say that 3D really improves my image quality.

The whole combination of digital techniques is what speeds up my work. I now work everything digitally. I no longer use pencils, brushes, or paper. From the first sketch to the final image, everything is done on the computer, with the help of a graphic tablet. This has been a revolution in my way of working, and it really has improved my productivity.

Why did you publish to the Internet?

Because it was my only option at the time for showing my work, being independent, and getting feedback. Drawing comics is about telling stories. So the process is not fully complete until the message gets to someone. The Internet is great: You can reach thousands of people without worrying about finding a publisher. The bad news is it's really hard to make any money from it.

What do you think of the Internet with regards to comics?

I believe that we are going to see a lot of comics on the Internet in the near future. There will be just a few with real quality, but I'm positive that some will be revolutionary and really interesting. Publishers are really afraid of taking risks and trying new things. That's why the whole comic industry is in crisis. I really believe that the next step in comics will come from the Internet.

OPPOSITE PAGE: AGUDIN USES 3D TO ASSIST WITH PERSPECTIVE AND CHARACTER DRAWING.

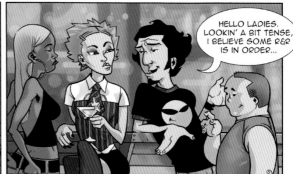

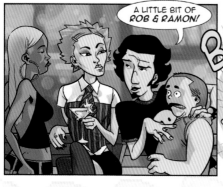

BOOYAH! BUTTERNUTSQUASH. RAMON PEREZ AND ROB COUGHLER.

www.butternutsquash.com.

Play It Again—
But Just a Little Different

Comic strips and cartoons that come back to the same characters and settings always have one thing in common: They repeat drawings of the same things. While views will vary from frame to frame, there will be times when they are pretty close. Computers are perfect for bypassing needless repetitive work. With a few tricks, you can hide the fact that old artwork is being rehashed. For some artist's styles, such reuse may not be acceptable, but for many a hard-pressed comic artist, valuable time saved can mean more of the comic being produced later. To make reuse work, careful planning is critical: You don't want to spend more time hunting for a particular drawing than you would spend drawing it again from scratch.

Along with reuse, there are other ways of saving time or introducing material to your work without actually drawing it yourself. This chapter also discusses montage and digital photography, techniques that use found images and pictures of the real world.

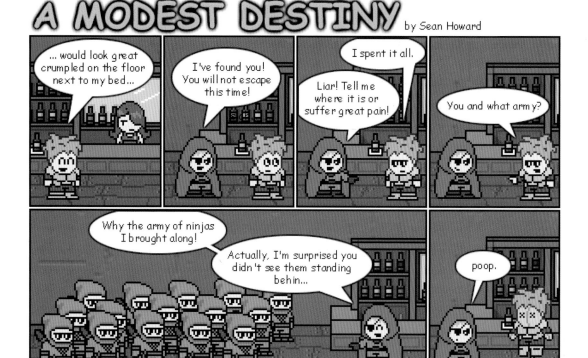

A MODEST DESTINY. SEAN HOWARD. SEAN'S WONDERFUL STRIP, IN A STYLE BASED ON EARLY ADVENTURE COMPUTER GAMES, MAKES OBVIOUS USE OF REUSE.

Looking Ahead for Reuse

> The best medium for reuse has to be 3D, as we saw in the previous chapter, but not everyone finds the time required to set-up and learn the software worthwhile. Don't worry—if you prefer to work with 2D tools, there is still plenty of opportunity to save time through reuse.
>
> Reuse is most effective when you plan for it from the outset.

The melting pot

A comic strip character sitting in a certain chair in a certain room can only be reused as a whole in the same situation. Take him away from the background, out of the chair, behead him, and take out his eyes, however, and you have many component parts with which to rebuild him in a different situation. Such levels of deconstruction work for only some styles of drawing: the simpler the drawing style, the greater the scope for reuse.

Drawing in parts

The most effective way to begin planning for reuse is to draw a thumbnail storyboard of your proposed strip. This is useful for planning the story, and it also allows you to

identify where backgrounds and characters are similar enough in different frames to reuse the artwork. Plan to draw each element of a frame on a different layer in your paint program. Keeping characters and backgrounds separate is an obvious idea, but there may be other elements of the picture that can be isolated and reused in different combinations.

Big background

If you are using the same setting across several frames, look at the way you use backgrounds. You can use a trick common in animation, wherein a larger-than-required background painting is made. For each frame, you can zoom into a smaller section of the background and place your characters in the foreground. This technique works particularly well with vector-based artwork.

Generic background

If your style is relatively simple, paint a few strips of generic background, such as a city skyline, distant mountains, endless repeating rooms, and so on, and then reuse them in all your strips.

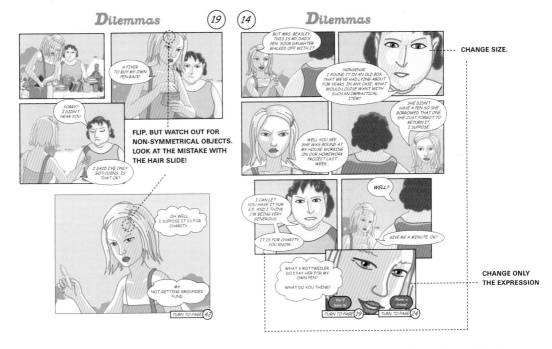

Textures

Always keep an eye out for a good texture, both in your own work, or from the real world through digital photographs. You can link textures to brushes in your paint program or use them in a "hose", through which a series of textures can be brushed onto the canvas in sequence. Again, this technique doesn't fit every style, but it's an effective time-saver when it works.

Expressions

With more economical styles, you can just keep a small bank of face parts with different expressions and use them in much the same way as the 3D morphs I discussed on pages 92 to 93.

The tricks

The problem with reuse is that if you make it too obvious, the reader feels cheated. This is less of a concern with short "gag" cartoons, where repetition is often expected. However, there are a number of ways of hiding your reuse, particularly that of characters. See the example above for a few.

The library

The best way to employ reuse is to create a well-designed library system so that you can locate the drawing you require quickly. This library doesn't need to be complex or difficult to set up—the important thing is that you rigorously categorize each drawing you put into it as soon as you have finished it. It's the kind of thing people say you should do with your accounts. If you don't you just end up with a great pile of paperwork that will never be sorted. The same principle applies here, and for this reason, it is worth having a digital "in-box," so at least you know that if you can't find the picture you want in the library, then it will at least be somewhere in the unsorted pile. Although the main theme of this chapter is reuse, I will also discuss the general organization of your projects on the computer hard drive. How you set up your file systems will depend on how you work, but applying a few rules may save you from scrabbling around in a digital version of the community dump.

Top tools

As an artist, the quickest way to identify what you are looking for is likely to be visual rather than via a long list of incomprehensible file names. Most operating systems come with a thumbnail view and picture viewer as standard, although these can be slow and very basic. It is worth investing in a dedicated picture viewer: They can rattle through a directory, converting images into thumbnails in a matter of seconds. You can then work visually, dragging images from the viewer directly into your paint program.

Picture viewing packages:
Acdsee Classic, **www.acdsystems.com**
Firegraphic XP, **www.firegraphic.com**
Thumbsplus, **www.cerious.com**
iSee X, **www.azinesoftware.com**

Organization

The most obvious way of organizing your work is to place everything relevant to a particular project into a folder dedicated to that title. This is an example of how I would structure it. (The only thing I have left out is Web pages. They are often best managed by the Web-design package you use.)

Deep Sea Star

- Development
- Documents
 - Bin
 - Emails
 - Letters
 - Promo
- Finals
 - Low Res
 - PSD
- In
- Library
- Reference
- Scripts
- Titles
- Working
 - Bin
 - Cover
 - Page_01
 - Page_02
 - Scans

← **DEVELOPMENT:** THIS CONTAINS ALL OF YOUR DEVELOPMENT SKETCHES AND CHARACTER SHEETS. NEVER THROW OUT SKETCHES: ONE DAY YOU MAY BE FAMOUS, AND YOUR EVERY DOODLE WILL BE LIKE GOLD DUST TO FANS.

← **DOCUMENTS:** KEEP ALL OF YOUR PROJECT-RELATED DOCUMENTS HERE. KEEPING EMAILS MAY NOT BE SO IMPORTANT, BECAUSE MOST EMAIL PROGRAMS DO IT AUTOMATICALLY, BUT FOR SAFETY, YOU MAY WANT TO KEEP COPIES OF IMPORTANT ONES HERE.

← **FINALS:** THIS IS WHERE YOU KEEP COMPLETED FULL-RESOLUTION ARTWORK AFTER ALL CHANGES HAVE BEEN MADE. THIS IS EFFECTIVELY SIGNED-OFF ARTWORK IN PSD FORMAT. KEEP A SCREEN-RESOLUTION (72 DPI) JPEG OR GIF COPY TO USE FOR LETTERING (*SEE CHAPTER 9*), TO PRINT FROM QUICKLY, OR TO SEND AS AN EMAIL ATTACHMENT.

← **IN-BOX:** THIS IS WHERE YOU DUMP STUFF WHEN YOU DON'T HAVE TIME TO FIGURE OUT WHERE IT SHOULD GO. DON'T FORGET TO SORT IT OUT OCCASIONALLY!

← **LIBRARY:** SEE OPPOSITE PAGE FOR ORGANIZATIONAL TIPS.

← **REFERENCE:** STORE ANY REFERENCE MATERIAL YOU COLLECT OR ARE USING HERE. SOMETIMES YOU WILL COME ACROSS TECHNICAL HINTS AND TUTORIALS FROM THE WEB. KEEP THOSE LINKS HERE, TOO.

← **SCRIPTS:** THESE INCLUDE STORYBOARDS, IF YOU SCAN THEM INTO THE COMPUTER.

← **TITLES:** A WORKING DIRECTORY FOR COLOR TEXT (TITLES, SOUND EFFECTS, ETC). FINAL TEXT SHOULD BE SIGNED OFF TO THE FINALS FOLDER.

← **WORKING:** THIS IS WHERE YOU WILL BE WORKING MOST OF THE TIME ON LAYERED PHOTOSHOP FILES. NOTE THE "BIN". PUT ALL OF YOUR OLDER VERSIONS, TEST FILES, AND THE HALF-FINISHED JUNK THAT SEEMS TO ACCUMULATE DURING A PROJECT HERE, BUT DON'T MOVE ANYTHING TO THE GARBAGE CAN ANYTHING UNTIL THE PROJECT IS FINISHED. EVEN THEN, IT MAY BE BETTER TO ARCHIVE IT, OR YOU MAY THROW AWAY SOMETHING USEFUL AND IMPORTANT.

Library
 Backgrounds
 Exterior
 Headquarters
 Interior
 Specials
 Characters
 Close
 Full
 Other Costume
 Specials
 Equipment
 Props
 Vehicles

Deep Sea Star

Project Template

Copy of Project Template

→ QUICK TIP: Once you have a directory structure that you're happy with, make a copy of it when it is still empty to store on disk. Next time you start a new project, just make another copy and rename it.

 Shortcut to Deep Sea Star - Working
Shortcut

→ QUICK TIP: Often, as a project advances, you will find yourself needing one folder then another, and regularly running up and down the directory tree can become tiresome. Most operating systems have a "favorites" or "shortcuts" feature. Use it to make a temporary quick-access directory of your working folders. You can always delete it when you have finished.

↑ THIS IS AN EXAMPLE OF A LIBRARY SYSTEM BASED ON SUBJECT. YOU MAY PREFER AN ALPHABETICAL SYSTEM. TRY TO KEEP IT REASONABLY SIMPLE TO AVOID HAVING TO READ HUGE LISTS OF FOLDERS, AND AVOID HAVING TOO MANY FOLDERS WITHIN FOLDERS BECAUSE SCROLLING DOWN THROUGH SUBDIRECTORIES CAN GET TEDIOUS.

SOME ITEMS MAY BE GENERIC AND USABLE IN ANY PROJECT. THE ANSWER HERE IS TO COPY THE ITEM INTO A SEPARATE LIBRARY SPECIFICALLY FOR GENERIC MATERIAL. YOU COULD JUST MOVE IT, BUT COPYING IT GIVES YOU PEACE OF MIND THAT ANY MATERIAL USED IN A PROJECT WILL ALWAYS BE FOUND IN THE PROJECT DIRECTORY.

→ **NOT A TIP: THE LAW!**
Now that you have all your eggs in one basket, back up, back up, back up!

→ **QUICK TIP: Keep a small text file in each directory to log any notes, phone numbers, addresses, problem pages, dates, and so on.**

LUNARCADAVER. JASEN LEX. JASON'S WORK USES A COMBINATION OF DRAWING AND PHOTOMONTAGE. HERE WE SEE THE STAGES INVOLVED IN CREATING A SINGLE IMAGE.

Montage

Max Ernst, one of the earliest surrealists, started montage in the 1920s, when he began cutting up contemporary engravings and rearranging them into new and haunting images. With the advent of digital manipulation and programs like Photoshop, montage, collage and photomontage have become easier to create and incredibly flexible. Montage techniques work well with gag cartoons, because digital tools can easily distort real characters into cartoon proportions. It's more difficult when using found images in strips, for the practical reason that, although it's easy to find one picture of something, finding several from different angles and poses is not so easy. In this instance, photomontage works better if you have willing models to photograph.

Montage uses many different techniques, from simple cutting-out, rotation, and scaling of picture elements, to advanced use of various Photoshop filters. To properly discuss these techniques would require an entire book to itself, and many such titles are available.

The basic building block of montage is the found image. If this is a technique that interests you, you really should create a coherent library that is searchable on subject matter. Your library may also need to contain images of props and costumes.

If you are collecting scans and digital photographs for your library, always take them at the highest possible resolution, higher even than 300 dpi. Typically, when you come to use the picture, you will want to extract just one part of it, and the higher the resolution of the whole, the smaller the piece can be before pixelation becomes a problem.

ABOVE: *UNIFORMS.* RICHARD CAMPS. **www.galumpia.co.uk**. RICHARD HAS BEEN TEARING UP AND REARRANGING PHOTOGRAPHS FOR YEARS TO CREATE CARICATURES AND FUNNY ILLUSTRATIONS.

LEFT: *YOU AREN'T ALLOWED TO THINK THAT WAY.* PAUL LEVY. **www.hippiehop.com**. PAUL MAKES CONSIDERABLE USE OF PHOTOSHOP FILTERS TO PUSH THE LIMITS OF THE IMAGE TO THE POINT OF ABSTRACTION.

Excuse me, miss? Hmm?

Hello again! Oh! Hi!

For my late wife, there is retrospective show at gallery. Opening is tonight. I think maybe you like to come?

Oh gosh, sure! Thanks!

Also, I ask maybe you do me favor: print this roll, and deliver to me there tonight. I pay up front, plus extra. Yes?

Sure, I can do that. No problem.

DAISY PAPAVASILIOU 1971-2001 SCANDALI GALLERY

Wonderful! Here is money. I be seeing you!

Eighteen minutes later...

110

Listen, I think I having job for you. You free at nights?

Um, sure, nights are fine...

Wonderful! Listen, I have son, he is very sick, cannot walk. My wife, she is dying recently, so... you see.

Oh, I get it. You just want a girl babysitter!

No, no, I make it worth your while! You use my darkroom, paper, chemicals. Make big prints. Plus good wage.

Hmm, that does sweeten the pot. Okay! It's a deal.

You can starting tomorrow?

Later...

RRING

Hello?

Uh, hi, it's Huey. I, uh...what are you up to?

Pixels at Work: Shutterbug Follies

Jason Little
www.beecomix.com

Shutterbug Follies went into print after a successful run as a Web comic on Jason's Beecomix site.

Did the book come about as a result of the Web comic?

No, not really. My publisher bought the book based on a pitch I made, not having seen it on the Web. I designed the book for print, but put it on the Web in order to build an audience. I was implementing a principle I'd read about in *Wired* that can be summarized as "give it to 'em for free, then take it away and charge 'em for it."

Why publish on the Web?

Shutterbug Follies was designed to build suspense and interest over a series of weekly episodes, so I felt that the Web was a fine place to present it. It appeared simultaneously in a couple of alternative news weeklies—the *New York Press* and the *Ripsaw News*. Note that Bee also won the Ignatz award for best Web comic at the Small Press Expo in 2002.

Are there any technical points you'd like to mention?

I find that maintaining a database of regular readers is extremely helpful. Readers can receive weekly email reminders. As a reader, getting a reminder is the only thing that will ensure I read a weekly episode.

SHUTTERBUG FOLLIES ON THE WEB.

SHUTTERBUG FOLLIES IN PRINT

9

Say What?!

Comic-strip and cartoon lettering has always emphasized and exaggerated the meaning in words using extra visual clues, from the shape of balloons to the size and shape of the letters themselves. Fascinating conventions have developed in comics that don't exist in any other literary or visual mediums. Nowhere but in the cartoon frame can you read or see sounds as raw, expressive artistic elements in themselves. Shouts, whispers, cracks, pops, and jaw-breaking thumps are all integrated with dynamic visual clues that make them audible to the reader's imagination. Even the gurgling, fetid, fume-laden utterances of the average zombie have their own equally putrid and decaying font.

Computers have become invaluable to the process of comic-book lettering. Most comics and cartoons are lettered using computer fonts, with the exception of a few where hand-lettering is an integral part of the art itself. There is a huge selection of computer fonts available, and placing text into balloons is as flexible and easy as using a word processor. Yet although the process seems simple, there are technical and aesthetic issues to consider, as you'll find in the next few pages.

Balloons

Before the words come the balloons, perhaps the most clever and efficient comic convention of all. They neatly package up characters' speech in a breath that floats above their heads, with a tail to remind you who uttered it. The convention goes further, in that every reader knows the main variants: the spiky shout, the dotted-line whisper, and the dreamy thinking cloud. Many other variations are possible; some you can create within your own strip—boxy robot talk, fizzy radio transmissions, sleepy wavy lines of the temptress, or the dripping goo of the melting man.

Planning balloons

Thinking about balloons should be a part of your initial planning at storyboard. The more text that has to go into a particular frame, the more important this becomes. A long explanation by a character can take up more than half the allocated frame space.

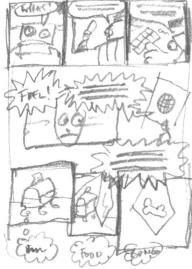

SKETCHED STORYBOARD WITH THE APPROXIMATE SIZE OF BALLOONS INCLUDED IN THE DESIGN

- If possible, always make artwork separate from the lettering. This builds in flexibility and allows for translation at a later date.
- When two characters are talking, avoid letting balloons interfere with their eye contact or split the frame in half. It is better to place them above or below the characters.
- Avoid long dialogues using joined frames.

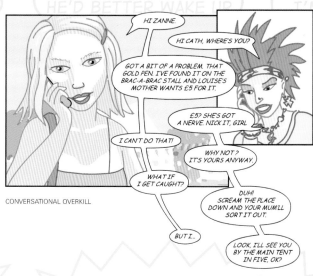

CONVERSATIONAL OVERKILL

- Make tails and connectors between balloons flow naturally and point toward the character's mouth.
- Leave plenty of space for balloons. Make them bigger to allow more room around the words. Apart from avoiding cramped reading, this leaves space for translation into other languages that require more space than the original text.

Basic balloons

The best programs for drawing balloons and lettering are vector based. If your artwork is bitmap, you will have to import it into a vector program. Import a reduced-size copy of the artwork, say at 72 dpi, so that the computer can work faster. Once positioned on the page, lock its layer and begin a new layer named "balloons." Open a third layer and name it "lettering."

↑ Type the dialogue into the "lettering" layer. This will give you a rough idea of how large the balloon needs to be. Temporarily lock the layer. In the "balloon" layer, use the *Circle* tool to draw around it with *Fill* set to white and *Stroke* to black. For color comics, *Stroke* should be set to *Overprint*.

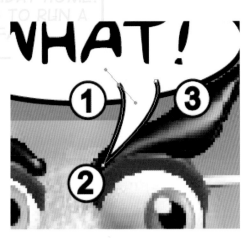

↑ Draw a tail using the *Pen* tool: Click first inside the balloon (1) and drag down while still holding the mouse down. The dragging tells the next line to make a curve. Then click once at the tail's sharp end (2). Now click at the final position (3) and drag up. You should end up with a nicely curved tail.

↑ Select both the tail and the balloon and choose *Unite* in the *Pathfinder* palette. You can adjust the shape of the balloon and tail using the *Point* edit tool and Bezier line handles.

↑ To clip a balloon to the edge of a panel, draw a box over the excess area, and send it to the back. Choose *Minus Back* in the *Pathfinder* palette to snip it off.
- Use the *Unite* tool to merge several balloons or link them with tails.
- Use the *Pen* tool to create irregularly shaped balloons.

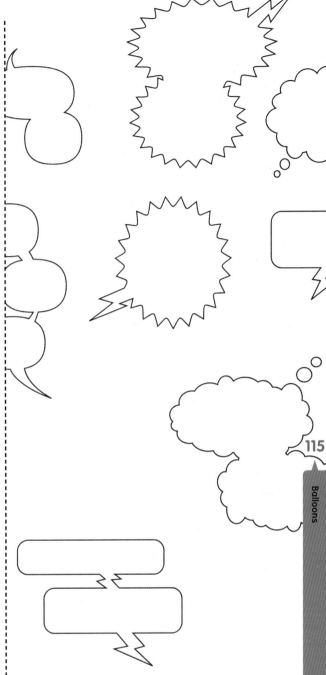

READY-MADE BALLOONS FROM BLAMBOT. **www.blambot.com**.

No balloons

Some artists find balloons too intrusive and place the text on the artwork instead. If you do this, position the text so that it is obvious who is talking, and make sure it's placed against a contrasting background so that it can be read clearly.

Flashy balloons

If you have an interactive Flash-based comic, you can have a lot of fun with animated or rollover balloons that are revealed as the mouse travels over a character.

MUMMY LOVES YOU

DAVEGIBBONS

FANBOY HARDCORE

YadaYadaYada

LADRONN

Mighty ZEO

MOUTHBREATHER

Comicrazy

KISSANDTELL

ANIME ACE

ARCANUM

ADAMKUBERT

CUTTHROAT

DigitalDelivery

Digital STRIP!

CASKET BREATH

RED LETTERING: A SMALL SAMPLE OF DIALOGUE FONTS FROM COMICRAFT, WHICH ARE SOLD BOTH AS DOWNLOADS AND AS CD COLLECTIONS. WWW.COMICBOOKFONTS.COM. PURPLE LETTERING: A FEW OF THE MANY FREE FONTS AVAILABLE FROM BLAMBOT. WWW.BLAMBOT.COM

JEFFCAMPBELL

Lettering

The style of comics lettering is another convention that is instantly recognizable. It grew out of the necessity for hand-lettering on artwork: it was much quicker to letter by hand than create awkward trays of lead type to fit the variable shapes and positions of dialogue balloons. The style also suited the more relaxed subjects in comics, and sat well visually with the artwork.

Choose your type

Even within the area of comics lettering, there are many styles from which to choose. What you settle for will depend on the requirements of the story, whether it's for print or for the Web, and how much you can afford. There are many free fonts on the Internet, while companies such as Blambot and Comicraft provide excellent font sets—and even predrawn balloons—at reasonable prices. For a truly individual style, you can even commission an original design.

Hand lettering

It seems crazy to go back to hand lettering when using fonts is so easy, but many artists still do. The slight mistakes and variations unique to hand lettering gives it a human touch that the computer cannot match. If you have the patience, you can also convert your own lettering into standard vector fonts using programs like Type Tool and Fontographer. Hand lettering is the only way to go if you want the freedom to experiment with new design ideas, the only proviso being to keep it clear and readable. When you combine hand lettering with your artwork on computer, you should scan it at a minimum of 600 dpi. Push the contrast up in Photoshop and convert the text to a 2-bit black-and-white image. You may also want to take a little time cleaning it up. It is important to keep the lettering separate from the artwork, and the balloons too, if possible.

> → QUICK TIP: If you find your collection of computer fonts growing so large that you can't remember what's what, print out some sample text in each face at various point sizes. Looking at printed examples is a much better way to get a feel for type styles than looking at them on-screen.

TYPETOOL FONTLAB. WWW.FONTLAB.COM

...IT'S FIXED! HAPPINESS REIGNS!

MY KERNING'S GONE ALL FUNNY

...AND HERE'S THE GOOD LEADING

HERE'S THE BAD LEADING

TRACKING'S A BIT ROUGH, EH?

THAT'S MUCH BETTER

The art of typography

Computers will not make a good letterer out of you. To make your text clear, easy to read, and pleasing to the eye, you must look to the traditional artistic skills of typography. A good graphics program like Illustrator will give you access to all size, leading, tracking and kerning controls. Learn what they do and make use of them.

Font size

Font size can vary depending on the space available, the artwork, and the quantity of text in the story. Once you settle on a size, it should remain the same throughout, except for special purposes such as shouting. For print, lettering can go down to 6.35 point and up to 7.5 point. The larger size is advisable for Web publishing, to allow for clarity on the screen.

The final package

The best way to combine lettering with artwork is in a desktop publishing program, such as QuarkXPress or Adobe InDesign. If you are working for a print publisher, they may well deal with this stage, and if you are having your strip printed yourself, you should discuss with the printer how best to prepare it.

TRACKING: TRACKING IS THE SPACING OF ALL THE LETTERS. USUALLY THIS CAN BE LEFT ON AUTOMATIC. HOWEVER, IT CAN BE INCREASED TO SHOW A CHARACTER S P E L L I N G S O M E T H I N G O U T.

LEADING: LEADING IS THE SPACE BETWEEN LINES. THIS CAN BE BASED, MORE OR LESS, ON THE CHOSEN FONT SIZE. SIMPLY MAKE IT THE FONT SIZE PLUS 0.5 POINT.

KERNING: KERNING IS THE SPACE BETWEEN THE LETTERS. YOU WILL NOTICE BAD KERNING WHEN LETTERS APPEAR TOO CLOSE OR TOO FAR AWAY FROM EACH OTHER, TO THE POINT WHERE THEY COULD BE CONFUSED FOR A SPACE BETWEEN WORDS. GOOD KERNING CHECKS FOR THE RELATIONSHIP BETWEEN DIFFERENT PAIRS OF LETTERS, NUDGING AN A CLOSER TO A T, OR GIVING AN I A LITTLE MORE BREATHING ROOM. FOR STANDARD DIALOGUE TEXT, THE PROGRAM'S AUTO-KERN FEATURE IS ADEQUATE, AND ANY AREAS OF POOR KERNING WILL NOT BE PARTICULARLY NOTICEABLE. WATCH OUT FOR FREE FONTS, WHERE THE KERNING INFORMATION IS OFTEN NEGLECTED.

Transferring artwork and text between programs or to a printer can be confusing and frustrating because fonts may not transfer properly. To avoid this, you can make the fonts into pure vector outlines in Illustrator, by choosing *Create Outlines* from the *Text* menu. Only do so after making a backup of the file—it's irreversible and you will not be able to edit the text again.

Page layout programs:
QuarkXPress, **www.quark.com**
Adobe InDesign, **www.adobe.com**
Serif Page Plus, **www.serif.com**

Big Noises

The most exciting area of lettering has to be sound effects, where you can use every visual and onomatopoeic expression you can think of to turn up the volume. There are no rules—you don't even need to worry about reading clarity—so long as it looks like it sounds. As always, it's best to sketch out your ideas on paper before you invest any time on the computer.

LEFT: *SPYBOY.* POP MHAN. DARK HORSE COMICS.
ABOVE: A SELECTION OF COMICRAFT'S SOUND-EFFECT FONTS.

Sound-effect fonts

There are a number of sound-effect fonts available for sale or free on the Net, but you can also have a lot of fun editing regular fonts.

WHOOP ASS
DAMN NOISY KIDS
ARMOR PIECING
RADIO ACTIVE GRANNY
12 TON SUSHI

SOME OF BLAMBOT'S FREE SOUND-EFFECT FONTS.

Making a noise

The first step is to type out the text and convert it into outline art. In Illustrator, you do this via *Menu > Type > Create Outlines*. After conversion, however, you will no longer be able to edit the text as text.

- Have the letters overlap each other a little.
- Give direction to sound to show where it emanates from. Think about where it starts and finishes, and don't be afraid to move away from the horizontal.
- Make some letters larger than others to emphasize "shape." A THUMP starts small and abruptly ends much larger. Some sounds, like bullets zipping past, are small and thin, whereas others, such as crashes or explosions, are big and jumbled up.

- Follow the sound: With a sweeping punch to the jaw, the letters could follow the lines of the fist in motion to end with a CRACK! on the jaw.

 - In tight spaces you can always stack your letters.
 - Play with the *Free Distort* tool in Illustrator to warp your lettering.
 - Take care not to overdo it. If there are too many sounds in too small an area, it becomes impossible to distinguish one from another.
 - Don't forget the little sounds.

ABSOLUTELYFABULOUS!

DESTROYER

IncyWincySpider

ACHTUNGBABY

STANDBY4ACTION!

Thingamajig

area51

A FEW OF COMICRAFT'S DISPLAY FONTS.

Titles

You'll need display lettering for the title of the project, the story's subtitle, and the chapter titles, if any. And the artists' credits, of course!

Title design is very important. It's part of the "branding" of the project or the character, as well as being an instant signal to the comic's potential buyers. Your titles have to weather and adapt to the vagaries of fashion as well as grab the attention— even comic books follow trends!

DRAWING YOUR OWN: ALTHOUGH DRAWING YOUR OWN SOUND EFFECTS CAN TAKE A WHILE, YOU CAN BE ADVENTUROUS WITH THEM. SKETCH OUT YOUR IDEA AND SCAN IT INTO ILLUSTRATOR TO USE AS A TEMPLATE. USE THE *PEN* TOOL TO DRAW THE OUTLINE ON A DIFFERENT LAYER.

COLORING SOUND EFFECTS: YOU CAN ACHIEVE A NUMBER OF EFFECTS BY USING DIFFERENT STROKE WEIGHTS, THE *COPY* AND *PASTE IN PLACE* (CTRL + F) COMMAND, AND LAYERS. IF YOUR EFFECTS OR LETTERS ARE COMPOSED OF SEPARATE OBJECTS, DON'T FORGET TO GROUP THEM BEFORE MOVING THEM AROUND LAYERS.

Pixels at Work: Blambot

Nate Piekos
www.blambot.com

Nate Piekos runs Blambot, a professional comics lettering company.

With digital comics fonts available, is there ever a reason to hand letter?

Increasingly, the answer to that question is "no." Publishers are interested primarily in speed. How fast can the book be put together to meet the deadlines? Hand lettering is a more laborious process and generally costs more for the publisher. Although that's good news for people like me, it's also unfortunate because hand lettering is an important part of our heritage. The hand letterers are the real inspiration—for me, anyway. These days anyone can letter a book with a computer and some fonts and call themselves a letterer. But the mark of a good letterer is his or her ability as a graphic designer. It's all about graphic design: knowing what works and what doesn't, knowing how to complement the art, and knowing how to pace things visually. Understanding what fonts work best in relation to the story. Is it creepy? Is it high tech? How can the title graphics be really effective but not overpowering? Unless a letterer has a very solid grasp of graphic design, he or she will do more harm than good.

Are there any special tips for artists planning to publish on the Web with regard to lettering?

Legibility. That is absolutely the number one concern. You're going to have to sacrifice a little bit of style for a little more legibility, because we're not talking about the printed page, which is generally between 400 and 600 dpi. We're talking a computer GIF or JPEG online, optimized to load fast. So we're talking about 72 to 300 dpi, generally. The viewer needs to be able to read it without struggling against the effects of pixelation. To my knowledge, I'm the only comic font designer who has made a conscious effort to design some fonts specifically for Web comics. In fact, a Web comics font I created, Digital Strip, is the most

popular font on my website. I did a lot of research, and many, many of the regulars on my bulletin board are Web comic creators. So I got a lot of input about my Web comic fonts.

What are the worst mistakes you see others making?

Lettering a comic without a developed sense of graphic design. Approaching that step of the process as, "OK, I'll just make a circle here, type some dialogue in and move on to the next thing." It shows. And it can destroy your comic, visually. A lot of novices are just learning, so there's no blame, but if you've spent any length of time in the "biz" you really have no excuse for not bettering yourself.

What's the bottom line for those reading who want their comics lettering to work?

Do a good job, do it efficiently, and don't sell yourself short. Study the design of everything around you (comics is such a tiny portion of the art world!) And remember... being a letterer is like

BiG BLOke BB
DETECTIVES INC.
BLAMDUDE BB
cajun boogie
MARS POLICE
PYTHIA
GUNHEAD CHICK
ORANGE FIZZ

A SELECTION FROM BLAMBOT'S DISPLAY FONTS.

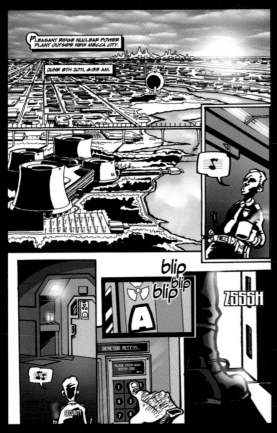

LINT MCCREE MYSTERIES. NATE PIEKOS. **www.piekosarts.com.**

being a ninja. You don't want to jar the reader out of the story—you want to be subtle. Get in there quietly, complete your mission without stirring the guards, and slip away! The people who appreciate good lettering will go back and say, "'Hey! That letterer was goooooood!"

On comics generally, how do you see the influence of the electronics revolution on the industry?

It's already had a massive effect. HUGE. I'd say if every computer in the world stopped booting up tomorrow, things would grind to a halt. Writers use word-processing programs. Many artists touch up their work in Photoshop before it gets emailed to the editor. Almost all colorists do their colors and separations in Photoshop. Letterers use Adobe Illustrator and Quark. It would take a while before a lot of people figured out how to do it old-school again!

Do you think that selling comics online has a future?

I think it even has a present! Lots of the people who visit Blambot every day are Web artists and some of them are even selling their work. Chris Mills, an amazing writer and editor, is doing great things at adventurestrips.com. And you have other sites like moderntales.com, komicwerks.com, and so on. They are all doing some good stuff. What really makes me mad is the artists who think that, because they're Web-based, they aren't as "valid" as print artists. Rubbish, I say! You're entertaining people just as much as a print book, and heck, you're saving some trees in the process! A good comic is a good comic, whether online or in a mylar bag. And an artist should be able to feed a family with his or her talents.

Is there anything in particular with the Web that's really exciting for the comic artist?

Exposure. That's tops. Anyone with basic coding knowledge can put up a site and potentially have exposure to the entire planet. That wasn't so easy just a couple of decades ago. Networking is key, as well. It's now so easy to communicate. Creative teams don't even have to be in the same country anymore, never mind the same room.

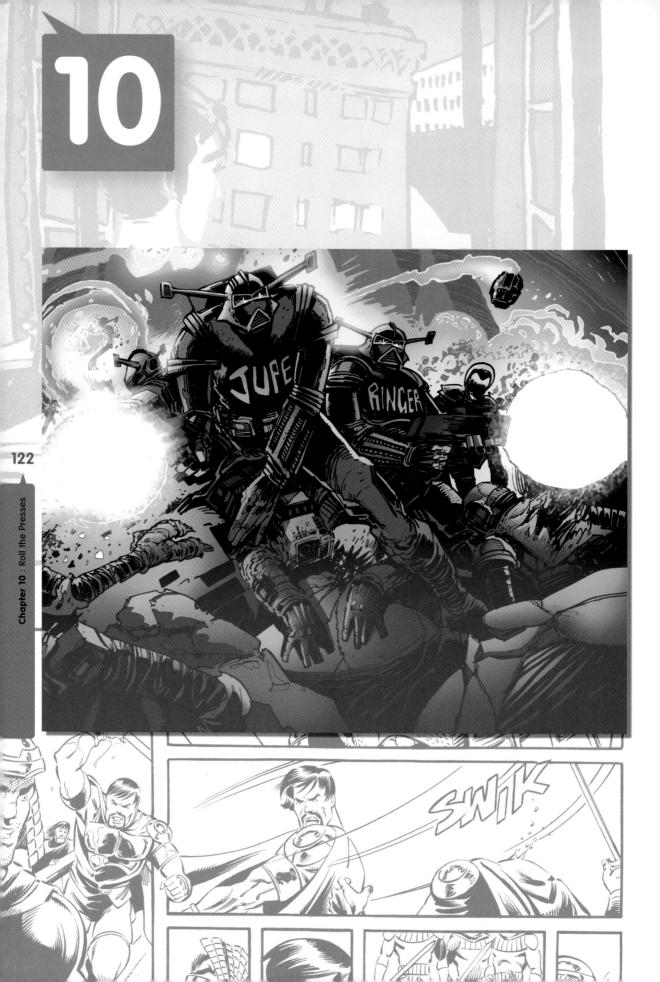

Roll the Presses

NOK KNOK

"MR. NORMAL? IT'S ROY COYNE. WE SPOKE OVER THE PHONE THIS MORNING. I'D

With your artwork disc under your arm, you knock at the door of Giant Comix, Inc. confident that a glowing future lies within. Before you strike out, it's worth knowing something about how the publishing industry works. You should also understand what your alternatives are if you aren't feeling confident, or if traditional publishing isn't the way you want to go.

On the downside, there is a lot of competition out there from other hopefuls entering the market, not to mention established artists, but don't let that discourage you. Comic-book publishing has seen a number of changes in recent times: The superhero genre has had to change and innovate, and the new breed of alternative comics has become increasingly popular. New technologies that allow small print runs are slowly becoming more common, allowing the less well-known to see their work on the shelves, potentially breaking the corporate stranglehold. On a smaller scale, even the cheapest personal printers produce high-quality output, making everyone a potential self-publisher.

Getting Started in the Traditional Business

If you are starting out and want to get your work into print, there are a few avenues to try. The obvious and most coveted option is to become a regular artist working for one of the big established publishers. However, this is also the most difficult route. Some publishers will not even consider seeing new artists, whereas others groan under the weight of unsolicited submissions. There are other ways of getting your work published, and publish you must if you are to break the classic catch-22 of comic art: You can't get into print if you've never been printed.

Working for free: 1

There are always opportunities to work for free, and this does get your work into print. College newspapers, fanzines, club flyers, a friend's tattoo…all have the potential of getting your work more exposure until the day a famous Hollywood studio head sees it and declares it the next blockbuster. What's more likely to happen, however, is that you'll just get more requests to do free work. Make sure you don't commit yourself to 200 issues of the local church newsletter.

Working for free: 2

At some time, you may be asked to collaborate on a project that you find interesting and that could give you good exposure. Be wary of these, however: There are many writers and producers looking to get their pet ideas off the ground, but who lack the artistic skills to produce anything themselves. A tiny handful of these projects may succeed, but the majority will fail, so whether you want to take the gamble is up to you. Before you embark on any such work, make sure you have a legal agreement in place between you and your collaborator to provide you with a fair cut of the booty in case the project becomes a success.

Unexpected publications

Small trade magazines are a good place to find paid slots for your work, particularly comic shorts and cartoons. You may not think a career can start on the back page of *Plumbing Monthly* or *Classic Factory Roofing Quarterly*, but these can be good training grounds, and the readers often appreciate a little light relief. Many of these publications are not visible in the mainstream bookstores, and you may have to hunt them down through the Internet.

Unexpected objects

If you look closely, cartoon drawing appears on all kinds of products and packaging, from cereal boxes to underpants, aircraft-escape instructions to children's toys. Although this work is usually done under very strict client control, the majority of such projects are well paid and fun to do. Virtually the only way to get your foot in the door is by contacting an artist's agent or by

random frog children

KEVIN K HANNA
FROGCHILDREN.COM

FROGCHILDREN. KEVIN HANNA.

advertising your services on Internet portfolio sites, some of which specialize in cartoon styles. Competition for such work— especially in advertising where the rates of pay are relatively high—is fierce, and there are many cartoonists already in the market.

Illustration agencies

Joining an illustration agency is another possible route into the business, but this approach can suffer from the same catch-22 mentioned above: Certain agents will only take you on their books once you have proven yourself with work in print (or on-screen, on a prestigious website). Some agents, however, will take on very talented artists without previous experience.

The advantage of joining an agency is that you have someone else doing the legwork—taking your portfolio to clients and drawing on established lists of contacts. They fight in your corner when negotiating better fees and terms, and they can comb complex contracts for unfair clauses. The disadvantages start with agent's fees, which are typically as much as 30%. They are also an extra layer between you and the client, which means that communication can be more like playing Chinese Whispers on the telephone. If you are unlucky, you might also get a bad agent who fails to give your work exposure or who just lounges around taking a cut on any subsequent work with an established client.

Deciding to work with an agent is a matter of personal choice, and of weighing the pros and cons. Agents are usually more useful where many small,

GOLD RUSH. MARTIN MCKENNA. **www.flyingsaucersoftware**. MARTIN'S CARTOONS FOR A PUB VIDEO GAME.

quick-turnover jobs with several clients are involved. An artist who typically works on single, large projects like long-form books would probably need only one or two clients, and once these are established, the agent becomes redundant.

The best way to find agents is via the *Writers' Market* or the *Artists' Market*, either of which can be purchased through the usual Internet bookshops.

LOOK & FIND. MARTIN MCKENNA. A SCROLLING IMAGE FOR A CHILDREN'S TOY.

Established Publishers

In any commercial venture, there is a manufacture-and-supply chain to the final user of the product. The comics and cartoons industry is no different. The creator's work is passed through publishers, printers, distributors, and retailers before finally landing in the hands of the reader. Such structures come about because of cost. As with any print-based industry, the cost of printing and distributing comics is one that few creators can bear, so publishers step in and effectively act as business investors. They also perform many more tasks, including organization, editing, design, pre-production work and, most important, marketing and publicity.

REX MUNDI. ARVID NELSON, ERIC J AND JEROMY COX. IMAGE COMICS.

126 How to start

You want to get your work in front of an editor, perhaps on the desk of the editor-in-chief of one of the big publishing houses. But before you even think about approaching a publisher, step back from your work and ask yourself a few tough questions. How good is your work, really? At the top end of the industry, the standard is jaw-dropping, and you will be going up against these people. You may be too close to your work to judge it objectively, so it may help to seek an appraisal from someone who can give you an informed opinion—perhaps another working cartoonist or a tutor from a local art school, but not your mother or your best friend.

Your work must be able to fulfill the following criteria:

- You can tell and draw a story.
- You can draw characters and backgrounds consistently from frame to frame, in different poses and from varied angles.
- If your comic is naturalistic, your drawing of the human figure must be good.
- You grab the reader's attention and keep them turning the pages.

If your work is lacking on any of these points, you are not ready to approach a publisher. This doesn't mean that you never will be; it simply means that you have to go back to the drawing board and work hard at improving the weaker aspects of your skills.

Once you are ready to take the plunge, you need to make sure that you direct your work at the right publisher. You don't want to waste everyone's time by sending your ideas for a skull-crushing antihero to the publisher of a preschool weekly.

Don't forget smaller publishers. There may be one that is flexible enough to recognize the talent in your work, and they may be more likely to take on a new artist.

Once you've targeted a handful of possible publishers, do your research. Most of the larger publishers have fixed policies regarding unsolicited submissions, which they post on their websites. Some publishers simply refuse to see any new artists. This may seem harsh, but many already have an established stable of artists and just don't need to look elsewhere.

If you are applying to an established publisher, such as DC or Marvel, send a short, polite cover letter with your samples.

NEVERMEN STREETS OF BLOOD. GUY DAVIS. DARK HORSE COMICS.

DURHAM RED. MARK HARRISON. 2000AD.

Trade shows

Comic-book trade shows are held all over the world, and these are the best places to learn more about the industry and make all-important contacts. It is also the most efficient way to show your work to many publishers at once. They often run portfolio workshops and critiques where you can show your work directly to the commissioning editors. A few big publishers will see artists' work only in this way.

Prepare yourself before you go by doing the research discussed above and setting yourself a rough schedule. Have a good stash of business cards to hand out to everyone you can. At the critique, be sure to make notes on the advice given and gently press the adviser for contact information so that you can reach him or her when you have new and improved work to show. This is especially important if you have a long-form comic idea that needs time for the reader to get into the story. Anything you take to a trade show needs to have instant impact, but the true potential of your work might not sink in during the limited time available.

The killer presentation

- You need to put together a portfolio to take to publishers or trade shows. Slim your work down to about 10 to 15 of your best pieces. The chosen pieces should clearly demonstrate the points discussed earlier.

- Make the pieces no larger than the actual comic even if you draw in enlargement. Display it in a small, neat, compact folder. You don't want to lug a huge folder around, and the editors don't want it all over their crowded desks, knocking their coffee over.

- Experiment with different printouts, but be careful about printing onto glossy photo paper. It may look gorgeous in your dimly lit back room, but on the trade-show floor you may find that the reflections are so dazzling, no one can see the work.

- Have something to leave behind—at the very least a business card, but perhaps a mini-comic, a flyer, a small poster, a card cutout of your character, a decorated calendar, and so on. You never know—a couple of weeks later it may serve to jog a memory.

Pixels at Work: 2000 AD

Matt Smith, Editor
www.2000adonline.com

The British weekly comic, *2000 AD*, first appeared in 1977 to appeal to teenage boys' growing interest in sci-fi. It brought a fresh visual style to the comics world, and established a number of very successful characters, including the infamous *Judge Dredd*. Its brand of irreverent violent action has grown with its audience into the adult *2000 AD* of today.

JUDGE DREDD. JOCK AND CHRIS BLYTHE.

How do you like work to be presented—digital or old-fashioned pen and ink?

We don't generally ask for artwork to be presented in a specific manner. More and more artists are supplying their artwork on CD because it's cheaper to ship; the art doesn't have to leave their home and risk getting lost in the mail; and a lot of them are using Photoshop to color pages. But there are still artists who supply penciled and inked—or even painted—physical artwork. It's important for *2000 AD*, as an anthology comic, to have a variety of styles in the artwork, rather than it all looking uniform, so there is always a place for computer-colored artwork, fully painted pages, and detailed black-and-white linework.

Do many of your artists work on computer?

Yes, an increasing number, and mostly for coloring. But some—like Mark Harrison (*Durham Red*) or Clint Langley (*Slaine*)—do nearly all their work this way, creating an individual style by fusing paint and pixels.

How do you deal with submissions from aspiring artists?

2000 AD does receive a lot of art submissions, most of which are not nearly ready to see publication in the comic. Whether their inking needs further work, or their human figure-drawing is wonky, it's a case of "keep on practicing." Constraints on time mean that I can reply only with a brief letter, but I try to point out the art's weak points. A lot of the time, it's a case of the prospective artist needing to read the submission guidelines and showing me they can tell a story rather than paint a lot of pretty pin-ups. If the aspiring artist shows potential, I give them a sample script, to see how they do with sequential storytelling.

How do you find new artists?

A few artists might come out of the submissions pile; others might show me their work at comic conventions, such as the main British one which takes place in Bristol. Some might have done work in America and would like to try their hand working for *2000 AD*.

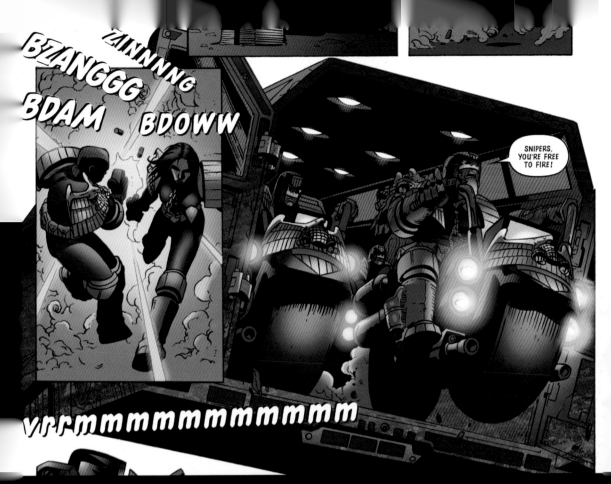

JUDGE DREDD. WAYNE REYNOLDS, LEE TOWNSEND AND CHRIS BLYTHE.

Unfortunately, there is only a finite number of scripts around and lots of freelance artists looking for work, so there's not always work available.

Do you have a fixed page rate?

For newbie artists, the starting rate for black and white is £120 ($180) per page; for color, it's £170 ($260). There's a sliding scale for different artists—more experienced and talented artists have a higher page rate.

What is your policy on copyright?

Virtually all stories published in *2000 AD* are owned by the its parent company, Rebellion. There have been a few instances of creator-owned stories in *2000 AD*—*Button Man*, *Mazeworld*—but by and large, the copyright on the story rests with the publisher. When a new story is commissioned, we have

How do you see the comic market both now and in the future?

As far as Britain is concerned, the comics market is very small. When *2000 AD* was first published in 1977, it was aimed at boys aged 8 to 11, and sold about 100,000 copies a week at its height. Now, our readers are in their mid-twenties and the comic's readership has narrowed considerably—it seems that kids have far more distractions now (PlayStations, etc.) for comics to make much of a dent in their attention. *2000 AD* needs a breakout hit—the same way Marvel has had with the *Spider-Man* and *X-Men* films—to bring the comic to wider audience. Rebellion's *Dredd vs Death* computer game may bring attention back to the comic, and more *Dredd* films are in the development stage. 2000 AD has an enormous number of intellectual properties, which if exploited would broaden interest in the British comics market

The Grand Opus

Many cartoonists make careers of working on licensed characters under the watchful eye of a publisher or client, drawing exactly as they ask with limited latitude. At the same time, most will harbor a nagging desire to write and illustrate their own story, their great work of self-expression. There are various ways of fulfilling this urge.

REX MUNDI COVER. ARVID NELSON, ERICJ, AND JEROMY COX. IMAGE COMICS.

Pre-funding

The first way is to complete a script of an entire story, illustrate a couple of sample spreads and a cover, and take it to a publisher to ask for an advance to fund your time to finish the project. Persuading a publisher to take this risk may prove difficult unless they are already confident in your work. In providing you with advance funding, they may well want some or all of the rights, and you can expect a degree of editorial interference. For further security, a publisher may also sell the project to publishers in other countries (provided you have signed over the rights to do so). You will also have to agree to a delivery schedule.

Self-funding

Self-funding means that you decide to write and draw the entire project yourself before finding a publisher. The best situation is to have an established relationship with a publisher who you are confident will buy the project when it is complete. Even if you aren't in this situation, there are a number of advantages to this route. First, you maintain creative control, and second, you retain all the rights. If you find an enthusiastic publisher, they will not be in a position to demand unfair ownership of those rights, and you will also find yourself in a stronger negotiating position, allowing you to demand fair terms and financial rewards.

The big disadvantage is that you need to find sufficient funds to keep yourself fed while you work on your project. This is achievable by working on the project in your spare time, or working on it part time with a regular job—be aware that it may require years of dedication to complete. Also, you must have faith in your project: you don't want to emerge after 18 months of work to have everyone tell you that your grand opus is hopeless drivel. One answer is to self-publish the work as you progress on the Internet; this will allow you to build an audience and receive feedback.

The grand plan

There are two ways of going about a major project. The first is to simply start at the beginning and allow things to develop organically as ideas progress. This is often the best way to work with certain types of strip, such as autobiography and freeform stream of consciousness, where planning too heavily can actually be detrimental to the story.

Most projects, however, need sound planning. This is essential for long-form storytelling, and advisable for most other story-based projects. Even if your cartoon is a hobby, the time you spend on it is still valuable and you want to avoid lengthy corrections later.

Draw up a schedule

Drawing up a schedule will give you a rough idea of how long it will take to finish the project or, at least, get it in a state where it is fit to take to publishers. Once you estimate a finish date, don't forget to build in dates for beginning your campaign to find a publisher. Also build in time to prepare for important conventions and trade shows.

WINTER KINGDOM. KEVIN HANNA.

Plan for format

Study the formats of different comic books, anthologies, and collected editions. For your first project, it is wise to go for a standard format. Anything unusual pushes up production costs and make it less attractive to publishers. Most book formatting is based on the way books are printed on giant single sheets, which are then folded and cut to make the book. Books that are single stitch—i.e., folded once, like a standard comic—come in 12, 24, 48, and 64 pages. Longer books require different multipliers depending on their binding. You lose at least the first two to the title page and copyright or history page. In the U.S., the standard comic book page is 6 ⅝ inches x 10 ¼ inches. In Europe, the standard size is A4, although there are others in use.

Draw up a map

A map is a diagram, breaking up the comic into double-page spreads to give a firm idea of the overall flow and structure. Even if you don't go into detail, make sure you have balanced the story across the whole book. As the project progresses, your ideas are bound to change and evolve, and it is important to keep revisiting and updating the map, maintaining an overview of the whole story. For day-to-day work, though, break the project down into small, manageable chunks of, say, three to four pages at a time—otherwise you may become disheartened by the amount of work ahead.

Integrity vs. Cash

Creating your grand opus is all very well, but you should keep the following in mind if you want to see it published.

Moderation: There is no shame in moderating your ideas into something more commercial, particularly if you need some income—and most of us do. Working on your own original ideas is always a gamble; it usually takes a considerable amount of unpaid work before you can publish—and there is no guarantee that you will be published.

Publishers: If you take the route of trying to get a publisher interested in your work, you have to consider what they expect. Publishers are typically cautious, and not generally inclined to take chances on something new and wildly different.

The Audience: Some decisions have major implications for the size of your potential readership. Writing for a younger audience automatically broadens it, because comics are perceived as a youth medium. Writing about themes such as sex and violence limits it, for the same reason. On the other hand, small, niche audiences can be very loyal, and your project may later be acclaimed as a challenging, mature work.

Originality: Out of necessity, you may decide to pursue well-established markets. It is worth remembering that even these markets are in constant need of regeneration, and they welcome fresh ideas.

THE V.C.'S. HENRY FLINT AND CHRIS BLYTHE. 2000 AD.

The Deal

Money

Perhaps the biggest mystery to anyone wanting to break into publishing is the financial aspect. It can be difficult to get established artists and publishers to reveal how much they get paid, mainly because they want to protect the confidence under which they negotiated their terms. Fees, royalties, and deals can vary considerably depending on many factors from the value of the publication to the state of the market to the popularity of the artist—and even the relative levels of desperation of those involved. For these reasons, it's impossible to give absolute figures, just some tips that can help you arrive at a satisfactory figure.

Generally, larger publishers pay standard page rates, especially for in-house jobs. Some of these bring few rewards, but poorly paid jobs are sometimes worth taking early in your career to break the "work in print" Catch-22 mentioned earlier. Be careful though, because less scrupulous publishers may hold out the lure of publicity just to get work on the cheap.

Be realistic about the minimum you need your work to earn for you to live. Work out what you need per month and compare it against how long it takes you to produce a regular page. Allow for time off, and you should come up with an amount per page. That is your minimum fee.

Avoid accepting a figure at a meeting if you can. Say you will think it over and continue negotiations on the phone, or even better, by email.

When negotiating fees, always quote the higher figure you had in mind. You may fear that the publisher will throw their hands up in despair and you will lose the job altogether, but this is unlikely to happen. If the figure is too high, you can always negotiate down. Once a publisher knows they can get your work for a certain fee, however, they are unlikely to negotiate upward.

Rights

The rights you negotiate are as important as the money. Every line you draw, so long as it isn't copied from someone else's work, automatically remains your legal property unless you explicitly sign its ownership over to someone else. The right to reproduce your work can be sold under various terms agreed between you and the publisher.

The OK all rights sale

This is often referred to as fixed or flat fee. Agreeing to sell all rights is typically a requirement if you are drawing licensed characters that are owned by someone else. It is also acceptable if you have to draw something to a very specific client brief that would have

MERGERS. GEORGE PARKIN.

SAVAGE DRAGON COVER. ERIK LARSEN. IMAGE COMICS.

little value in another context—a cartoon on the back of a cereal box, for example.

The less-than-OK all rights sale

I've heard this described as a "copyright grab." This is where a publisher attempts to secure total rights on a project that you have devised. If you take an original idea and characters to a publisher, avoid signing anything that relinquishes your ownership unless you are completely satisfied you're being paid enough. This money will be the only payment you can expect. This won't upset you if the comic becomes only a moderate success, but imagine how you will feel if it goes on to be a worldwide blockbuster, with film and toy rights up for grabs.

The partial-rights sale

Partial rights means that you agree that the publisher can pay to make limited use of your work. They might, for example, be free to publish in a number of countries for an agreed period, or free to publish your work in limited contexts—in book form but not, say, on a lunchbox.

Advances and royalties

The publisher may offer to pay royalties: These are percentage payments based on each book sold.

Along with royalties, you may also be offered an advance: A large sum split into two or three payments to cover living costs while you work. This money isn't free, though, and is paid off with the royalties you otherwise receive from the book sales.

Contracts

If a publisher wants to publish your work, you will both have to sign a contract. Until that contract is signed, you own all rights to your work. The publisher will probably provide the contract, which will cover the amount of money you can expect, both from normal sales and under special circumstances, such as if the book were made into a TV show or a film. The contract will also cover the time period you have to complete the work, as well as a number of other obligations. You must guarentee, for example, that the work is entirely yours. Don't trust publishers to look after you: They are commercial entities, and it is in their interest to get as much out of you as they can for as little as possible. This applies to the big names as much as it does to smaller firms. Read the contract carefully and, if in any doubt, have a lawyer check it. Keep in mind that there is no such thing as a standard contract—anything can be negotiated if you feel the need.

Self-publishing

The ultimate answer to publisher problems is to self-publish. You keep total creative control, and you also get to keep all of the money. However, it is not as simple as that. All of the functions that a publisher would handle, you have to cope with yourself—not least the advance funding for drawing the comic and the cost of printing and distribution. Luckily, there are differing levels of publishing and some of the smaller-scale options are more attainable. Indeed, a limited, personally printed version of your comic may be your goal from the start. If your aim is to make a profit, you will have to do the math very carefully and expect that any rewards you do see may be some way off.

ALTERNATIVE COMICS. **www.indyworld.com/altcomics**.

Full-scale publishing

Full-scale publishing is a serious and expensive business that relies on heavy up-front spending. If you manage it, you may see your comic jostling on the shelves next to Marvel and DC; after all, even the big players had to start somewhere. Perhaps a more realistic approach would be to set your sights on being a small, niche publisher like Jeff Mason, who runs Alternative Comics. Although the initial cost of printing cannot be avoided, there are avenues open for low-cost distribution, such as having your books listed on Amazon.com or specialist websites.

Micro presses

A micro press is the smallest printing operation possible—printing from your own computer. The advantage is that you only have to print as many copies of your comic as you can sell. The high-quality prints obtainable from modern inkjet printers would be ideal if it weren't for the equally high cost of the ink and paper. One option is a color laser printer, which are rapidly falling in price. Their running costs are considerably lower than inkjet printers and they are more capable of high-volume printing. Prepare your pages as an Adobe Acrobat file and, if you have a second computer, print from that. You may need to leave it going night after night.

As an alternative to doing your own printing, try small printers and copy bureaus, which are beginning to use digital printing machines, allowing for small print runs. Again, you will have to work out the costs carefully before proceeding.

Artwork preparation

If you are responsible for the final preparation of artwork, you should check with the printer about any special requirements. By far the best way to send artwork is in Adobe Acrobat format, because all of the components—art, type, and layout—are combined into a single file. When preparing the Acrobat file, make sure that you do not have compression switched on. Although Acrobat can generate huge files this way, you will most likely be sending it via CD or broadband where size is less of a problem. CDs should be in the baseline ISO 9660 standard—you should be able to set this with you CD-burning software—with filenames set to 8 characters + 3 to avoid incompatibility problems with different systems. Always send files with a detailed instruction sheet describing your exact requirements, such as paper type, file names, any included fonts, and so on.

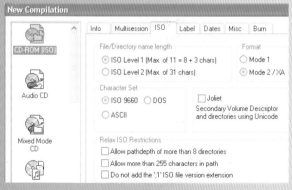

SELECTING THE ISSO 9660 STANDARD FOR BURNING A CD IN NERO. **www.nero.com**.

Print on demand

Print on demand is based around a recent technology that can best be described as a glorified photocopier. These machines take an electronic version of a book held on disc, print it along with a color cover, and bind it into a finished book. This development has led to a number of online publishers operating a POD service that works like this: You upload your comic, usually as an Acrobat file, onto the service's servers. A reader can then buy it, paying online at the POD provider's site, and a single copy of the comic is printed, bound, and shipped. The obvious advantage is that there are no upfront costs to the artist. The disadvantage is that the price of each individual copy, combined with postage to the reader, is still too high to compete with mainstream printing. However, a niche market may well be prepared to pay a premium for your particular work. The technology is still relatively new, and no doubt prices will fall in time.

Dehanna Bailee maintains a detailed database of POD providers on her website:

http://www.geocities.com/dehannabailee/pod.htm

Roger Langridge publishes *Fred the Clown* himself.

Where do you have your comics printed?

I've used two different printers, both Canadian. Lately it's been Quebecor, who do a lot of comics for independent publishers.

Roughly how much does it cost to have them printed?

It's about a fifth of the cover price. That's the usual rule of thumb: Multiply your per-unit cost by five to avoid losing your shirt—or your house.

Did you have to buy thousands and have them stacked up in your garage?

Pretty much! The distribution thing is quite intelligently handled: You get the orders from the comic shops through Diamond Distributors, and only then do you pass the figures on to the printer, so you only need to overprint a small amount for reorders and selling at conventions or what have you. There's very little risk of having thousands in your garage unless you're really stupid. Me, I only have hundreds in my garage.

Are there any good or bad points about self-publishing that you'd like to mention?

Good: Total control! If it's a success, nobody shares the credit. Bad: Total responsibility! If it's a failure, nobody shares the blame.

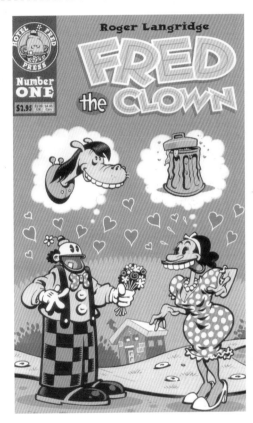

FRED THE CLOWN COVER. ROGER LANGRIDGE.

Do you have any tips for the beginner?

Yes: Find a publisher if you can. It's much easier and much cheaper. Don't self-publish unless you've had the work rejected over and over again, yet you still believe in it with all your heart and soul. When you feel you can't avoid becoming a publisher, or when the thought of not becoming a publisher is keeping you awake at night, that's the time to do it. Only that kind of irrational obsessiveness will be enough for you to see it through.

Pixels at Work:
Heart of Empire

Bryan Talbot + James Robertson
www.bryan-talbot.com

James Robertson has taken Bryan Talbot's fantastic alternate-history epic and presented it on a single CD with a wealth of background information.

DETAIL OF THE WEB BROWSER BASED INTERFACE IN ACTION.

How was *Heart of Empire* originally conceived?

James: I'll let Bryan handle that one: The actual comic is his personal labor of love.
Bryan: As I was finishing *The Adventures of Luther Arkwright,* I started to think about what would happen next, what would happen to Arkwright's children. I continued to think about the story over the next 10 years till I actually had an opportunity to do it.

What was the idea behind presenting it on CD?

James: Bryan wanted to answer all of the people who kept coming up and asking "where do you get your ideas from?" I wanted to create an utterly definitive "directors cut" of the graphic novel. I took the point of view that if I, as a fan, could expect a link from a place to another place on the CD, then there *would* be a link. This is why everyone who has used the CD says it is so easy to navigate—it is created by a fan with a passion for easy to access, user-friendly interfaces.
　　I also wanted to create what I call "a teachers aid to creating a comic"—if someone wanted to know anything more about *Heart of Empire* then it would be on the CD—from artists materials to funny anecdotes. At times I was almost consciously creating a record of Bryan's thought processes when he was creating the comic.

Originally you sold it through a traditional publisher. How do you find it selling directly from the Web?

James: We can offer it at a lot lower price because of the low cost of publishing and printing it ourselves. The online payment people seem OK at handling the money. Of course, we cannot put a CD into every comic shop, but I know that the site is at number one in every search engine for the search

term "bryan talbot" and so as soon as someone looks for it they will find it and we can sell it to them. Sales aren't enough to retire on (yet!) but it is a profitable activity overall.

Were there any special challenges or problems with presenting a comic on CD?

James: I wanted the CD to be readable on a Mac, PC, and Linux, and so I was constrained to using only flat HTML. I went for absolutely the lowest common denominator: All you need is a computer and a browser. Therefore, the 1,500 plus pages and 60,000 links were all hand-coded by me. In making it cross platform and user-friendly I talked myself into about 18 months of evening and weekend work. But the reviews have been universally glowing, and of course I got to work creatively with Bryan: result!

What are the advantages of CD format?

James: It was very good to be able to work in a hypertext environment without worrying about download speeds: CD's offer the best of both worlds—the ability to present a large amount of information in a format that is instantly familiar—i.e. Web pages. We could also control the complete look and feel and not have to worry in the slightest about download times. Of course, offering it as a bunch of Web pages meant that we could always seamlessly integrate it with the Web.

What do you think about artists and writers selling their work directly via the net?

James: I think it is a great idea, cutting out the middle men. It is best suited for the sale of merchandise and original artwork—the big comic companies needn't worry yet, as they have the marketing muscle to break new

HEART OF EMPIRE. BRYAN TALBOT.

writers and artists that would otherwise take years to break through. But once someone has got a fan base they can sell custom items directly to their fans —such as pages of artwork—in which the comics companies would not be interested. Also, a lot of new writers and artists are coming to the fore now by self-publishing their work, which can only add to the pool of creativity and diversity out there.

Bryan, do you use computers at any stage of artwork? For coloring perhaps, and if you do has it helped your work?

Bryan: Yes, I've used it both for full coloring, and also for scanning in painted artwork, finishing it off, tidying it up, adding effects, and so on. For the first time, with my new graphic novel *Alice in Sunderland*, I'm putting it all together on computer, mixing scanned drawings and paintings in computer collage and doing the text with my own lettering font, which is based on my *Luther Arkwright* hand-lettering and made into a typeface by Starkings Fonts (www.comicraft.com).

11

Digital Distribution

INVINCIBLE. ROBERT KIRKMAN, CORY WALKER AND BILL CRABTREE. IMAGE COMICS.

The biggest revolution in comics is happening now, and it's happening online. Once a page of ink and paper becomes a digital collection of 0s and 1s, it is suddenly free from physical boundaries. Creators have a new tool with which to deliver their work to their audience, and it's quicker and cheaper than any traditional distribution system.

The Internet has a vibrant, growing community of comics and cartoon artists who are successfully reaching a worldwide audience. Artists with original and experimental ideas are now able to find and broaden the minds of new and enthusiastic readers. In the longer term, the Internet will help to redefine and expand the entire comics genre, with the artist maintaining complete creative control from the moment the original idea comes into his or her head to the moment it enters the mind of the reader.

This is an exciting vision of the future, but is there any money in it? Yes, there is. It's only a trickle at the moment, but the trickle is growing, and as word spreads and new payment systems become accepted, it may well turn into a stream.

ISPOT. **www.theispot.com**. OTHER EXAMPLES: **www.portfolios.com**, **www.cartoonpeople.com**, **www.illustrationweb.com**

Using the Web as a Showcase

Even if you write, draw, ink, and color without a computer, having a presence on the Internet to showcase your work is now considered essential. Although the process of hauling a physical portfolio around to prospective publishers has not been entirely abandoned, much of this legwork can be done online. You can invite people to visit your online portfolio, using just a Web address mentioned in an email, on the phone, or printed on your business card. There are two main methods for establishing a presence on the Net: using a portfolio site or creating your own website.

Portfolio sites

Perhaps the easiest way to get your work online is to register with one of the many portfolio sites that present the work of illustrators, cartoonists, and photographers as a searchable online database. The advantage of this is that setup is simple; you fill in a few forms and follow the instructions to upload your work. The fees can be fairly high, but the sites claim

to provide a central place for clients seeking to commission artists. You are limited to the number of images you can show, as well as to the layout and design of the site, but this is a good option if you need a quick Web presence with very little work.

Building your own website

Putting up your own site is a lot easier than you might think. There are many books on the subject, and even more free information on the Web to help you. The first step is to buy yourself a domain. Although you may already have some free space with your Internet connection, it will probably have a Web address that does not best reflect you and your work. If possible, choose a domain that contains your name. Avoid naming it after a comic or characters, or even after your studio. These may become redundant if you move on to new ideas.

You can pay someone else to build a site, but this can work out to be very expensive, both in the short term and in the long term, because you will want to update it regularly. Creating a site yourself gives you total control and can be a lot of fun. It's relatively easy to learn hypertext mark-up language (HTML), the scripting language read by Web browsers to describe a Web page. If you prefer not to get involved in coding, there are many website design

```
Ideas_Machine[1] - Notepad
File  Edit  Format  View  Help

csref="../Fantasy%20Cutouts.da

h="28" t="Button" ht="images/b
href="about.html" onmouseover
onmouseout="return CSIShow(/
CSButtonReturn()"><img src="i
name="Cmp00521E3054about" |
Cutouts"></a></csobj><br>

h="30" t="Button" ht="images/b
href="news.html" onmouseover:
onmouseout="return CSIShow(/
CSButtonReturn()"><img src="i
```

THE HTML SOURCE CODE GENERATED IN ADOBE GOLIVE.

LAYING OUT THE PAGE IN ADOBE GOLIVE.

programs to simplify the task; you may even find that your word-processing program has such a facility. For those who don't work in pure HTML, it is still an advantage to learn the basics so that you can troubleshoot problems more easily.

Design quick tips

- Keep your website clear and simple. Whatever graphic style you choose, you must focus on showing your work in an easy-to-navigate environment
- Be careful of overintrusive Flash and animated presentations, which, unless directly functional, can just be irritating.
- Include sketches as well as finished examples, along with scripts, thumbnails, and character concepts. Keep them at the back of the site to avoid any confusion.
- You can easily find good and bad examples of Web-design by surfing the Web yourself.

Web-design programs

Macromedia Dreamweaver, **www.macromedia.com**
Adobe GoLive, **www.adobe.com**
Visicom AceHTML, **www.visicommedia.com**
Netobjects Fusion, **www.netobjects.com**
Serif WebPlus, **www.serif.com**
Microsoft FrontPage, **www.microsoft.com**

KEEP NAVIGATION SIMPLE AND UNCLUTTERED

Web Comics

Charley Parker is widely renowned as a pioneer of the Web-comic concept. He started the first Web comic, *Argon Zark*, in 1995. The idea is straightforward: to publish ongoing episodes of a comic strip on the Internet, often weekly but sometimes daily. As a method of distribution, the process is simple, controllable and above all, inexpensive.

Since Zark's inaugural outing, many artists have followed Charley's lead, but although the idea of Web comics seems perfect, there are drawbacks. Reading on screen is not ideal: It's hard on the eyes and plain lethal to do in the bath. Many readers miss the physical feel—even the smell—of paper and ink. It's part of the comic-reading experience, as is the ownership of a growing pile of back issues. The Web comic is pure content, an ephemeral, fizzing collection of electrons that dissipates at a mouse click. Web comics need not preclude the printed page, however, and many Web comics are making their way into print after finding a readership on the Web.

ARGON ZARK. CHARLEY PARKER.

Web comic design

Before embarking on your website, you should consider how you plan to present your comic and how flexible you want to keep the artwork. As I mentioned before, it is strongly advisable to keep your working files at 300 dpi, just in case you need them for print later.

Format

There are a number of ways you can show work on the Web. The simplest is to have three or four panels that fit the landscape aspect ratio of a regular computer screen (1.33:1). This also more or less fits half a standard portrait format comic page. It suits the screen in that the reader doesn't have to scroll down, but it does limit your design options if you ever transfer them to a printed comic page.

There is an ongoing debate, regarding not only Web comics but websites generally, about what size screens you should prepare your site for. Because of the amount of space a Web comic needs to be legible, it's better not to use the smallest size standard of 640 x 480 (pixel dimensions) or even the larger 800 x 600, opting instead for the common 1,024 x 768. With this resolution across, you can comfortably display a handful of frames. Web pages have no restrictions on vertical length—the user can scroll down easily as they read. Jason Little offers both options for reading *Shutterbug Follies*.

Size

You need to strike a balance between image quality, size on screen and download time. You can use your paint program to resize your comic page so that it will comfortably fit in your Web page, usually no larger than 720 x 460 pixels. Be very careful not to save the reduced size file over your 300 dpi original. If in any doubt, back up your original working PSD file first.

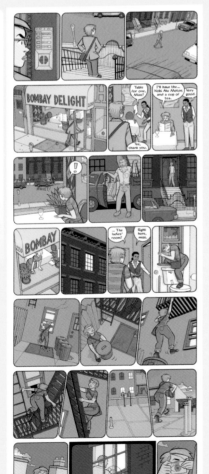

SHUTTERBUG FOLLIES. JASON LITTLE.

You will then need to save the file in a compressed file format to facilitate a reasonable download speed for your readers, many of whom have slow dial-up connections. You have two usual choices of file format, JPEG or GIF, and you will have to experiment with each to gain the best balance between file size and image quality. The final test is always legibility: Can the picture and text still be clearly read on an average screen? Ideally, you want a file that is under 200 kilobytes (KB) in size.

JPEG format

The JPEG format handles full-color, 24-bit images. It is a "lossy" format, which means that at higher compression settings the image can suffer a loss of quality. You will need to experiment with the quality control, compressing the file as much as possible while maintaining an acceptable image.

← Zooming in on the same image shows how quality can suffer with too much compression in JPEG format.

GIF format

The GIF format is good if you have black-and-white or flat-color artwork with a limited color set, but it has one major problem. GIF files are limited to 256 colors. This is fine if your comic uses large areas of flat color, but not so good if you want to use a lot of realistic shading or lighting effects.

← GIF is not good with tonal images, because its limited color palette can't cope with the full range of tones.

Website design

Whatever Web-creation software you use, you should keep the navigation of the site as simple as possible. Web comics generally use a similar tried-and-tested navigation format: see the *Smell of Steve* website (*above right*) for a typical example.

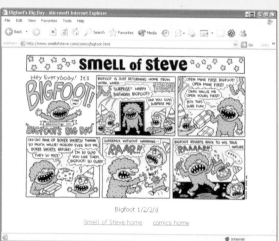

BIGFOOT. SMELL OF STEVE. **www.smellofsteve.com**. *SMELL OF STEVE* IS A GREAT EXAMPLE OF AN EASY-TO-NAVIGATE COMICS WEBSITE. CLICKING ON A CHARACTER TAKES YOU STRAIGHT TO THAT CHARACTER'S LATEST STRIP, AND YOU NAVIGATE THROUGH THE PAGES USING TEXT LINKS AT THE BOTTOM OF THE PAGE. PROVIDING A LINK TO THE CENTRAL HOME PAGE MAKES IT EASY TO SWITCH TO ANOTHER STRIP AT ANY TIME.

Downloads

The browser isn't the only method of distributing comics online. Scott Reed (*see page 52–53*) provides the option of downloading a small program that runs as a virtual on-screen comic with a turning-page effect. You could also package your comic as a printable PDF kit, which the reader can print out and assemble into a physical comic, and then read in the bath.

Flash Comics

As comics go digital, they can easily stray into the realms of multimedia, mixing movement, animation, sound, and even gameplay. There is a huge, barely explored, territory between the static narrative in comic frames and full animation. The most universally accepted program that can combine these media for the Web is Macromedia Flash. Even if you are using static images, Flash is worth considering, particularly with vector-based artwork, where considerable file-size savings can be made. Some sites use Flash for everything from the artwork to the navigation, but these run the risk of excluding users whose computers are too old to run the program. You should also be aware that the more you make use of multimedia in this way, the more difficult the project will be to translate into print, should you ever want to do so.

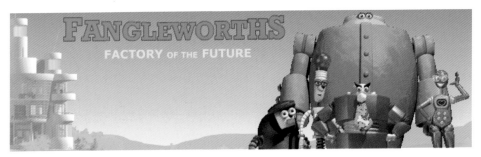

FANGLEWORTHS. LEO HARTAS AND DAVE MORRIS. WHILE FLASH IS PRIMARILY A VECTOR FORMAT, BITMAPS CAN BE STILL BE IMPORTED AND USED EFFECTIVELY.

→ QUICK TIP: Don't forget that Flash can use bitmaps if you don't want to use the flat-color style often associated with it. If you are careful with the bitmaps, they don't have to increase download times by too much. Use JPEGs for backgrounds and GIFs for foreground elements, where you can take advantage of transparency to cut them out.

ARQ ANGEL. MICK SZIRMAY AND MIKE MERRYWEATHER. ARQ ANGEL USES A SYSTEM OF TEXT AND STORY REVEALS.

Reveals

At its simplest, Flash can be used as a cool way to reveal the next frame. Fading it in or sliding it in from the side work well, as do a multitude of other effects. Speech bubbles can be intrusive in a traditional comic, sometimes limiting the amount of text. In Flash, the bubbles can remain hidden until the reader is ready, when they can be revealed in the correct order of the story. Simple two-frame reveals in the picture can move the narrative on inside a single frame—for example, showing a door closed, then opened.

Animation

Animation is a close cousin of the comic strip, and the two share a lot of common ground. There is the argument that if you use too much animation you may as well do without the comic altogether—go the whole hog and make an animated film. There is a middle way, however, which avoids the headaches and the huge quantity of work involved in full animation. This involves a quasi-animation using simple "camera" pans and scaling of flat, cutout characters. The effect is highly stylized, but also effective. The movement makes the action feel more dynamic.

Interactive pictures

Another way to use Flash to enhance a comic is by including buttons and hotspots in the pictures, which let you reveal extra information to enrich the story. You could, for instance, add hotspots to items in the background that would reveal something about that item and its relationship to the characters or setting.

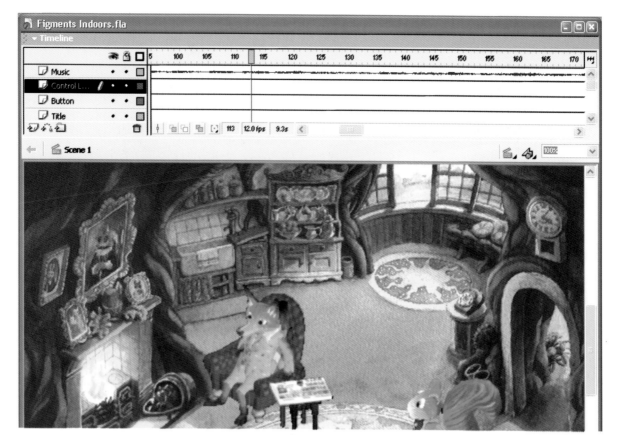

MACROMEDIA FLASH MX.

Flash Comics

Fans are often intrigued to see how an artist works, so you could add director's notes in the form of text or pencil sketches. Other buttons could reveal hyperlinks to relevant Web pages—a historical strip might have links to museum sites that contain interesting background information.

Interactive stories

Interactive stories go back to the "choose your own adventure" books of the 1980s, where the reader played the protagonist and made choices at the end of each chapter as to how to progress the story. The same can be done in Flash, Java, and even plain HTML with the computer quickly "hyperlinking" you to the next part of the story. The problem for anyone writing and drawing interactive stories is that the plot can split into several alternate strands, resulting in huge quantities of work that no reader might ever see. However, employment of the reuse techniques detailed in chapter 9 (*see page 104*) can make a project like this a practical proposition and an unusual hook to attract new readers.

see page 104

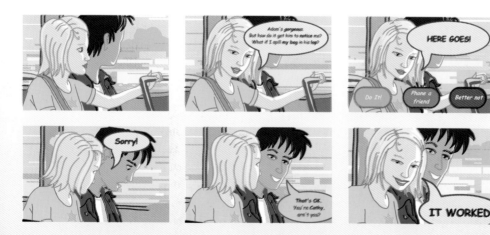

DILEMMAS. DAVE MORRIS AND LEO HARTAS.

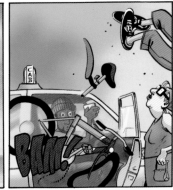

BUTTERNUTSQUASH. RAMON PEREZ AND ROB COUGHLER.

Getting Known

Probably the single biggest problem for anyone doing anything on the Web is telling people that you are there. Out of the billions of pages floating around in cyberspace how do you get the right people to find yours? The simplest way is to make sure that you have relevant keywords in your site's meta-tags—the HTML tags placed in the page's header—so that Web search engines can latch onto them. Beyond that, unless you have the kind of money that large companies fritter away on advertising, you have to rely on the clever use of word of mouth and guerrilla-style marketing, both online and offline. Don't forget that you already have one big asset to start off with—your cartoons or comic. You have a form of entertainment that Web surfers are actively searching for and, when they find it, they will come back for more.

Word of mouth offline

In the real world, you can contact a surprisingly large potential audience just by passing the word around. Make a joke of constantly reminding your friends and family to check out the latest episode. Make sure your Web address is quoted on your letterhead and business cards, and paint it on the tailgate of your car if you have to. It may be worth investing in a print run of small flyers, postcards, or posters featuring an intriguing panel from your comic, and leaving them in coffee shops.

Word of mouth online

Online, you can reach a worldwide audience, but it takes a bit of work. The first port of call is the comics community itself, which has vibrant discussions on Internet bulletin boards. Take care not to flood them unannounced with a gauche plug for your site; instead, spend some time joining in discussions and getting to know the contributors. Apart from anything else, these sites are a great source of support and help. Next, you should turn to the content of your stories to find communities that may be of interest—there are websites and discussion groups devoted to just about everything, from fly-fishing to Tantric sex. It's important to think beyond the comics community, both to gain a wider audience and to bring the delights of Web comics to the masses.

TALK ABOUT COMICS IS ONE OF THE MOST POPULAR ONLINE COMICS DISCUSSION SITES.

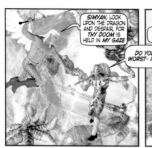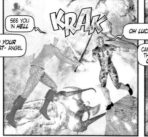

THE STARRY ONES. MITCH WAXMAN AND ANCRAM HUDSON. **www.weirdass.net.**

ALL WIZARDS HAVE A *PLACE OF POWER*. A SPOT WHERE THE UNIVERSAL WELL OF MAGICKAL POTENTIAL FLOWS STRONGLY AND IS EASILY TAPPED. HERE, *IN DEEP SPACE AT THE GATES OF FTHLAGEN*, BATHING IN THE FLOW OF POWER FROM HIS GOD, *HERE* IS SIMYAN'S CEREMONIAL STRONGHOLD.

WHEN HE LAST BATTLED LUCIFER IN NY CITY, *SIMYAN OF THE OLD ONES* WAS STILL A *MAN-GOD*. HERE HE IS A *GILGAMESH*, A *HERACLES*, A *WARRIOR BUDDHA*, *SHIVA ENFLESHED*. HE FACES THE LEFT HAND OF GOD, *THE BEL*- DARK LORD OF ALL GROSS MATTER- *LUCIFER MORNINGSTAR*.

LUCIFER AND HIS *BRIGHT BROTHERS* DO NOT FIGHT FOR *YOU* OR *I*. *NEVER FORGET* THE *TREACHEROUS* AND *IMPISH NATURE* OF THESE BEINGS MANKIND CALLS *ANGELS*. *TRUST IN THEM* TO FIND A WAY TO *BURN AND TORTURE INNOCENTS* ALONG WITH THEIR ENEMIES. *ITS BEST TO AVOID THEM.*

> ➔ QUICK TIP: Never spam. You will instantly lose all respect and become, quite justifiably, hated.

variable quality, so you may want to think before applying to some of them. One example that is well worth contacting is www.topwebcomics.com.

Interlinking

Look for other comics sites and sites that have some relevance to the content of your comics, and politely get in touch with the owner. You will often find them willing to swap links.

Branding

"Branding" is a blunt term for a subtle but important part of your Web campaign. It covers the overall visual feel that your work and site leaves imprinted on the reader's mind, an imprint that you hope will stick. You need to find the essence of your comic's style and carry it over into the design of your site. Make every part of the site simple, clear, and consistent—from the title to the humble "back" button.

Comic directory sites

A number of comic directory sites that act as hubs for surfers. They are usually run by amateurs and are of

Fanbase

Make sure you have a contact email on your site, but open a secondary mail account for it to maintain your privacy. One of the pleasures of running a website is that people write to tell you what they think. (Hopefully the majority of such correspondence will be positive.) This gives you a level of feedback that you rarely get when working through a publisher. You should reply as often as possible, inviting readers to receive notification of new episodes. Because of the sensitivity around unsolicited email, you should always ask permission to send notifications.

> ➔ QUICK TIP: You can add a bulletin board to your site to start a discussion group about your comic. The following sites can help: www.ezboards.com and www.dream-tools.com

BLOOD ON THE EARTH. LEO HARTAS.

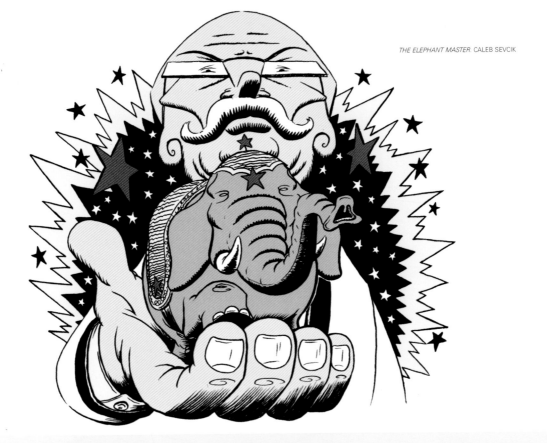

148 Making Money from the Web

After the dotcom boom came crashing down, many people discounted the possibilities of making money directly from the Internet. This situation is slowly improving as more people are going online and becoming comfortable spending money there, but there are specific problems for comics artists. The largest is that surfers have enjoyed a culture of free content and are not used to paying for it. Because publishing costs are so low on the Internet, the artist can undercut traditional print media considerably and offer competitive prices, but they need an extra hook to compete with free content. The hook is quality, and people will pay for it.

Selling directly on the Web is still in its infancy and is currently too small-scale to provide a full income. What makes it exciting, though, is the simplicity of the math. For an artist to make money from a regular printed comic, many thousands have to be sold because of the production overheads and the numbers of people in the chain taking their cut. On the Internet, production is just your time, and no chain exists—you get to keep all the money (bar a small percentage for payment systems). In other words, you need far fewer sales to make the same amount of money.

Freebies

Free content is the key to getting people hooked. You need to give away the first few pages of your comic to prove its quality and get readers so embroiled in the story that they will pay to find out what happens next. Some sites have the latest episode online for free, but charge visitors to look at archived episodes.

Payment systems

Until recently, online payment for "pocket-money" purchases, such as comics, has been troublesome.

However, one system is becoming accepted, and other interesting developments are coming into view. Currently, there are two options for collecting money online: online merchants and micropayment systems.

Online merchants

This involves setting up an online store capable of collecting credit-card payments. The process is quite expensive, and you need to comply with the credit card companies' rigorous credit requirements. For small comic sales, this just isn't viable or necessary.

Micropayment systems

Paypal is quickly becoming the standard system in the small-payments sector. The system is easy to set up, both for consumer and vendor, and it charges a tiny percentage for transactions.

www.paypal.com

Bitpass is quite new, but it processes payments as low as a penny and the system is easy to operate.

www.bitpass.com

The important thing with these systems is that people are becoming comfortable using them, and more are buying comics in this way. They also allow buyers who don't have credit cards the freedom to spend online.

Comic collection sites

A number of sites present the work of several artists, charging small subscription fees to access all the strips, which typically come out in weekly episodes. The income is then divided up among the artists. There are a couple of advantages with this system, the first being that these sites get more hits than you expect from an individual site, because everyone benefits from the marketing efforts of each artist. The second is that submissions are screened for quality, which helps to guarantee that the site will not become flooded with second-rate strips.

Syndication

Just as in the physical world, online syndication works by "renting out" use of your comic or cartoon to other sites in need of content. The advantage is that if you strike a deal, it will most likely stand for several months, thus providing a regular income.

Modern Tales

After a year of brainstorming with 30 top Web cartoonists and comics artists, Joey Manley launched the website Modern Tales. The idea was to slowly build a platform for selling Web comics on a subscription basis. Joey purposely kept expectations low, forecasting just 500 subscribers. Within 2 weeks, the site had 700 subscribers and it now has more than 2,000. He is the first to admit that this isn't big business, but the site is growing continuously and he confidently predicts that his artists will eventually be able to make a modest living from it. The venture has proved beyond doubt that the Web comic can work as a commercial entity.

The strength of Modern Tales is its ability to sidestep the mainstream print industry, which has suffered a slow decline in recent years. It brings a diverse collection of work to a worldwide audience, work that would not have appealed to traditional publishers.

With any Web venture, free content reels in initially skeptical readers, and Modern Tales is no exception. The site displays the most recent episodes of its artists' series free for a week before it is saved into the subscriber-only archive. There are other benefits for the subscriber, such as access to artists' sketchbooks and one-off specials. Considering the low cost of subscription, the site delivers amazing value compared to print comics.

From these early successes, Joey has opened a handful of sister sites to appeal to the varied tastes of the readership. Serializer.net has a more avant-garde collection, whereas Girlamatic.com hosts comics mainly by and for women. There are also two experimental single-artist sites, American Elf: The Sketchbook Diaries of James Kochalka and Lea Hernandez's RumbleGirls.com.

Perhaps the most important role that Joey has taken on in the ever-expanding area of Web comics is that of editor. The Web is a publishing free-for-all where anyone of any ability can publish his or her work for all to see. While this is commendably egalitarian from a reader's point of view, it becomes difficult to find the really interesting and worthwhile material from the mediocre stuff. Sites like Modern Tales are critical if the Web comic is going to mature into a recognized and financially successful art form. They serve as a showcase for high-quality work and provide a goal for students still developing their talents.

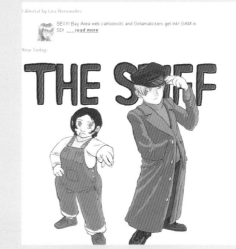

BELOW: www.serializer.net

ABOVE: www.girlamatic.com

MODERNTALES
PROFESSIONAL WEBCOMICS

Choose A Feature!

Home Subscribe Log In Forums About Account Contact Submissions New! >> Modern Tales IRC Chat

News: *serializer.net expands*
serializer.net is almost a year old ... have you looked at it lately?

... read more ...

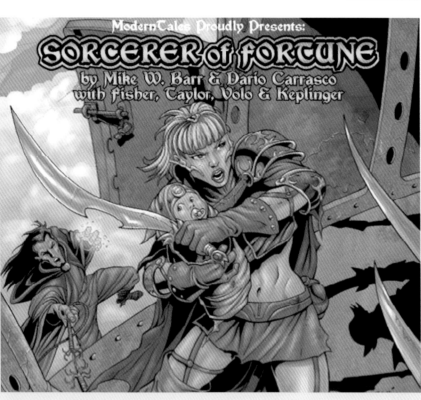

Jump To:
Modern Tales Creators
Sketchbooks and Journals
Current MT Series
Completed and Archived Comics
Modern Tales Sister Sites

Did you know that if you
subscribe now, you also
get full access to dozens
and dozens of full-length
graphic novels and short
story collections in
Modern Tales Longplay?

ABOVE: www.moderntales.com

ewis Weinstein Guldemond Feazell Fitzpatrick Bertozzi Welch Elliott French Rege, Jr. Henderson Garrity Sendelbach Gruber Jensen Devlin Hart Weing

Paradise Place
By Bishakh Som

... current installment ...
... table of contents ...

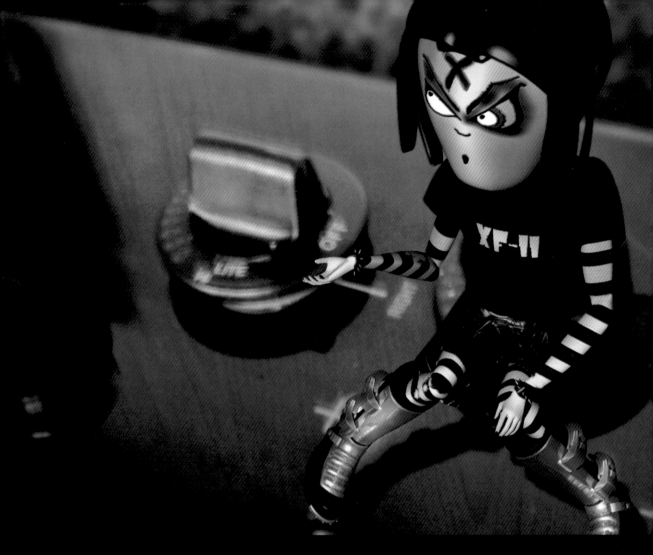

Pixels at Work: Pax-iLL

Eddie Robison
www.pax-ill.com

Creating Pax-iLL
Eddie Robison describes how he created the Internet comic character known as Pax-iLL (aka Pax):

In the wake of all the crap that invades my life every day, I decided to invent an alter-ego that I could use to vent my frustrations. I am an Emmy Award nominee and have been working in Hollywood on high-profile episodic TV shows and films for the last 9 years.

I created Pax in late November 2002. I modeled him in LightWave 7.5, which is, in my opinion, the best modeling program available. Because I didn't want to deal with skeletal rigging for Pax, I left him as a layered object that was parented together. Also, because the initial idea for this project was print, I didn't worry about intersecting geometry or cloth deformation (faults that can appear when you create 3D objects, and which usually take time and attention to avoid) because I could paint it in or out

camera angle, focal length, and the amount of coffee I had to drink! If I needed him to be holding something practical, I would hold the item up and shoot it, then paint out my hand and put Pax in. I would also render shadow and reflection passes, where necessary, and assemble the final image in Photoshop. I have found the methods described above to be solid—although there is nothing terribly groundbreaking going on here as far as techniques go.

The future of Pax-iLL

Here's where things get to be fun with animating Pax. Since I am looking to take him into the TV and video game world, my techniques for doing still, comic book–style animations go right out of the window.

I have now created a single-mesh version of Pax with a full skeletal system of 80 bones. With the help of an amazing piece of software called MotionBuilder from Kaydara, I have the option to hand-animate Pax with the very best Forward Kinematics and Inverse Kinematics setup I've ever seen. I can also apply Motion Capture data to Pax in MotionBuilder and export my results straight back to LightWave, where I can light and render. I am so impressed with this software and its ease of use that I strongly recommend it to anyone looking for realism without having an army of character animators at their disposal.

I am setting up environments using photogametry (a process where you shoot objects from various angles, then overlay those stills onto a 3D model), which enables me to move my CG camera about freely and also makes Radiosity rendering (a method based on the analysis of light bouncing off diffuse surfaces) much easier. I also shoot live-action plates with a progressive scan Canon Mini DV Camera with what can best be described as guerrilla motion control rigs and dollies. Finally comes compositing, where Digital Fusion (DF) saves me. I do shots in DF for Pax and for my TV, HDTV, and film work.

Just to clarify, Pax is entirely a one-man show. I have not received help from anyone, which is my preferred method of working. For me, Pax is proof that if you have the drive and ambition—and don't mind spending every waking moment of your life on your computer—you too can create your own alter-ego

ater. I shot my textures with my Canon Elf digital camera and painted the rest, including Pax's face, n Photoshop 7.0.

Once the modeling and texturing—and the all-mportant storyboards—were complete, I moved on to shooting the background plates. Using practical backgrounds not only works well for my whole process, it allows this very busy artist enough time to do this project while holding down a day gig and still maintaining a personal life! Plates were shot digitally and I covered a wide variety of angles, since Pax's world takes place in my world. After mporting the best shots, I moved on to treating the plates. I cleaned them up, cloned out imperfections, and added heavy blurs to the extreme foreground and background to simulate macrophotography. The dea was to make everything look as though it were a miniature.

After finishing my plates, I rendered Pax out to

Equipment

Although I gave some general advice earlier about computers and software (*see pages 12–13*), some of you may like some more detailed information. Of course, this information will become dated as computer technology advances, so regard any specification listed here as a sensible minimum for working with high-resolution graphics.

APPLE POWER MAC G4 WITH WITH STUDIO DISPLAY. **www.apple.com**

154 The computer

PC or Mac

Despite all the myths you might hear, for practical usage in comic production there is little difference between a Mac and a PC.

- Macs are manufactured by one company, Apple. PCs are made by many different companies, both large and small, to a common system standard (IBM compatible).
- Macs have traditionally been the choice of people working in the graphics industry.
- Occasional problems transferring files between the two systems can be avoided by embedding graphics and fonts into application files.
- All graphics, drawing, 3D, and layout software has some equivalent that runs on each system.
- Both Windows XP and the Macintosh operating system are now very stable.
- In the past, Macs were considered easier to operate, but in practice there is little difference between them and PCs. It's more a question of preference and what you're used to than real usability.
- Because there are fewer Macs in use, hardware peripherals are less common and more expensive. There are fewer non-design programs, particularly games, for the Mac.

Central processor unit

The CPU is the "brain" of the computer, and governs the speed with which it can perform tasks such as rendering 3D graphics or running a filter in Photoshop. Speeds are quoted in Mhz: the higher, the faster.

- Recommended minimum: 1 Ghz (1000Mhz) G4, 2Ghz Intel Pentium 4 or AMD Athlon processor.

Memory

Memory, or RAM, is the space the operating system has at its disposal to load files, run programs and work on data. Once it runs out of memory, the operating system starts using the hard disk to do the same job, which slows things down considerably. With large graphics, it is important to have as much memory as possible. RAM is usually quoted in megabytes (Mb).

- Recommended: 512Mb

Graphics card

A graphics card is the sub-system that creates the image you see on screen. All current models are adequate for 2D work, but more expensive graphics cards will enhance 3D work (and 3D games—no, back to work!) This is a constantly changing area, with much competition between different manufacturers. Avoid "integrated" graphics, where the graphics chip is mounted directly on the motherboard. It's often slower, and you might not be able to upgrade the system later. Cards with Ati and nVIDIA chips are recommended. Cards also have their own video memory, used to buffer the screen display and store 3D textures and data. More video RAM—64Mb at least—is better for 3D work.

- Recommended: 64Mb ATI Radeon 9200 (**www.ati.com**) or 64Mb nVIDIA Geforce FX52000 (**www.nvidia.com**).

Hard drive

The hard drive is the space available to store your work, both while you are working on it and while the computer is switched off. Graphics work generates

ABOVE: WACOM INTUOS A4 GRAPHICS TABLET. www.wacom.com. ABOVE RIGHT: EVESHAM AXIS 3000 PC RUNNING WINDOWS XP.

more and larger files, so the bigger the hard drive the better. Quoted in gigabytes (Gb) (1Gb = 1000Mb).
● Recommended: 80Gb

CD and/or DVD drive
You will need a rewritable CD drive (CD-R/W) to back up your work and send material to clients. DVD writers (DVD-R/RW) are also available and falling in price. DVDs hold five times the data of a CD, making them a wise investment for heavy duty graphics work.
● Recommended: CD-R/W drive.

Graphics tablet
Graphics tablets are used for drawing and painting on the computer. What you sketch on the pad appears in roughly the same shape onscreen. Wacom is the best-known manufacturer. It's unnecessary—and expensive—to buy larger tablets. An A4 or A5 pad is fine.

External hard drive
This is essential for backing up work. At the end of each day, copy your work on to it and take it home or to a safe location. Losing your computer to thieves or fire is bad enough, but losing all your work at the same time makes it far worse.
● Recommended: 60Gb External FireWire or USB 2.0 hard drive.

Screen
Also referred to as VDU (visual display unit), monitor or display. If you want to spend more, a large, high-quality display is a good investment for your eyes. Flat screens (also called TFT or LCD) use less energy and desk space.
● Recommended: 17-inch TFT or 19-inch CRT monitor.

Scanner and printer
Virtually all low-cost scanners and inkjet printers are adequate. If you plan to print your own comic in any sort of volume, look at laser printers, both color and monochrome.

Internet connection
If broadband Internet connections are available in your region, get one! You will save money long-term while avoiding the frustration of a slow dial-up connection.

Glossary

Bezier curves A method of drawing curved lines in digital graphics applications, by placing points to create straight lines, then adjusting the shape of those lines using control handles.

Bit depth The number of bits of data assigned to each pixel in a digital image. This defines the number of colors that the pixel could potentially display. For example, a 2-bit color image can only show two: black or white. A 24-bit color image, however, can store approximately 6.7 million colors, giving it the appearance of photographic true-color.

Bitmap The main method used to store and display digital images on a computer, with the picture stored as a grid of differently colored pixels. When viewed at an appropriate size, the pixel patterns resemble a continuous tone image, like a photograph.

Bones A feature used in 3D modeling, where the parts of a model are joined by virtual bones, which control how they can be positioned or moved in relationship to one another.

Boolean Operator A method by which different shapes in 2D or 3D can be combined or subtracted from one another to create new ones. By subtracting one circle from another, for example, you can make a ring.

Cel-shading A 3D rendering process which adds black lines to the edges of 3D models for a convincing cartoon look.

CMYK The primary colors used in the vast majority of printing processes. Cyan, Magenta, and Yellow are combined in different strengths to create the full range of colors. While this range could include black, a separate black (the K) is added, as it's more efficient and creates a better final result.

Coloring The third stage of creating traditional cartoon artwork, where the colored ink or paint is added to the linework to add flat color or shading to the final page.

Compression The process of "squeezing" digital data files in order to make them take up less space on a disk or take less time to transfer over the Internet. Compression can be "lossy" or "lossless." If lossy, some data will be lost in the process, which can degrade the quality of image, audio or video files. If lossless, all the information is retained.

DPI Dots per inch. The measure of printed resolution. See resolution.

File format The different formats in which a computer program stores data files, including images. Some formats are native to a particular program, although others may be able to read them, while others, such as JPEG and GIF image files, are standard file formats that can be shared and displayed by a range of applications.

Flash An application and file format developed by Macromedia and used to create images and animations, which may have audio or interactive elements. Flash is mainly used to provide rich audio-visual content on the Web.

Font A typeface selected in an application and used in a digital image, Web page or other digital document, onscreen, or in print.

Gag A single frame cartoon or short strip designed to make a single point or get a quick laugh.

Hard Drive or Disk A fixed disk drive used as the main storage area in a computer to keep programs, documents, and other data for quick access or regular use.

HTML Hyper Text Markup Language. The simple code used to lay out and store Web pages on the Internet. HTML is created using some form of Web design package (although it can just be typed into a simple text editor), and the instructions in the code are interpreted by a Web browser, which reproduces the Web page on the screen.

Inking The second stage of traditional comics artwork, where the pencil lines are redrawn in black ink to create the final linework. Any blocks of black color may also be added at this stage.

JPEG Joint Photographic Expert Group. The international standards organization, which created the widely used lossy compressed image file format of the same name.

Layers A method of isolating elements of an image while working on them. The image is divided into separate layers which can be made more or less transparent and stacked on top of one another, like the acetate cells used in traditional animation. First

Reference

implemented in Adobe Photoshop, layers are now common to most graphics packages.

Lettering The process of adding dialogue text to a cartoon or comic strip. Originally handwritten, lettering can now be done using specialized fonts on the computer.

Linework The (usually) black inked or penciled lines that make up the initial stage of a drawing or cartoon.

Map In publishing, a spread by spread diagram showing the basic layout of pages in a magazine, book, newspaper, or comic book.

Micropayment A system for the payment of small amounts of money over the Internet, where the user sets up an account with one company, who make tiny payments to other companies on their behalf.

Modeling In 3D graphics, the process of creating a basic structure that can be surfaced, textured, and rendered to produce a 3D object.

Penciling The initial stage of creating comic artwork, with each page roughed out on board or paper with pencil, before the lines are firmed up for inking and coloring.

Pixel Picture element. The individual dots that make up a computer image.

Plug-in A separate sub-program which can be installed within a larger application to extend or improve its features and functions.

POD Print On Demand. A service offered by some printers, where an electronic version of a book is held on a central server, then printed, bound, and shipped in response to an individual order from a consumer.

PPI Pixels per inch. The measure of resolution in a digital image for screen use.

PSD The native file format of Adobe Photoshop, including not just the image but the layers and channels that make it up, plus additional, auxiliary information that could help the user or other users to rework or reproduce it.

RAM Random Access Memory. The area of a computer where your image and program resides while you work on it. RAM is volatile—anything not saved to hard disk will be lost in the event of a power failure or crash.

Rendering In 3D graphics, the process of taking the models in a 3D scene, plus surfaces, textures, and lighting, and then calculating the appearance of that scene from a particular viewpoint to create a finished image or animation.

Resolution The number of pixels in a screen bitmap image (or dots on a printed image) contained within a given surface area, usually stated in pixels or dots per inch. This resolution effectively acts as a measure of the detail contained in an image, and also defines how much you can blow up or zoom into the image before the pixels become apparent.

RGB The color model used by all screens, including computer screens, where red, green, and blue light combine at different intensities to create the full range of other colors.

Tablet An input device used by many digital artists consisting of a flat, pressure sensitive board and a stylus, allowing the artist to draw onto the screen as if he or she were working with traditional pencil and paper.

Texture A 2D-bitmap image applied to a 3D model during rendering to create a "skin" for the underlying polygon mesh. When combined with other techniques, this gives the model a realistic surface.

Vector A method of creating and storing images as a series of points, connected by lines of a particular width, shape, and color, along with fills of various textures and patterns or flat and graduated colors.

Index

A

Acrobat 134, 135
Adams, Neal 83
Adobe 12, 15, 56–57, 117, 121, 134, 141
advances 130, 133
advertising 125, 146
agencies 124, 125
Agudin, Gil 100–101
Amazon 134
animatics 14
animation 11, 14, 17, 42–43
 3D 96, 98
 distribution 141, 144, 153
 line 64
 reuse 104
 text 115
Animation Master 87
appraisals 126
Atherton, Justin 71

B

backgrounds 41, 85, 95, 97, 104, 144, 153
Bailee, Dehanna 135
balloons 114–115
Bezier curves 61, 62
bitmaps 56–57, 60–64, 67, 92, 95, 114, 144
Bitpass 149
black and white 55, 101, 116, 128–129, 143
Blambot 116, 120–121
book formatting 131
branding 147
broadband 134, 155
Bryant, Steve 82–83
Bryce 67, 91
bulletin boards 146, 147
bump maps 93
business cards 127, 146

C

cameras 41, 81, 94–95, 153
cartoon, definitions 8
CDs 73, 128, 134, 136, 155
cel shading 96
character design 42–43, 92–93, 95–96, 98, 104

character license 10, 130, 132
children 9–10, 22, 24, 32, 48, 70, 129
Clowes, Daniel 9, 11, 22
CMYK 37, 72–73
collaboration 14, 124
collage 109, 137
color 15–16, 19, 28, 37, 68
 calibration 73–75
 composition 50
 example 78–79
 line 55–58
 modes 72
 planning 70–71
 publishing 128–129, 137
 text 121
Comicraft 116
comics 9–11, 22, 26, 30, 32–33
 3D 87, 96, 98, 101
 collection sites 149
 color 71, 74, 83
 composition 39, 41, 43–44, 53
 distribution 139, 146
 interlinking 147
 line 57, 67
 publishing 123–124, 126–129, 131, 133–135, 137
 reuse 103, 111
 stories 37
 text 113, 116, 119–121
composition 47–51
compression 73, 134, 143
computers 12–13, 14–15, 16–17
 3D 85, 87
 color 68, 76–77
 distribution 140
 inspiration 23
 line 56, 58, 61
 publishing 128, 136–137
 requirements 19, 154
 reuse 103
 text 117, 121
connectors 114
consistency 126
contacts 127
contracts 125, 133
conventions 113, 114, 116
copyright 16, 129, 131, 133

Corel 15, 56, 60, 77
costs 126, 131, 133–135, 148
cover letters 126
critiques 127
cross-hatching 61, 62
Curious Labs 90–91

D

Daly, Paul 82–83
DAZ3D 90, 91
deals 132–133
deconstruction 104
delivery schedules 130
dialogue 114
Digital Strip 120
Digital Web Book Author 53
directory structure 106–107
distribution 123, 126, 135, 138–153
dots per inch (dpi) 56, 109, 114, 116, 120, 142, 154
download times 73, 136, 142–144
Drake, Stan 83
DVDs 155

E

effects 17, 77, 118, 137
Elements 13
email 12, 23, 83, 111, 121, 132, 147
emotions 43, 71
equipment 154–155
Ernst, Max 109
Europe 9, 11, 101, 131
exploitation 129
exposure 121, 124, 125
expressions 105
eye contact 114

F

fans 137, 145, 147
feedback 130, 147
fees 132, 140
Fidler, Chad 83
files
 formats 13, 37, 73
 names 73, 105, 134
 size 56–57, 134, 142–144

transfers 154
film see movies
fixed fee 132
Flash 11, 17, 29, 57, 62
 comics 144–145
 distribution 141
 line 64–65, 67
 text 115
flat fee 132
Fontographer 116
fonts 113, 116–118, 120, 134, 137
formats 131, 142
forms 32–33
found images 109
frames 45, 47
free work 124
Freehand 15, 17, 56
full-scale publishing 134
funding 130, 134

G

gags 8–10, 26–27, 105, 109
gaming 85, 87, 98–99, 129, 144, 153
genre 10–11, 22, 123, 139
GIF files 37, 120, 143–144
graphic design 120
graphics cards 154
graphics tablets 14, 60–61, 101, 155
grayscale 72
grouping 63
growth 24
guerrilla marketing 146

H

hand lettering 116, 120, 137
hard drives 154, 155
hardware 12, 154
Harrison, Mark 128
Hergé 11, 48
Hernandez, Lea 150
highlights 77
Hollywood 85, 124, 152
hotspots 144
HTML 11, 19, 67, 136, 140–141, 145–146
humor 42, 43, 70
hyperlinks 45, 83, 145

I

Illustrator 15, 17, 56–57, 62,
 117–119, 121
impasto 77
InDesign 117
inking 58, 60, 128
interactivity 17, 64, 67, 144–145
interlinking 147

J

Japan 9
Java 145
JPEG files 13, 120, 143, 144

K

Kaydara 153
Kazan, Elia 101
kit 154–155
Kochalka, James 150

L

Langley, Clint 128
Langridge, Roger 36–37, 135
Larson, Gary 27
lawyers 133
layers 12, 45, 73–77, 81, 83
 3D 96
 equipment 154
 text 114
layout 14, 44–45, 48–51,
 73, 134
Lee, Jenn Manly 18–19
legal agreements 124
lettering 15, 19, 83, 113–114
 impact 116–119, 120–121
 publishing 137
library system 65, 105, 109
licensed characters 10,
 130, 132
lighting 94
LightWave 67, 152, 153
Little, Jason 110–111, 142
London, Jack 101

M

Macromedia 15, 56–57,
 141, 144
Macs 154
Manley, Joey 83, 150

mannequins 90
manuals 13
maps 131
marketing 53, 126, 136,
 146, 149
Mason, Jeff 134
memory 154
Merryweather, Mike 66–67
micro presses 134
micropayment 148
micropublishing 23
Mills, Chris 83, 121
modeling 92, 101, 152–153
Modern Tales 150–151
money-making 148–149
monitors 12, 73, 155
montage 103, 109
Moore, Alan 9
MotionBuilder 153
movies 9–10, 22, 34, 87, 101
 distribution 152
 publishing 129, 133
multimedia 144

N

New Wave 11
New Way 11
niche markets 131, 134–135
non-uniform rational b-splines
 (NURBS) 92
note-taking 127

O

one-liners 26–27
online merchants 148
organization 106–107
out of gamut 72

P

packaging 124
page rates 129, 132
page size 131
Painter 15, 56, 60, 77
Paintshop Pro 13, 56
palette 50, 70–71, 74
paper 81, 123
Parker, Charley 142
partial-rights sales 133
payment 129, 132–133, 136,

139, 148–149
Paypal 149
PDF files 143
percentages 129, 133, 148
photogametry 153
photography 16, 81, 83, 86–87,
 103, 109
photomontage 109
Photoshop 12, 17, 19, 28–29
 3D 97
 color 70–74, 76–77, 81
 distribution 153
 equipment 154
 line 56, 60–61, 67
 montage 109
 publishing 128
 text 116, 121
Piekos, Nate 120–121
pixelation 109, 120
pixels per inch (ppi) 56, 60
point size 117
portfolios 125, 127, 140
Poser 67, 90–91
pre-funding 130
presentations 127
print on demand (POD) 23, 135
printers 73, 155
protagonists 24, 145
PSD files 13, 73, 142
publicity 132
publishing industry 123–124,
 126–127, 131–133

Q

Quark XPress 73, 117, 121
quasi-animation 144

R

Radiosity rendering 153
RAM 154
Rand, Ayn 101
readership 111
real-time 3D 87
Rebellion 129
Reed, Scott 52–53, 143
removable hard drives 155
reprints 129
research 126, 127
resolution 60, 109, 142

reuse 15, 45, 65, 85, 91
 3D 95–96
 distribution 145
 role 102–109
revision 39
RGB 72
rigging 92
rights 130, 132, 133
Robertson, James 136–137
Robison, Eddie 152–153
Rovnak, John 71
royalties 129, 132, 133

S

sample spreads 130
saving work 13, 19, 73, 107, 117
scanning 15, 19, 45, 58, 64
 color 73, 77, 81, 83
 equipment 155
 publishing 137
 text 116
schedules 130
scripts 30, 32–35, 83, 128–129,
 130, 141
search engines 14, 136, 146
self-expression 130–131
self-funding 130
self-publishing 19, 23, 30
 3D 101
 color 83
 role 123, 130, 134–137
 stories 37
 text 120–121
settings 41
shading 76
showcases 140–141
sidekicks 24
sketching 88–89, 118, 141
Smith, Matt 128–129
software 12–15, 17, 19, 53
 3D 85, 87, 90–92, 94
 color 73
 distribution 141, 143, 153
 equipment 154
 line 56–57
 publishing 134
 reuse 104–105
sound 144
Starkings Font 137

Index

Index

storyboards 14, 114, 153
storytelling 34–35
stream of consciousness 130
submission guidelines 128
subscriptions 11, 53, 149, 150
Sullivan, Lee 28–29
superheroes 11, 22, 24, 43, 45, 123
surfacing 92–93
surrealism 109
syndication 149
Szirmay, Mick 66–67

T
tails 114
Talbot, Bryan 136–137
television 10, 22, 133, 152–153
texture 16, 57, 60, 68, 76

3D 92–93, 95, 97, 101
color 81
distribution 153
reuse 104–105
thumbnails 14, 30, 32, 44, 83, 104–105, 141
tie-ins 10
TIFF files 13, 73
tips 95, 141
titles 119–120, 131
toons 9, 96
toy rights 133
trade magazines 124
trade shows 127, 130
translations 114
turnarounds 42
type 116–117, 134, 137
Type Tool 116

U
underground 11
United Kingdom (UK) 9, 11, 129
United States (US) 9, 11, 32, 128, 131
unsolicited submissions 124, 126
updates 140
UV mapping 92

V
vectors 56–57, 61–65, 104, 114, 116–117, 144
viewing packages 105
visual display units (VDUs) 155
Vue d'Esprit 91

W
Ware, Chris 9, 11
watercolor 77
Web comics 142–143
websites 14, 19, 56–57, 87
3D 87, 91, 101
collection 149
comics 150–152
design 140–141, 143, 147
directories 147
examples 19, 28, 37, 53, 67, 83, 101, 111, 120–121
publishing 125–126, 128, 134–137
reuse 105, 111
text 117, 120–121
word of mouth 146
working for free 124

Reference

Further reading and web resources

How to Self-publish Your Own Comic Book
Tony C. Caputo
Watson-Guptill
1997

Graphic Storytelling
Will Eisner
North Light Books
2001

Comics & Sequential Art
Will Eisner
North Light Books
1994

Understanding Comics
Scott McCloud
HarperCollins
1994

Reinventing Comics
Scott McCloud
HarperCollins
2000

How to Draw and Sell Comic Strips
Alan McKenzie
Titan Books
1998

Digital Prepress for Comic Books: The Definite Desktop Production Guide
Kevin Tinsley
Stickman Graphics
1999

Toon Art
Steven Withrow
Watson-Guptill
2003

Acknowledgments

Thanks must go to all the artists and publishers who kindly gave their time to contribute to the book. I would also like to thank Rebecca Green, whose wonderful organization helped keep this disorganized author on track, and my wife and kids for their support.